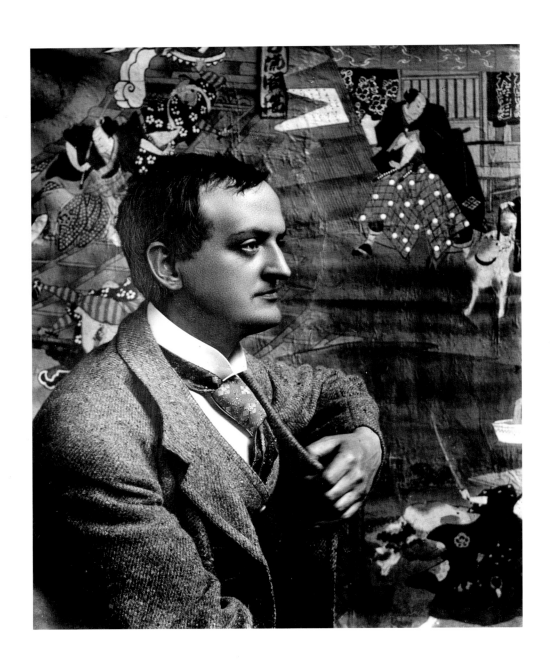

HORNEL

The Life & Work of Edward Atkinson Hornel

BILL SMITH

ATELIER BOOKS

Edinburgh

ATELIER BOOKS

First published in Great Britain in 1997 by
ATELIER BOOKS
6 DUNDAS STREET EDINBURGH EH3 6HZ

Text Copyright Bill Smith

Hardback ISBN 1 873830 14 9
Paperback ISBN 1 873830 19 X

Cover designed by Dalrymple
Production and publishing consultant Paul Harris
Printed in The Republic of Slovenia by Gorenjski Tisk

CONTENTS

BRIEF CHRONOLOGY

1864	born 17 July at Bacchus Marsh, Victoria, Australia
1866	family returned to Kirkcudbright
1880-83	studied at Trustees Academy, Edinburgh
1883	exhibited for first time at Royal Scottish Academy
1883-85	studied at Academie Royale des Beaux-Arts, Antwerp
1885	met George Henry
1886	exhibited for first time at Glasgow Institute of the Fine Arts
1886	Kirkcudbrightshire Fine Art Association formed by group of local artists including Hornel
1886	elected to Glasgow Art Club
1890	collaborated with Henry on *The Druids*
1890	exhibited with the Glasgow Boys at Grosvenor Gallery in London
1890	exhibited with the Boys in Munich
1891	collaborated with Henry on *The Star in the East*
1891	probable visit to Paris with Henry and several other Boys
1892	*Summer* purchased by Liverpool despite considerable controversy
1893	exhibited with Societe des XX in Brussels
1893-94	visited Japan with Henry
1895	first one-man exhibition at Alexander Reid in Glasgow
1895	exhibited with the Boys in St Louis, Chicago, Cincinnati and New York
1896	portrait painted by Bessie MacNicol
1897-99	served on Kirkcudbright Town Council
1898	exhibited at inaugural exhibition of International Society in London
1899	began to make serious use of photography in his painting
1900	*Fair Maids of February* purchased by Glasgow
1901	purchased Broughton House in Kirkcudbright
1901	declined Associateship of Royal Scottish Academy
1901	one-man exhibition at Alexander Reid in Glasgow
1902	joint exhibition with David Gauld at Alexander Reid in Glasgow
1903	one-man exhibition at Alexander Reid in Glasgow
1905	joined The Society of 25
1907	exhibited for first time at Royal Academy
1907	visited Ceylon and Australia with sister Elizabeth
1909	one-man exhibition at George Davidson in Glasgow
1909-10	gallery and studio designed by John Keppie added to Broughton House
1911	elected honorary member of Society of Scottish Artists
1912	one-man exhibition at George Davidson in Glasgow
1917	one-man exhibition at James Connell & Sons in London
1919	purchased Thomas Fraser's book collection, marking start of Hornel Library
1920	Hornel Trust drawn up
1920-21	visited Burma, Japan, Canada and America with sister Elizabeth
1923	elected Fellow of The Society of Antiquaries of Scotland
1925	appointed Honorary Sheriffs Substitute for Dumfries & Galloway
1925-28	served on Stewartry's Education Authority
1931	opening of Cochran Memorial Gymnasium at Kirkcudbright Academy
1932	suffers cerebral haemorrhage
1933	died 30 June at Kirkcudbright
1950	Hornel Trust came into being on death of sister Elizabeth

PREFACE & ACKNOWLEDGEMENTS

HORNEL IS ONE OF THE FINEST COLOURISTS SCOTLAND HAS PRODUCED
More than sixty years after his death his Kirkcudbright paintings of children playing in
Senwick Wood or among the burnet roses on the seashore at Brighouse Bay are as
popular as ever with collectors and public alike. A 'Hornel' immediately brings to mind
a quite specific and very individual work of art. Yet his early work, which placed him at
the forefront of progressive painting in Scotland in the first half of the 1890s and helped
earn Scottish art international acclaim in cities as far apart as Munich and St Louis, is
now largely forgotten. I hope to redress the imbalance with this book, the first biography
of an artist who was an important member of the Glasgow Boys.

Hornel very rarely threw away any papers. Thus there is a large amount of
information about him, his work and his friends in the archives at Broughton House,
Hornel's home in Kirkcudbright for over thirty years. I acknowledge with grateful thanks
the permission of the Trustees of the Hornel Trust to access those archives and to include
in my book excerpts from many letters and other documents.

I have been fortunate too that I was able to interview a handful of people who knew
Hornel. Inevitably a body of rumour and gossip builds up around a prominent figure and
Hornel is no exception. I have tried as far as possible to distinguish between fact and
myth.

In the course of my research over the last four years or so I have been helped by many
people. Chief among those is the staff at Broughton House. Without the kindness and
ready assistance of the late Mrs Dale Russell, Frances Scott of The National Trust for
Scotland and the Hornel Trust's Librarian Jim Allan this biography would not have been
possible. The latter in particular has been very patient and diligent in dealing with my
numerous requests for information and explanation.

My thanks are due to many in and around the Kirkcudbright area, including the late
Jock Mitchell, Robert Lyall, Effie McNeillie, Peggy Miller and Lizzie Rae, all of whom
remember Hornel, and also Jim Campbell, Miss Charters, Marie Harper and Heather
Black, the latter looking after me so well on my visits to the town. Many other people
have assisted me with information or advice, including Kathleen Hannay, Euan Robson,
J.E.Russell, Kathleen Wright, Gwyn Moore of the Bacchus Marsh & District Historical
Society, Roger Billcliffe, Ellen McCance of Kirkcaldy Museums, Michael Main, Jennifer
Melville of Aberdeen Art Gallery, Adrian Mibus, Ewan Mundy, Andrew McIntosh
Patrick, George Rawson of Glasgow School of Art, Tomoko Sato of Barbican Art
Gallery, London, Joseph Sharples of National Museums & Galleries on Merseyside,
Helen Smailes and Mungo Campbell of The National Galleries of Scotland, Joanna
Soden of The Royal Scottish Academy and Hugh Stevenson of Glasgow Museums. I am
particularly grateful to Frances Fowle, William Hardie, Jeanne Sheehy and Ailsa Tanner
for sharing with me their own research on Alexander Reid, Hornel, Antwerp's Academie
Royale des Beaux-Arts and Bessie MacNicol respectively, and also to Michael Russell,
whose thesis on the Hornel Library was very helpful.

I am indebted to the many private collectors for their kindness, hospitality and above
all their patience in allowing me to see their pictures and to have them photographed in
many cases. I am grateful also to the curators and staff of galleries throughout Scotland
and England, who have spared the time to show me work by Hornel in their collections,
as well as the staff of the National Library of Scotland and the Scottish Records Office in
Edinburgh, the Mitchell Library in Glasgow and the De Witt Library, the Guildhall
Library, The London Library and the National Art Library in London.

Lastly I would like to thank Patrick Bourne for reading the manuscript, Fiona Drennan and Fiona Robertson for organising the illustrations, Ian Biggar for photography, Selina Skipwith, my assistant at Flemings, who read the manuscript, helped with the illustrations and also looked after the Flemings Collection when I was otherwise occupied with this biography, and especially my wife Audrey, not only for the preparation of the index, but also for her infinite patience and understanding.

BILL SMITH *December* 1996

THE GREAT ADVENTURE
1856-1866

THE MONTH OF JULY 1851 IS A MEMORABLE ONE IN THE HISTORY OF THE State of Victoria in Australia. On the first day of the month the area around Port Phillip Bay as far as the Murray River in the north gained its independence from New South Wales and the colony of Victoria was born. Later that month gold was discovered. The first event was the occasion for great rejoicing. The latter caused a universal excitement verging on madness. Late in August the discovery of substantial deposits of gold near Ballarat, some seventy miles north west of Melbourne, turned the rush of men to the discoveries into a flood. Ordinary life came to a standstill, as almost every able-bodied man left for the diggings. Many businesses were forced to close down, there being virtually no one left to run them. The Squatters had no labour to help them look after their sheep, whose wool was the staple product of the colony. There was a run on the banks as depositors withdrew their savings to pay for food and equipment.[1] After six or seven weeks the inevitable reaction set in and many returned home bitterly disillusioned and with little to show for the perils and privations they had endured. By the end of October, however, an even larger discovery at Mount Alexander - present-day Castlemaine - brought about a rush of gigantic proportions. Melbourne and Geelong were almost emptied of their male population. Many, ignoring the disappointments they had suffered only a short period before, left for a second time, borne along on a tide of unbridled optimism. By the middle of December fully twenty thousand men were swarming over Mount Alexander in the quest for gold, a huge number when compared with Victoria's population of just over seventy-seven thousand shortly before gold was discovered.[2] Not surprisingly, however, the great majority made little or nothing at the diggings. Indeed some quickly realised that it was much easier to get rich by supplying goods to this vast army of diggers than by digging themselves.

News of the discoveries reached Britain in December 1851. However it was not until the following April, when the finds at Mount Alexander became known and ships carrying the gold began to dock in London, that gold fever - later described as 'the Australian madness' - gripped the popular imagination and the rush to Australia began.[3] During the nine years from 1852 to 1860 some 290,000 men, women and children emigrated from Britain to Victoria. In ten years the colony's population grew from 77,345 to 540,322. The Pre-Raphaelite painter William Bell Scott, who was Master of the government design school in Newcastle at the time, noted after a visit to London in May 1852 that he '...found the train lengthened by many waggons filled with working men bound for the other side of the world....From London, as from Newcastle, people of every condition and age were embarking.'[4] The majority of migrants in the early 1850s were young and single, attracted by the apparent prospect of limitless wealth and planning to return to Britain with their riches as soon as possible. However as the truth dawned that digging for gold was an absolute lottery, so the character of migration changed. Families were attracted by the general prosperity of the infant colony and the opportunities it seemed to offer to better themselves. Wages were relatively high compared with those in Britain. Thus after about 1853 most of the migrants went with the intention of settling there permanently or at least giving Victoria a reasonable chance. Scottish newspapers noted the departure from their shores of '...some of our best workmen...' '...well behaved and energetic young men....of the most respectable class...' '...first-class tradesmen from the country.'[5]

A recession in Victoria in 1854-55 cut the number of immigrants sharply. Prosperity returned in 1856, which prompted some forty-three thousand to emigrate from Britain to the colony the following year. Ironically this coincided with the start of an economic downturn which was to last until 1861, the crisis being accentuated by this unexpected inflow of migrants seeking work.

Among those who landed at Hobson's Bay in 1857 to start a new life in Victoria were a number of members of the Hornell family from Kirkcudbright, a small county town in the south-west of Scotland. The Hornells were an old-established family in the town. As early as 1578 the burgh records note that at the Burgh Court held at the Tolbooth on the third day of December a Thomas Hornell was confirmed as the lawful heir of Johne Hornell deceased, a burgess of Kirkcudbright, following a dispute over the title to property in the town.[6] Although the name was not uncommon in Galloway in the eighteenth and nineteenth centuries, Hornell is an unusual surname, the derivation of which is uncertain. Even within the same family it is variously spelt Hornal, Hornel, Hornell and Harnell.

In the nineteenth century Kirkcudbright was celebrated for the manufacture of boots and shoes.[7] Hornells had been boot and shoe makers in the town for at least four generations. In 1788 a John Hornel is recorded as Deacon of the Shoemaker Incorporation, one of the six guilds making up the Incorporated Trades of Kirkcudbright, and Hornells feature as officials of the guild throughout the nineteenth century.[8] It seems that John Hornel was a poor provider for his large family. However John's eldest son, also called John, in partnership with a brother built up a very successful shoe-making business from nothing, at one time employing twenty-four men. John was famed for the quality of his boots and shoes, sending them to all parts of Britain, as well as to the colonies and to America. Mindful of his own early struggles, he left on his death in 1859 a relatively large sum of money for the foundation of a Ragged School for the benefit of neglected and destitute children.[9]

The local trade directory lists no fewer than five members of the Hornell family carrying on business as boot and shoe makers in Kirkcudbright in 1852.[10] These included the younger John Hornel mentioned above, his brother William Hornel and the latter's son William Lidderdale Hornell.

William Lidderdale Hornell was born in Kirkcudbright in 1822, the second of eleven children born to William Hornel and his wife Margaret Heron. He followed in his father's trade, being admitted a Freeman and Craftsman of the Shoemaker Incorporation in 1851. Three years later he married Ann Elizabeth Habbishaw, a girl from Bingley in Yorkshire some ten years younger than himself. Margaret their first child was born the following year.

In November 1856 William and Ann, then six months pregnant, left their house and business in the High Street and with their daughter aged twenty-one months sailed from Liverpool for Australia on board the sailing ship *Shooting Star*.[11] They were accompanied on their great adventure by William's brothers Samuel and Charles and his sister Janet and her husband, farmer Robert Wightman. No doubt they felt, like so many others at that time, that there was a brighter future waiting for them in Victoria. Perhaps they also entertained a fond hope that they might just strike it lucky by being in the right place at the right time. Although the mad rushes of the early 1850s were a thing of the past, gold discoveries were still being made. In case things did not work out, however, William did not sell their house, but left it in the charge of two maiden aunts. The adjacent shop was rented out for irregular periods as opportunities occurred.

Until the Suez Canal opened in 1869, ships sailing to Australia had to round the Cape of Good Hope and head due east across the South Indian Ocean - a voyage of over twelve thousand nautical miles to Melbourne, taking on average about three months. In its

length, its rigours and its dangers it was not a journey to be entertained lightly. Shipboard life at that time was hard enough in normal conditions without the additional discomfort and sickness associated with rough weather or the sheer terror generated by storms. The inactivity and the boredom brought about by prolonged calms was almost as demoralising. Ever present was the dread of an outbreak of one or more infectious diseases.

At the beginning of February 1857, shortly after leaving Africa behind, Ann gave birth to her second child, a daughter who was named Ellen Janet Gillies, the last name being that of the ship's master. Twenty-six days later the *Shooting Star* dropped anchor in Hobson's Bay, just a few miles from Melbourne, after a voyage lasting one hundred and three days.[12]

The Melbourne of 1857 was a far cry from the rough frontier town of 1851. In the six years since the discovery of gold Melbourne had developed rapidly into a city of ten thousand dwellings and a population of some fifty thousand. It was regarded with justification as the jewel of the Southern Hemisphere. It eclipsed even San Francisco 'The Queen of the Pacific'. In the centre of the city fine stone buildings lined the wide macadamed streets, which were lit by gaslamps. It had Parliament Houses, a public library and a university. Banks and stores attempted to outdo each other in the splendour of their buildings. There was running water. Stone was rapidly superceding wood in private dwellings. Well planned suburbs were being developed. The first railways were being constructed.[13] Yet just over fifty years earlier the first settlers had abandoned Port Phillip Bay after only two years, describing it as '...an arid, barren country, too inhospitable even for the rigours of a penal colony.' The area had not been finally settled until 1835.[14]

By the time William Hornell and his family arrived in Melbourne, the brief prosperity of the year before had given way to slump. Gold yields were falling, cheap imports from the United Kingdom were flooding in, prices and wages had fallen and unemployment was becoming serious.[15] It seems that Hornell stayed in Melbourne for about a year, presumably trying to follow his trade as a bootmaker. However, because of fierce competition from imports, there was substantial unemployment among tradesmen. About half of the three thousand bootmakers in Victoria were out of work and the remainder were forced to concentrate on repairs only.[16] Although economic conditions were very bad in Melbourne and Geelong, there were jobs available in the interior at relatively good wages. Wool production had risen. The gold miners represented a huge local market for meat and there was a valuable export trade in hides. Away from the coast farming was developing rapidly. Established agricultural areas such as Bacchus Marsh, Kyneton and Kilmore were prospering due to their proximity to goldfields.

Sometime in 1858 William Hornell decided to move with his family to Bacchus Marsh, a small township about thirty-five miles from Melbourne on the road to Ballarat, where the first major gold discovery was made. Hornell may have moved there at the suggestion of his brother-in-law Robert Wightman, who might already have been farming in the area. The district of Bacchus Marsh was one of the earliest agricultural settlements in Port Phillip. It got its name from Captain William Henry Bacchus, who, after a career in the British army and farming in Sussex, emigrated with his family to Australia in 1837. The following year he acquired a run in the basin now known as Bacchus Marsh, where he and his son farmed sheep and cattle.[17] Surrounded and sheltered by wooded hills, it was excellent agricultural land. Travelling throughout Victoria in the 1850s, William Kelly described Bacchus Marsh as a fertile tract '...of unequalled productiveness, and cultivated through its entire extent in the best style of husbandry, yielding crops of surpassing abundance....The road passing through it for over two miles is quite a street in some places, lined with well-stored shops, neat dwellings,

and a due proportion of excellent hotels far in advance of the general run, which had been improvised, as it were, to shelter the digging influx. I also remarked three steam flour-mills, substantially constructed, and at full work...'[18] The township itself developed as a result of the gold discoveries at Ballarat and Blackwood. Hornell probably established himself there as a bootmaker. Over time he must have prospered, because he was able to purchase land in the district. In 1864 he described himself as a farmer. On his death in 1879 *The Bacchus Marsh Express* noted that he was the owner of considerable property, which included three farms totalling 1300 acres and a tan-pit.[19]

In this veritable Garden of Eden the Hornells' family continued to grow. Elizabeth was born at Bacchus Marsh in 1859 and Sarah in 1861, but Sarah died aged six weeks. Janet was born the following year. On 17 July 1864 Ann gave birth to twin boys. The elder boy was named William and the younger Edward Atkinson, taking his middle name from his maternal grandmother, Helen Atkinson, one of the daughters of a well-known Kirkcudbright family. Edward, who was to be known as Eddie or Ned to his family and close friends, was destined to become an artist, a leading member of the Glasgow Boys and one of the most popular Scottish painters during the first three decades of the twentieth century.

Sadly the Hornells' daughter Ellen, who had been born on the voyage to Australia, died aged seven only twenty-one days after the birth of the twins. Eighteen months later, after nearly ten years in Australia, the Hornells and their family embarked at Melbourne for London on board the *Suffolk*. Another daughter Grace was born on the voyage home. They arrived in London early in May 1866 and returned to Kirkcudbright.

The reasons for leaving Australia can only be guessed. It cannot have been because they were not successful in a material way for they retained substantial property in and around Bacchus Marsh. It seems more likely that Ann was not happy there, particularly after the death of a second child, and wanted to get back to the country she regarded as home.

1 Geoffrey Serle, *The Golden Age: A History of the Colony of Victoria*, 1851-1861, Melbourne, 1963, p.21
2 Ibid., p.23
3 Ibid., p.38
4 W. Minto (ed.), *Autobiographical Notes of the Life of William Bell Scott*, London, 1892, i, pp.296-7
5 Quoted in Searle, op.cit., p.47
6 *Kirkcudbright Town Council Records 1576-1604*, Oliver & Boyd, Edinburgh, 1939, pp.71 & 86
7 *Statistical Account of the Stewartry of Kirkcudbright*, 1845, pp.29-30
8 Minute Book of Shoemaker Incorporation, Kirkcudbright (Hornel Trust)
9 *Mr John Hornel's Fund for a Ragged School, Letter to the Editor* dated 9 January 1882 from John Hornel's solicitor (pamphlet)
10 *Slater's Directory, 1852*, facsimile edition, *Commercial Directories of Dumfries & Galloway from the nineteenth century*, Dumfries & Galloway Libraries, 1992
11 *Marine Register Book of Births*, Registry of Births, Deaths and Marriages, Melbourne
12 Ibid.
13 William Kelly, *Life in Victoria*, London, 1859, vol.I, pp.37-43
14 Ibid., vol.I, pp.23-4
15 Serle, op.cit., pp.240-1
16 Ibid., p.247
17 I am indebted to Gwyn Moore of the Bacchus Marsh & District Historical Society for information relating to Captain Bacchus and Bacchus Marsh
18 Kelly, op.cit., vol.II, pp.139-41
19 *The Bacchus Marsh Express*, 22 March 1879 & 21 June 1879

CHAPTER TWO

STUDENT DAYS
1866-1885

KIRKCUDBRIGHT STANDS ON THE LEFT BANK OF THE RIVER DEE AT THE
point where it opens out into its estuary, some four or five miles from the sea. It is an old
town. Although Kirkcudbright is not mentioned as a burgh until 1330, it was a seaport of
some significance by 1296, so there must have been some sort of community there for a
number of years before then. It was raised to the status of a royal burgh in 1455.[1] Its name
may derive from the Celtic *Caer-cuabrit* - a fortified place on the bend of a river - or it
may denote 'the church of St Cuthbert'. At the head of the estuary, lying between the
town and the Dee, is a series of large grassy mounds and hollows known as Castledykes,
all that is left of the once-mighty royal castle of Kirkcudbright, which dates from the late-
thirteenth century. Its moment of fame occurred as early as July 1300, during Scotland's
War of Independence with England, when the castle was then in English hands.
England's Edward I decided to mount a campaign in Galloway against the Scots. After
recapturing nearby Caerlaverock Castle, his large army, comprising infantry and cavalry,
camped at Kirkcudbright for ten days, before moving on to Twynholm on the last day of
July. Lying at anchor in Kirkcudbright Bay was a large fleet of supply ships. The vast
array of ships, men and horses, tents and banners must have been a splendid sight.
However Edward's campaign turned out to be a rather futile exercise and it was
abandoned at the end of August.[2] Kirkcudbright Castle was used by the English as a
supply base until Edward's death in 1307. By 1500, however, it was little more than a
ruin, a source of stone for many of the buildings in Kirkcudbright's High Street.

The county town of the Stewartry of Kirkcudbright until it was swallowed up into
Dumfries and Galloway Region in 1974, Kirkcudbright is one of the most attractive of
the Galloway burghs. Until the early nineteenth century the tidal river and its marshlands
partly encircled the town. That eminent Scottish judge Lord Cockburn viewed the town
from Tongland Hill in 1839 and again in 1844, writing in his journal:

> I doubt if there be a more picturesque country town in Scotland. Small, clean, silent and
> respectable; it seems (subject, however, to one enormous deduction) the type of a place to
> which decent characters and moderate purses would retire for quiet comfort. The
> deduction arises from the dismal swamps of deep, sleechy mud, by which it is nearly
> surrounded at low tide...It is only at full tide, or nearly so, that Kirkcudbright is to be
> viewed...And then, how beautiful does it stand! With its brown ruin of a castle, its church
> spire, the spire of its old town-house, and the square tower of its new one, all seen above its
> edging of trees, and the whole village surrounded by wooded hills and apparently
> glittering sea. There is no point...at which it does not present the same appearance of
> picturesque peacefulness, of intermingled wood and water. From several aspects it is the
> Venice of Scotland.[3]

It was this view which greeted the Hornell family in 1866 on their return to the house
in the High Street they had left almost ten years earlier. Apart from the arrival of the
railway in 1864, which signalled the beginning of the end of Kirkcudbright's centuries-
old role as a significant seaport, the town had not changed at all. Indeed the old part of the
town has hardly changed to this day, except for the harbour basin, which has been filled
in and converted to a car park. The L-shaped High Street is dominated at its elbow by the
seventeenth century Tolbooth with its forestair and its clock tower and spire, one of
several which can be seen from a distance above the jumble of roofs and trees. To the
north and east the street is lined with an attractive mixture of houses of various sizes,

dating from the seventeenth to the early nineteenth centuries, standing end to end, broken here and there by a narrow close, lined with several humbler dwellings. In the Old High Street, formerly the much wider King's High Street, which runs north from the Tolbooth to the harbour, several of the larger houses have arched gateways, leading through to a courtyard or large garden beyond. For the most part the stone facades are plain, many whitewashed or painted, but occasionally there is a modest ostentation in the form of an ornamental doorway, many with an attractive Georgian fanlight. Rubbing shoulders with these houses are one or two fine eighteenth century mansions, formerly the town houses of Galloway's landed gentry. Near the north end of the Old High Street, overlooking the River Dee, stand the picturesque ruins of MacLellan's Castle - Cockburn's 'brown ruin of a castle' - a rather grand and extensive late-sixteenth century tower house built by Sir Thomas MacLellan of Bombie.

William Hornell and his wife Ann began to rebuild their lives in Kirkcudbright. Hornell resumed his trade as a boot and shoe maker in the High Street. In 1867 he was re-elected Deacon of the Shoemaker Incorporation, an office he was to hold for the next ten years or so.[4] During the time they had been away from the town their family had increased to three daughters and the twins William and Edward, ranging in age from eleven to an infant of barely one month. A further set of twin boys, Charles and John, were born in July 1868. It must have been a bitter blow to them all when both boys died within a month of each other almost a year later. Another son David was born in 1870 and Annie, their twelfth and last child, in 1872. In the latter year the Hornells moved to a larger house at 18 Old High Street, dating from 1810. To the rear it had an outbuilding, which Hornell used as a shop, and a large west-facing garden reaching almost to the River Dee. It was to remain the family home until the death in 1959 of Annie, the last survivor of that large family.

The Hornells still owned three small farms in Australia. In 1877 William Hornell decided to go out there again. Whether he intended to stay for an extended duration or for a relatively short period, while he checked on the state of their property in and around Bacchus Marsh, is not known. In March 1879 an advertisement appeared in *The Bacchus Marsh Express*, offering the three farms to let for a term of years, so this may indicate that he was thinking of coming back to Kirkcudbright thereafter. However some three months later he died of a stroke at his married sister's house in nearby Coimadai aged fifty-eight. In reporting his death the same newspaper wrote that he had '...led a lonely life upon his Lucknow property.'[5] The Lucknow farm was sold in 1881, although it did not realise as much as they had paid for it, because the land had 'become badly infested with rabbits.'[6] The other two farms were retained, perhaps in case one or more of their sons wanted to farm in Australia when they grew up. In his book *The Glasgow School of Painting* published in 1897 the artist and critic David Martin suggests that it was Edward's intention 'to take up farming and return to Australia. This, however, he was prevented from doing by the death of his father...'[7] This seems rather unlikely. There does not appear to be any evidence to support the assertion. Indeed had he been keen to pursue a career in farming, there would have been more reason to go out to Australia following the death of his father. In fact the youngest son David went out to Bacchus Marsh as a youth, but sadly died at Coimadai in 1890 a few days before his twentieth birthday.

Following Hornell's death, his widow Ann would have carried on much as she had been doing. After all she had been on her own for the previous two years. Although she was by no means well off, it seems probable that her financial position was secure. In addition to their house at 18 High Street, the Hornells owned other property in the town, although it was all held in family trusts.[8] Ann supplemented her income by keeping fowls and several 'four footed beasts' in the extensive garden.[9] All her children were now at school with the exception of Elizabeth, who was a teacher in Edinburgh, and her eldest

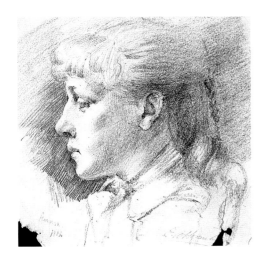

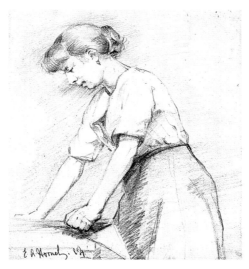

daughter Margaret, who in June 1874 had married William Mouncey, a house-painter and glazier by trade. He was twenty-three and she nineteen. Margaret was the only one to marry of the Hornell's eight children who survived into adulthood.

Mouncey was born and brought up in the town, living nearby in Union Street. He was a keen amateur landscape painter. Following in the steps of artists such as Alexander Nasmyth (1758-1840) and David Farquharson (1840-1907), both of whom had begun their careers as house-painters, Mouncey decided in his mid-thirties to give up his trade and to concentrate full-time on his art. He was largely self-taught, although he must have been tutored by his father, himself a talented amateur painter. He studied for a very short time in Edinburgh.[10] In technique he was influenced to some extent by his brother-in-law Edward. Mouncey's painting became skilled and assured. He revelled in the simple beauty of the landscape, rarely straying far from Kirkcudbright for his subjects, except for a sketching holiday in Bedfordshire in 1896, which was followed by a brief visit to London.[11] He exhibited at the Royal Scottish Academy for the first time in 1881, sending work to the Academy almost every year thereafter until his unexpected death in 1901 at the comparatively early age of forty-nine. He also exhibited at the (Royal) Glasgow Institute of the Fine Arts each year from 1887. An exhibition of his work was held at the Glasgow gallery of James Connell & Sons in 1898 and again in 1902.[12]

It is uncertain when Edward himself first demonstrated an aptitude for art. None of his very early work has survived. He received his early education at Townend School and, as was usual at the time, he spent his final year at Kirkcudbright Academy. It seems he was a 'very ordinary pupil', but he did have a natural talent for drawing.[13] When he was about sixteen, his mother, unable to make a judgement herself, showed some of his drawings to a picture restorer. The latter suggested that her son should take lessons in order to establish whether he had a genuine ability. Her uncle, who had a love for art, agreed, writing to his great-nephew that he showed 'considerable ease and freedom in your drawings, seeing you have not had any lessons...' However he went on to caution the youth: 'An artist must be first class in order to command patronage - anything short of that standing is a poor way of making a living, and attended with privations.'[14]

It was decided that Hornel should go to art school in Edinburgh. It seems probable that Edinburgh was chosen in preference to Glasgow because his sister Elizabeth was teaching there at the time. Although she was due to return to Kirkcudbright shortly, she could keep an eye on her younger brother - then just two months past his sixteenth birthday - until he had settled in. He left for Edinburgh at the beginning of October 1880 and enrolled for classes in the Antique Department at the School of Art. His great-uncle urged the young Hornel never to omit his prayers morning and evening and encouraged

him in his work to 'try to put Tom Faed in the shade.'[15] Thomas Faed RA (1826-1900), one of three artist brothers born at nearby Gatehouse of Fleet, was a very well-known and successful genre painter, then working in London. Early on Elizabeth must have taken her brother round the sights of Edinburgh, because in a letter to his mother, written shortly after he arrived, he reported that she had walked him off his feet. He also told his mother that he liked the school and that his lodgings were very comfortable. '...does Mrs Harper do your washing?' his mother asked in reply.[16]

Edinburgh's School of Art, located in the Royal Institution building fronting Princes Street, was one of the larger of the one hundred and fifty or so government schools of art, controlled from South Kensington in London. When Hornel enrolled, it had almost five hundred male students - although the majority attended evening classes only - and over three hundred female students. The school was the successor to The Trustees' Academy, which had been founded in 1760 as a drawing school.[17] In 1858 the School of Design, as the Academy was then known, had lost both its independence and its life class. In a far-reaching reorganisation that year the School of Design was affiliated with the Department of Science and Art in London. The life class was wrested from it by the Royal Scottish Academy, which thus achieved part of its long-held ambition of being responsible for fine art training in Scotland.

By the time Hornel arrived in 1880, the school had 'quietly withered into insignificance.'[18] The brief flowering of the early 1850s, when the inspired teaching of Robert Scott Lauder produced painters such as Robert Herdman (1829-1888), George Paul Chalmers (1833-1878), William McTaggart (1835-1910), John Pettie (1839-1893) and John MacWhirter (1839-1911), was but a fond memory. The curriculum laid down by South Kensington was rigid and regimented, encompassing some twenty-three stages. Most of the three years' course was spent drawing and shading from casts of antiquities. In 1872 a pupil wrote to the *Courant* - one of the city's newspapers:

> Fancy a student on two hours for three evenings a week during the best part of two sessions [ten months] working on one single figure drawing... 'The Department' will not allow us to draw a group, nor even select a figure - the head of Ajax, the figures of Germanicus, Discobolus, and Antinoux are the stereotypes...willingly would the most of us return, were the teaching altered to what it was when Scott Lauder was the master.[19]

Another adverse factor was the loss of its life class - the principal goal of most students - which led to an acute loss of vitality.[20] It is little wonder that a great many of the school's students looked back on their training there as next to useless in their bid to become

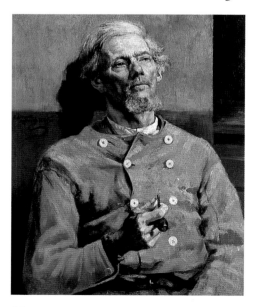

PLATE 3
Portrait of a Man in a Red Tunic *1885*
Oil on canvas, 28 x 23
Hornel Trust

painters. Yet, within the severe limitations imposed by the South Kensington system, during the ten years 1875-1884 the school under its Head Master, Charles Dosewell Hodder, himself a product of the South Kensington School, consistently achieved results well above average in the annual National Competitions.[21] Hodder, who was described as a 'good and enthusiastic teacher' but who can be regarded only as a very minor artist in his own right, had taken over from Lauder and was to remain as Head for over forty years.[22]

Other first-year students included George Denholm Armour (1864-1949) from Lanark and Thomas Bromley Blacklock (1863-1903) also from Kirkcudbright, who were about the same age as Hornel. Another arrival, William Stewart MacGeorge (1861-1931) from nearby Castle Douglas, was about three years older. Hornel and MacGeorge became great friends, although many years later they fell out. Hornel knew Blacklock before he went to Edinburgh, but he had a prejudice against him for some reason; Hornel's friend and fellow artist Charles Hodge Mackie (1862-1920) told him he thought Blacklock was 'a nice, quiet, ill-used, inoffensive fellow, very diffident of his own powers', but to no avail.[23] During his time at Edinburgh Hornel made many friends, including Robert Duddingstone Herdman (1863-1922), Peter Kerr (1857-1940), Mackie, James Smith and William Walls (1860-1942).[24] He knew William Miller Frazer (1864-1961) and probably James Pryde (1866-1941), other fellow students, and may have met some of the students at the Royal Scottish Academy's Life School, such as Thomas Austen Brown (1857-1924), James Cadenhead (1858-1927), Charles Martin Hardie (1858-1916) and Robert Noble (1857-1917), who attended classes in the National Gallery building to the rear of the Royal Institution.

Hornel's youthful enthusiasm soon turned to disappointment and disillusionment. Indeed he came to regard his time at Edinburgh as a waste of three years. He found little to motivate him. He was not taught to paint, which was what he wanted to do, but spent his time for the most part painstakingly copying from prints and drawing from casts.[25] It was a frustrating time, sadly an all too common experience among the students. However it was not in Hornel's nature to knuckle-down to such rigid and authoritarian teaching. His time in Edinburgh was spent in 'veiled, and sometimes open, revolt.'[26] It is not surprising, therefore, that he did not shine at the school. His friend MacGeorge won a Queen's Prize in the National Competition in his second year and a School Prize in his third. Blacklock was awarded a School Prize in his second year and Armour a Queen's Prize in his third year. Hornel managed a class prize in 2nd Grade Time Exercises in his first and second years, but he did not feature at all in the lists in his third year.[27]

His rejection of the academic approach taught at the school is apparent in the work Hornel executed while at Edinburgh. Two undated canvases (both about ten inches by fourteen) - one of a country road near Edinburgh and the other of a river scene with, in a field on the far bank, a building with a conical-roofed tower - are early essays in composition and technique. Both are low-toned, the paint broadly handled, but with a rather heavy touch. The two paintings are reputed to have been given by Hornel to John Telford, a ship's master living in Leith, in payment of a fare, possibly to Antwerp.[28] This broad handling is also evident in a woodland scene dated 1882 (twelve inches by sixteen), executed in an almost monochromatic yellow-green tonality. The composition - in particular the carefully observed group of butterbur leaves on their tall rhubarb-like stalks in the foreground - is a distinct advance on the earlier canvases. The painting was gifted to, or exchanged with his friend and fellow-student Peter Kerr from Greenock. In *A Glimpse of Kirkcudbright*, which Hornel painted in 1882 and exhibited at the Royal Scottish Academy the following year, this broad technique is continued. Hornel's mother was very proud that her son had a painting hanging in the Academy, writing to him 'you will hold up your head on the Street now...'[29] Her remark probably refers to her son's

unhappiness that he had not yet had a painting exhibited, whereas already Armour, Blacklock and MacGeorge had had work hung in the Academy. The proud mother travelled from Kirkcudbright to Edinburgh and purchased her son's painting for four guineas. It hung in Ann's bedroom until her death, when it passed to her daughters.

In the middle of 1883, after almost three years at Edinburgh School of Art, Hornel decided that he had to undergo a period of *proper* training. He chose to go to the Academy in Antwerp. It seems that he persuaded MacGeorge and Walls to accompany him. In a letter to Hornel just before he left for Belgium, his student friend James Smith wrote 'Well, whatever benefit the others may derive from being in Antwerp they will have to thank you for it as I think had it not been for your resolution &...' (remainder of paragraph torn off).[30] Hornel was missed by the friends he left behind in Edinburgh. By all accounts he was a popular figure, a good fellow to be with. He was a very good raconteur.[31] Smith wrote to him later that year 'More than once your name turned up, accompanied by the wish that you were with us.'[32] Mackie remarked that he '...could not help feeling the want of that cutty pipe and burglarian slouch hat of yours.'[33] Hornel liked his pipe. He also liked a drink.

There is a tendency today to regard Paris as the only worthwhile training ground for painters during the second half of the nineteenth century. This was far from the case. There were a number of important artistic centres, of which Antwerp was one. Founded in 1664, Antwerp's Academie Royale des Beaux-Arts is one of the oldest academies of art. In the 1870s and '80s it had an international reputation as a major art school, attracting a relatively large number of foreign students from a range of countries. When Hornel arrived in October 1883, he was one of thirty-seven students from Britain (including Ireland).[34] Another arrival that month was the Irishman Roderic O'Conor, then within a few days of his twenty-third birthday. Recent students had included Norman Garstin, Frank Bramley and Fred Hall, who were all to gravitate to Newlyn in Cornwall, and Walter Osborne. Although he never enrolled as a student, George Clausen came into contact with the teaching at the Academy for a brief period in 1875, which had a dramatic effect on his painting.[35]

Why Hornel chose Antwerp, when many of his fellow Scots had decided on Paris, can only be surmised. Probably he was attracted by the reputation of the Professor of Painting, Charles Verlat, and the much more robust approach to painting then prevalent at the Academy, certainly compared to Edinburgh. Antwerp was cheaper than Paris; tuition was free and according to Alick Ritchie, a later student from Dundee, writing in *The Studio* in 1893, good lodgings could be obtained at moderate prices.[36] Possibly Hornel's mother felt that Antwerp would be a more sensible alternative for a young man still in his teens with fewer distractions than Paris. However Antwerp, then as now a major seaport, must have had no lack of fleshpots to 'distract' anyone so inclined.

The Academy is housed in a former Franciscan monastery, parts of which date from the fifteenth century. In his article in *The Studio* Alick Ritchie noted that small square slabs, marking the resting-places of the monks, could still be seen in the stone floor. Ritchie contrasted the noise and alien life-style of the art students with the letters 'R.I.P.' cut into the slabs.[37] The Academy ran two principal classes, the *Antiek* class - drawing classical antiquities from plaster casts - from which students progressed to the *Natuur* class - drawing and painting from life. There was also a class in landscape and animal painting. Judging from the number of British and Irish students who went on to become realist painters, at that time there must have been some emphasis placed on landscape, genre and plein-air painting in the teaching of the Academy.[38]

Discipline in the Academy was strict and breaches were punished. Punctuality was regarded as important. Absence from classes was forbidden without permission. The students worked a relatively long day. During the Winter Course, which ran from the first

day of October until the end of March, classes were held from 9 until noon, from 1.30 until 4 in the afternoon and in the evening from 5 until 8 each day except Sundays and public holidays. The Summer Course ran from the first day in May to the end of August, when the hours were 8 until noon and 2 until 6. At the end of each Winter Course students submitted work to a competition - *Concours* - in which they were marked and placed in order of merit.[39] In what little spare time they had during term time, students were expected to study the works in the Musee Royale des Beaux Arts, which was then housed in the same building as the Academy, and get out and draw or paint in the city and the surrounding countryside. The students had free access to the city's renowned zoological gardens for the purpose of sketching. Despite the long hours and the strict discipline, however, Ritchie considered that student life at Antwerp was very pleasant.[40]

Charles Verlat, who took the painting classes and went on to become Director of the Academy in 1885, had an international reputation as an artist and teacher. He was renowned as a painter of animals; many of his major works are hung in a special room at Antwerp zoo. He was born in Antwerp and had studied art there. After spending nineteen years in Paris, where he was greatly influenced by the work of the French realists and of Courbet in particular, he taught at the academy in Weimar, before returning to Antwerp in 1877. Verlat was described as 'a typically Belgian figure, with his pointed black beard, hair en brosse, and loose shirt collar.' He had '...a social verve and a characteristically slap-dash method in his brushwork which powerfully attracted youth.'[41] In his teaching Verlat emphasised the use of thick paint, vigorous brushwork, adventurous colour and strong tonal contrasts. He considered that an artist should be drawing and painting at the same time.[42] Verlat was something of a celebrity, a larger than life character noted for his 'tempestuous and boisterous nature'.[43] A hero to many of his students, he and the Academy were synonymous - many artists are described as having trained 'at Verlat's Academy' or 'at Antwerp under Verlat.'

At the end of September 1883 Hornel, MacGeorge and Walls travelled to Antwerp. Together with William Burn-Murdoch (1862-1939), a fellow Scot from Edinburgh, they enrolled in the *Antiek* class at the Academy on the first day of October. All four found lodgings that term at 48 Olijftakstraat. Peter Wishart (1846-1932), a mature student from Aberdour in Fife, who had studied with the four Scots in Edinburgh, arrived at the Academy in mid-November.[44] Within a month or so, when they had demonstrated their

drawing ability, they transferred to the *Natuur* class, Hornel being the last to move over on 20 November. Also in that class was Robert Atkinson from Leeds. It is possible that Atkinson was a distant cousin of Hornel, whose maternal grandmother was an Atkinson. Several members of that family had moved to England. Certainly the two students lodged together the following term.

Although Hornel appears throughout his life to have kept all letters written to him, very few of his own letters have survived. Consequently there is little first-hand evidence of what he was doing during his period in Antwerp, which was to last almost two years. However it seems that Hornel and his fellow students settled down at the Academy very well. In a letter to Hornel in November 1883 James Smith wrote from Edinburgh that '...he was very glad to hear that you are all liking it & were getting on.'[45] Charles Mackie wrote back to Hornel in January 1884 'I am very glad that your anticipations regarding Antwerp were not blasted. Two years of the training which your letter described should work wonders on you and your confreres.'[46] How Hornel supported himself while he was at Antwerp can only be guessed. He probably got a small allowance from his mother, which he may have supplemented by selling his sketches, as little of his work of this period seems to have survived. Some of the students earned money by selling to tourists copies they had made of paintings in the Musee Royale [47]

After the rigid and uninspiring regime at the School of Art in Edinburgh, the teaching at the Academy must have seemed like a blast of fresh air to the Scots. In contrast to Edinburgh, the whole aim of the training at Antwerp was to turn out good *painters*. Hornel later described Verlat as 'the finest teacher that ever lived.'[48] In an article on Hornel in *The Scots Pictorial* in 1900 Edward Pinnington wrote:

> [he] used to awake with a feeling of delight that he was again going to school, and there, with an hour or two for meals, he worked for six days in the week from eight in the morning until nine at night. This was the happiest period of his life. He felt inspirited by the eager joy of progress, the bouyant confidence of forward movement.[49]

Even allowing for the journalistic hyperbole of the time, it does seem that Hornel's interest was re-ignited and he felt compelled to work hard. This was to be borne out in his examination results, particularly in the Winter 1884/85 *Concours*, when he achieved an average of 54 marks out of 60 for his four subjects. Out of the five Scots in the *Natuur* class he came second equal with Walls. MacGeorge came first among the Scots in both the 1883/84 and 1884/85 *Concours*.[50]

Two pencil sketches (Hornel Trust, pls.1 & 2), executed by Hornel in 1884, show the progress he was making in drawing from life. One is a three-quarters length study in outline of a girl working at a table; the other - a girl's face in profile - is an exercise in light and shade. Both demonstrate a sensitive treatment of the subject. The drawing is very competent, something which would not always be the case; in some of his later oils Hornel can be criticised with justification for slovenly draughtsmanship, particularly in his depiction of hands and feet.

Antwerp's dynamic approach to the teaching of painting was soon reflected in Hornel's work in oil. *Figure in a Scarlet Coat* (1884, Harrogate), a confident portrait of an old man in a red tunic, represents a significant step forward in comparison with his Edinburgh work. The subject matter is more ambitious. Its execution is more painterly. The following year he painted another version - *Portrait of a Man in a Red Tunic* (Hornel Trust, pl.3) - which clearly demonstrates the progress he was making. Well observed and composed, it is a good characterisation of an old man in reflective mood. The handling in the second version is more assured, the paint applied with a loaded brush in broad strokes. Hornel was obviously trying to follow Verlat's precepts of robust approach, vigorous brushwork and adventurous colour. Those were the very principles which at that time W.Y.Macgregor in Glasgow was propounding to the small group of young artists who gathered in the winter for life classes and discussion in his studio at 134 Bath Street.

1 Geoffrey Stell, *Exploring Scotland's Heritage: Dumfries and Galloway*, The Royal Commission on the Ancient and Historical Monuments of Scotland, Edinburgh, 1986, pp.49-50; Close Roll, 25 Edw.I.m.22, dorso

2 List & Index Society, vol.132, *Itinerary of Edward I Part II 1291-1307*, London, 1976

3 *Circuit Journeys by the late Lord Cockburn*, Edinburgh, 1888, pp.254-5

4 Minute Book of Shoemaker Incorporation, Kirkcudbright (Hornel Trust)

5 *The Bacchus Marsh Express*, 21 June 1879

6 *The Bacchus Marsh Express*, 19 March 1881

7 David Martin, *The Glasgow School of Painting*, London, 1897, p.30

8 Burgh of Kirkcudbright, Valuation Rolls

9 Letter from Ann Hornel to Hornel dated 7 February 1881 (Hornel Trust)

10 Malcolm McL Harper, *William Mouncey, Artist, The Gallovidian*, vol.6, 1904, p.141

11 Ibid., p.138

12 Ibid., p.140

13 Obituary, *Galloway News*, 1 July 1933; the obituary states that he received his education at Townhead School, but surely this must be a misprint - Townhead is about three miles from Kirkcudbright (his older sister Elizabeth is recorded in 1874 as being a pupil-teacher at Townend School)

14 Letter from Edward Atkinson to Hornel dated 1 September 1880 (Hornel Trust)

15 Letter from Edward Atkinson to Hornel dated 5 October 1880; letter from Ann Hornel to Hornel dated 7 February 1881 (both Hornel Trust)

16 Letter from Ann Hornel to Hornel dated 13 October 1880 (Hornel Trust)

17 The Academy derived its name from the fact that it was founded by The Honourable the Board of Trustees for Fisheries, Manufactures and Improvements in Scotland, itself established by Act of Parliament in 1726

18 Lindsay Errington, Master Class: *Robert Scott Lauder and his Pupils*, National Galleries of Scotland, 1983, p.37

19 Quoted in Lindsay Errington, op.cit., p.37

20 Parliamentary Departmental Committee Report 1903

21 Annual Reports of the Science & Art Department 1876-1885; an analysis of the weighted results in nine of the years (no detailed report issued for 1883) indicates that the Male School in Edinburgh's School of Art gained medals and prizes from twice (1875) to five times (1878) the average of all government schools of art

22 Obituary, *The Scotsman*, 15 June 1926; there is a self portrait in the Scottish National Portrait Gallery in Edinburgh (PG1441)

23 Letter from Charles Mackie to Hornel dated 26 January 1884 (Hornel Trust)

24 The identity of Smith is uncertain; probably he was James Mackie Smith, who came from Montrose

25 Edward Pinnington, *Mr E A Hornel, The Scots Pictorial*, 15 June 1900, pp.171-3

26 *The Bailie*, 1 May 1895

27 Scottish Record Office, Edinburgh, *Trustees' Board & Committees' Minutes 1727-1907* (file NG1/1)

28 In conversation with owner's brother 17 August 1995

29 Letter from Ann Hornel to Hornel dated 19 February 1883 (Hornel Trust)

30 Letter from J Smith to Hornel dated 14 September 1883 (Hornel Trust)

31 *Quiz*, 16 February 1893

32 Letter from J Smith to Hornel dated 15 November 1883 (Hornel Trust)

33 Letter from Charles Mackie to Hornel dated 26 January 1884 (Hornel Trust)

34 Academie Royale des Beaux-Arts d'Anvers, *Rapports Annuels 1883-84*

35 Dewey Bates, *George Clausen ARA, The Studio*, vol.V, 1895, p.4

36 Alick P F Ritchie, *L'Academie Royale des Beaux-Arts d'Anvers, The Studio*, I, 1893, p.142

37 Ibid., pp.141-2

38 Jeanne Sheehy, *Walter Osborne*, The National Gallery of Ireland, exhibition catalogue, 1983, p.43

39 Printed *Extract from the Internal Regulations of the Royal Academy of Fine Arts, Antwerp* (Hornel Trust)

40 Ritchie, op.cit., p.142

41 *Glasgow Herald* 4 July 1933, *An Editorial Diary: Hornel's Teacher*

42 Pinnington, op.cit., p.173

43 Frans Mertens & Hilda Van Loock-Verberckmoes, *Karl Verlat (1824-1890)*, 1977, p.92

44 I am indebted to Dr Jeanne Sheehy for sharing with me her research on the Academy's class lists

45 Letter from J Smith to Hornel dated 15 November 1883 (Hornel Trust)

46 Letter from Charles Mackie to Hornel dated 26 January 1884 (Hornel Trust)

47 Thomas John Lucas, *Art Life in Belgium, The Portfolio*, vol.X, 1879, p.182

48 Pinnington, op.cit., p.173

49 Ibid., p.173

50 Hornel's marks were as follows: 1883/84 *Concours* Drawing from Life 33.7 out of 60; 1884/85 *Concours* Painting from Life (torso) 57.6, Painting from Life (clothed male model) 52.8, Painting from Life (clothed female model) 54, Drawing from Life 51.6 (all out of 60); I am indebted to Dr Jeanne Sheehy for sharing with me her research on the Academy's *Concours* results

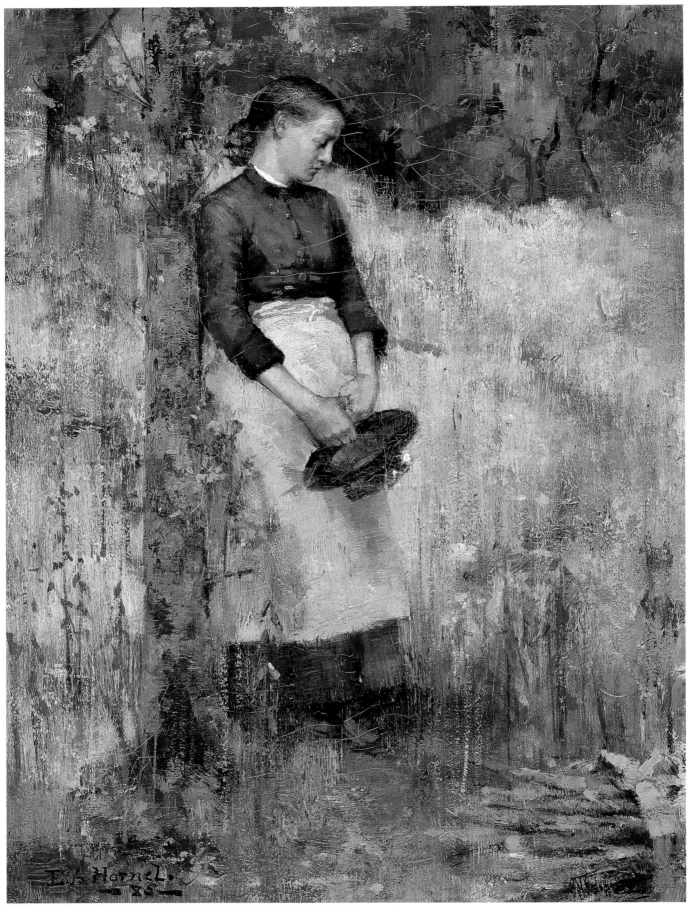

22

GLASGOW BOYS
1885-1886

IN THE LATE SUMMER OF 1885 HORNEL RETURNED FROM HIS STUDIES IN Antwerp, along with his friends William Burn-Murdoch, W S MacGeorge and William Walls. Walls went on to enrol at the Royal Scottish Academy Life School in Edinburgh. Burn-Murdoch and MacGeorge were to join him at the Life School the following year.[1] Hornel went back home to Kirkcudbright, where he was to live for the rest of his life. He set up his studio at 21 Old High Street, a single-storey building to the rear of the former Custom House, just across the street from the family home.

He had just turned twenty-one. Tall and handsome, he had a commanding presence. His high forehead, Roman nose, prominent chin and brown-grey eyes gave him the appearance of a Roman emperor, a resemblance which had not failed to strike his fellow students in Edinburgh on at least one occasion when he happened to be engaged in drawing a head from an antique cast.[2] *The Bailie* noted that his 'striking, strongly marked features' provided 'splendid material' for a sculptor, when in 1892 it applauded the bronze bust of Hornel by his friend James Pittendrigh Macgillivray (1856-1938) on display in Glasgow Art Club.[3] The artist Archibald Standish Hartrick (1864-1950), who knew Hornel well, described him as 'a fine-looking man of strong character and stronger language, which got him a reputation for being much rougher than he really was: just as was the case with Cezanne as a young man.'[4]

Shortly after his return to Scotland there occured an event which was to shape his life until almost the end of the century. Hornel met fellow artist George Henry for the first time in the autumn of 1885.[5] The manner of their meeting and whether it took place in Glasgow or Kirkcudbright are unrecorded.[6] It was the beginning of a close friendship, which lasted ten years or so and which throughout that period was to enrich the work of both men.

Henry was the senior by some six years. He was born in Irvine in Ayrshire on 14 March 1858, the only child of William Hendry, a brewer in Irvine, and his wife Ann Fisher from Catrine near Mauchline, who had married in March the previous year. When Henry was just over eighteen months old, his father, then an innkeeper in Kilbirnie, died of typhus fever aged about thirty-five.[7] The infant Henry and his mother - a widow at twenty-seven - returned to live with her mother at Catrine. By 1871 the three of them had moved to 4 Binnie Place, Glasgow to live with Ann's younger brother James, who was a muslin warehouseman in that city. Henry lived with his mother and uncle at this address certainly until after 1891 and possibly until he moved to London around the turn of the century.[8] As a youth he spelt his surname *Hendry*. Then he called himself *George F Henry* - presumably adopting his mother's maiden name - but later he dropped the middle initial.

Henry later recalled in an interview published in the magazine *Black & White* in 1907, the year he was elected an Associate of the Royal Academy in London:

> [I] first started drawing in a patent office. One learns precision from engineering drawings, but there is not exactly scope for originality. And then I did posters, the sort of thing one sees on circuses and music-halls, and drew for decorators, and did all sorts of work in connection with wood-engraving, and later with process-blocks... [my hardest job was] a commission from an American firm. There were seven hundred little drawings...all of kitchen ranges...it nearly broke me up. Then I studied at the School of Art in Glasgow. I did the necessary daily grind of drawings, these kitchen ranges and other mechanical stuff, at night, and the School of Art in the evening, so as to give the daylight to painting.

(left)
PLATE 5
Resting 1885
Oil on canvas, 15 x 11
Private Collection

Each kitchen range drawing was about the size of a small matchbox.[9] This laborious and exacting work 'tore the eyes out of him.'[10] Henry enrolled at Glasgow School of Art in, or possibly before, 1875 (the admission books are lost), as he won prizes for mechanical drawing in 1875-76 and 1876-77.[11] He must have attended classes - perhaps on and off - until some time in 1883, because it is reported that he won a further prize in 1879-80 and his name appears in the earliest extant Register of Admissions in 1881-82 (in which he is described as a clerk) and in 1882-83 (described as an art student).[12]

Henry was an early member of that group of young artists who became known as the Glasgow Boys. Within the short space of fifteen years - from about 1880 to 1895 - they challenged the art establishment in Scotland, did much to revitalise Scottish art and put it on the international map, and pointed the way for their successors. They are often referred to as the 'Glasgow School', but this label is accurate only in the sense that the city became their base. They did not all live in Glasgow, but at various times used or visited studios in that city. The Boys were all individualists. They came from very different backgrounds and their training, if any, varied considerably. Although springing from a common root, within a few years their work was to develop in a variety of directions.

It was no coincidence that this remarkable flowering of painting occurred as Glasgow approached the peak of its industrial and commercial prosperity around the turn of the century. The city was renowned throughout the world for its shipbuilding, heavy engineering and the building of railway locomotives, as well as the enterprise of its merchants. Glasgow considered itself at the time not just the second city of Britain, but the second city of the Empire. However it was also a city of stark contrasts. At one extreme there was an industrial and commercial elite, generating great wealth for themselves and their families. At the other end of the spectrum thousands were trapped in abject poverty, living in dreadful, overcrowded conditions.

As the city prospered, so too did the arts. There was an ever increasing public awareness of art, stimulated by Glasgow's growing civic collection and by the founding in 1861 of the (Royal) Glasgow Institute of the Fine Arts by a group of prominent citizens, including a number of artists. The Institute inaugurated annual exhibitions - in direct competition with the Royal Scottish Academy in Edinburgh - thus providing a showcase for Glasgow and west of Scotland artists, who claimed that the Academy unfairly discriminated against them. An important feature of the Institute's annual exhibitions was the inclusion of work by English and foreign artists, such as Corot, the Barbizon and Hague School painters, Burne-Jones, Millais, Rossetti and, particularly in the 1890s, Whistler, thus expanding the horizons of Glasgow's artists and public alike. The artists themselves formed Glasgow Art Club in 1867. Whereas anyone could join the Institute, membership of the Art Club was by election only and was tightly controlled by the Glasgow art establishment, prompting the younger artists to direct the same accusations at the Club as were being levelled at the Royal Scottish Academy.

The wealth generated by the city's industrial and commercial success created a growing number of art collectors. This led to several art dealers establishing themselves in Glasgow. They provided an outlet for the work of local artists, but, perhaps of more importance, they also introduced the work of foreign painters to Scottish collectors, who at that time were more adventurous than their English counterparts.

Craibe Angus opened a gallery in 1874 and, because of family connections with Holland, specialised in the work of Hague School artists such as Johannes Bosboom, Jozef Israels, H.W.Mesdag, the three Maris Brothers - Jacob, Matthijs and Willem - and Anton Mauve. That such painters were proving popular can be appreciated from the fact that four Glasgow collectors alone were able to lend no fewer than eighteen of the sixty-three works of the Hague School exhibited at the Glasgow International Exhibition in

Kelvingrove Park in 1888.[13] Angus also acted as the Glasgow agent for Daniel Cottier, the Aberdeen-born dealer with galleries in London and New York. Cottier was very keen on the French painter Adolphe Monticelli (1824-1886) and was instrumental in introducing his work to a number of Scottish collectors. As we shall see, Monticelli's painting was to exert a powerful influence on Hornel.

Alexander Reid, the most notable of the city's art dealers, opened his own gallery - La Societe des Beaux-Arts - in 1889, following a short period in Paris with the renowned dealers Boussod & Valadon. There he worked alongside Theo van Gogh and met his brother Vincent, who painted two portraits of him. As well as the Hague School, Reid specialised in paintings by Corot and Barbizon artists such as N.V.Diaz de la Pena, Constant Troyon, Theodore Rousseau, Jean-Francois Millet, Charles Francois Daubigny and Henri Joseph Harpignies. Reid also strongly promoted the work of Monticelli, being referred to as 'Monticelli Reid' in a letter from Henry to Hornel in 1892.[14] He was the first dealer to show the work of the French Impressionists in Scotland and to handle Whistler's paintings. Unfortunately for Reid, no more than a handful of Scottish collectors were yet ready to buy what were considered to be *avant-garde* French paintings. At that time Impressionism was still barely understood and he burnt his fingers.[15] However he persisted and became one of the foremost art dealers in Britain, dealing well into the third decade of the twentieth century in the work of the Impressionists and Post-Impressionists. Reid also supported the younger Glasgow Boys, mounting exhibitions of the work of Joseph Crawhall (1861-1913), Hornel and David Gauld (1865-1936). He continued to deal in the work of the Glasgow Boys and of the Scottish Colourists until his retirement.

Of course it was not just the monied classes who were interested in art. The man in the street visited the city's art collection and the exhibitions of the Glasgow Institute in increasing numbers. The merits or otherwise of individual artists and individual paintings were ardently discussed. In an article in the *Glasgow Art Review* in 1946 William Power recalled his childhood days in Glasgow, when the work of the Boys was being shown at the Glasgow Institute:

> I was too young to be fully conscious of what was going on, but I was caught up by the enthusiasm of my older associates, all ordinary folk. The crowded Institute was as exciting as cup-tie football. Arguments were raging in front of every 'Glasgow' canvas, and they were continued at home over the tea-cups.[16]

This interest in painting was fed by the newspapers. At that time all of them, as well as many journals, carried reviews of the exhibitions and articles about art on a regular basis.

Anxious to share in the rich artistic life of the city, young artists in the west of Scotland and elsewhere were drawn to Glasgow, many taking studios in Bath Street or West Regent Street. A number of them, sharing common ideals about painting, gradually came together in the early 1880s to form a loose-knit brotherhood of artists. They were united in their rejection of the academic values of the art establishment, whether exemplified by the established, but now largely forgotten, Glasgow painters such as Alexander Davidson (1838-1887) and Duncan MacKellar (1849-1908), or by the staid, blinkered attitudes of a majority of the Academicians in Edinburgh. They despised the highly finished romantic landscapes and sentimental and anecdotal genre paintings of the 'Glue Pat school', as Henry later described the establishment men in a letter to Hornel.[17] Initially attracted to Realism, the Glasgow Boys now set out to emulate the Naturalism of the French painter Jules Bastien-Lepage (1848-1884). In general they shunned the rich diversity of everyday life in Glasgow as subject matter. They preferred to get out into the countryside and paint *en plein air* local scenes, rather than the panoramic landscapes of their predecessors, and simple everyday incidents, without introducing any social or political overtones. Turning away from the nineteenth century tradition of Scottish

painting, they aimed for a bolder, broader style, wishing '...to represent nature seen as a whole rather than in detail, and especially the mass and weight of things...'[18]

In this the Boys were following the example of Bastien-Lepage, who laid great stress on complete fidelity to visual facts in his depiction of the simple reality of life in provincial France. His success lay in the convincing portrayal of real people and places 'without the appearance of artifice, but as they live; and *without comment, as far as is possible, on the author's part.*'[19] Among older artists, however, opinions were divided on the merits of his work. His critics included Degas and Camille Pissarro, but it has to be said that his paintings were appreciated by the public much more than those of the Impressionists at that time.[20] Indeed the work of the Impressionists had little impact on the Boys themselves, except perhaps on the pastels executed by James Guthrie in 1888-90.

To the younger generation of artists, such as the Glasgow Boys, Bastien-Lepage was akin to a hero at the time. He was 'the special idol of the students, everything he produced and everything he did being discussed with reverent enthusiasm.'[21] He had studied in Paris at the Ecole des Beaux-Arts in the *atelier* of Alexandre Cabanel, but he was less than impressed with the tuition: 'I learnt my trade at the Ecole and I do not wish to forget it, but in reality, I did not learn my art there.'[22] He made his debut at the Salon at the age of twenty-two. Five years later, after fighting in the Franco-Prussian War, he entered for the prestigious *Prix de Rome*, which he was expected to win. Although his *L'Anonciation aux Bergers* was highly praised, it was rejected on the grounds of a technicality. His entry the following year also failed to gain the coveted award. Disillusioned, Bastien-Lepage decided against a career as an Academy painter and retreated to his home village of Damvillers in north-east France.[23] He lived there for the rest of his short life - he died when he was thirty-six - painting *en plein air* the day-to-day life of the village and the surrounding countryside. He exhibited work in London at the Royal Academy from 1878 to 1880. At the Grosvenor Gallery Sir Coutts Lindsay featured nine works, including seven portraits, in his Summer Exhibition in 1880. Over the next few years his paintings were shown by several of the smaller London galleries. His *Le Mendicant* was exhibited at the Glasgow Institute in 1883. Thus his work became known and admired by a growing number of artists and collectors in Britain as well as in France.

The origins of the Glasgow Boys lie in three separate friendships. Several years older than the majority of the Boys, William York Macgregor (1855-1923) and James Paterson (1854-1932) came from prosperous Glasgow families and knew each other at school. During the summers of 1878 to 1881 they painted together on the east coast of Scotland at St. Andrews, Nairn and Stonehaven.[24] In the winters up to 1882 Paterson went off to study in Paris and Macgregor went back to his studio in Bath Street, which acted as a meeting place for artists and where he held life classes for the benefit of some of the younger Boys. His studio was the nearest thing to a Paris *atelier* to be found in Scotland.

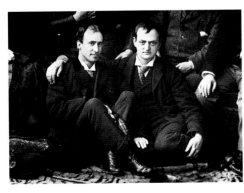

PLATE 6
Hornel and Henry
detail of photograph of members of Glasgow Art Club
Glasgow Art Club

The second link was forged in Glasgow in the winter of 1878 when James Guthrie (1859-1930) met Edward Arthur Walton (1860-1922) and, through Walton, Joseph Crawhall. Guthrie, a natural leader, was one of the key members of the Glasgow Boys. Although Macgregor was acknowledged as the 'Father of the Glasgow School', leadership of the Boys was assumed by Guthrie around the mid-1880s.[25] In 1888 he was the first of the Boys to be elected to the Royal Scottish Academy, marking a notable victory for them in their struggle for recognition by the Academy. Guthrie went on to become President in 1902, an office he ably filled until 1919.

Guthrie, Walton and Crawhall painted together at Rosneath on the Gare Loch in the summer of 1879. They returned there the following year and then made their first visit to Brig o'Turk, a village between Loch Vennachar and Loch Achray in the Trossachs, which had been popular with artists for some time.[26] In the summer of 1881 they were painting at Brig o'Turk again and on that occasion they were joined by George Henry.[27] Henry may have met Walton at Glasgow School of Art in the late 1870s or he may have made contact with either Guthrie or Walton at the St Mungo Art Society, which had been established in Glasgow in 1874 to provide life classes, an annual exhibition and social gatherings for young artists, who had to be elected to the Society. It must have been an invigorating experience for Henry, working alongside Guthrie, Walton and Crawhall - all four in their early twenties - and may have been a factor in Henry's decision the following year to give up his job as a clerk in order to concentrate full-time on his painting.

In the summer of 1882 Guthrie, Walton and Crawhall moved south to paint in the flat fen-lands around Crowland in Lincolnshire[28] The following year Guthrie and Walton came to Cockburnspath, a small village just off the Great North Road some twelve miles south of Dunbar and a short distance from the sea, where, according to the Glasgow weekly *The Bailie*, the landscape painter James Alfred Aitken (1846-1897) had been painting the year before.[29] Their presence there attracted other artists, including a number of the other Boys, and for a few years this old Berwickshire village became the 'Barbizon' of Scotland. Situated between the Lammermuir Hills to the west and the North Sea, the narrow coastal plain with its pleasant, undulating landscape and its simple hamlets seemed ideally suited to the naturalist style and subject matter of Guthrie and Walton. Indeed Guthrie liked the area so much that early in 1884 he and his mother took a lease of the factor's house at nearby Dunglass, staying there until the spring of 1886. Henry was painting a little further south at the fishing port of Eyemouth in 1883. The following year he was at Cockburnspath with Guthrie, Walton, and Crawhall. Also there were James Whitelaw Hamilton (1860-1932), Thomas Corsan Morton (1859-1928) and probably James Nairn (1859-1904), three of the other Boys.

A notable new arrival on the scene during the summer of 1883 (or possibly 1884) was Arthur Melville (1855-1904), who had heard that Guthrie and some of the Boys were at Cockburnspath.[30] By then Melville was an established artist with a studio in Edinburgh. He had not long returned from a journey to the East, which had lasted almost two years, staying in Cairo for some eighteen months, before moving on to Suez and thence to Karachi and coming back by way of Muscat, Baghdad, Constantinople and Vienna. In Turkey on his way home he was twice attacked by bandits, as well as being detained for a time - in some luxury - by a local Pasha, who thought that he was a British spy.[31] The dazzling light of the Middle East brought forth a series of watercolours of sunlit market places and mosques, audacious in terms of spontaneity, technique and intensity of colour, which had startled the critics when some of them were shown in London in the spring of 1883.

Melville - 'stalwart of figure, forcible in the expression of his ideas, full of enthusiasm and driving power - something of a figure of romance 'Prince Arthur' was' - was to be a key element in the development of the Boys, associating particularly with Guthrie and Crawhall.[32] Later one of the Boys wrote:

> The visits of Melville to his western friends were always occasions of stimulus and propaganda. There was something tonic in his speech; his big, handsome courageous cavalryman presence infested all the group with joie de vivre and the self assurance it badly needed though its brave words might suggest otherwise. He had an unerring instinct for the 'right stuff'; and a generous way of encouraging it whenever he found it, his opinions were repeated, his advice was always sound.[33]

Four artists who were together in Paris in the early 1880s - Thomas Millie Dow (1848-1919), John Lavery (1856-1941), William Kennedy (1859-1918) and Alexander Roche (1861-1921) - make up the third grouping of Boys. The Paris of the Third Republic acted as a magnet for art students from many countries. They flocked to train in the *ateliers* of members of the Academie des Beaux-Arts, hoping that their own works would soon be hanging in the Salon, which the majority of them imagined was the key to fame and fortune. Universally acknowledged as the capital of art, Paris must have been an exciting and stimulating city in which to live and work. The English-speaking students formed a close fraternity, having very little social contact with their French counterparts.[34] They maintained 'the traditions of hard work and frugal living which were, as a rule, inseparable from the probation time even of the most gifted. What careful yet careless days those were! How ready all the young fellows were to rejoice in each other's successes and to condole with each other in their far more numerous

disappointments...'[35] Dow, Kennedy, Lavery and Roche would have met each other within a short time of arrival and immediately would have felt at home with kindred spirits. They must have encountered James Paterson, who had been studying in Paris during the winters since 1878 and was working at the Academie Julian up to the winter of 1882-83. It is possible that they also came across Joseph Crawhall, who was in Paris for a short time towards the end of 1882. In the Quartier Latin food and lodging were relatively cheap. In their leisure time they would meet at a cafe near the Musee du Luxembourg to talk. Roche later recalled that 'ardour and tobacco were burned freely before the shrines of Puvis de Chavannes and Jules Bastien-Lepage. Between these extremes the talk went to and fro on some evenings, but, as a rule, the favourite topics were Bastien-Lepage and *plein air*.'[36] Lavery greatly admired Bastien-Lepage, whom he had met very briefly in Paris, telling his biographer 'When I saw Bastien's work, it took away my breath.'[37]

During the summers of 1883 and 1884 Lavery worked at Grez-sur-Loing, where Melville had been painting several years earlier. He was introduced to the village by Eugene Vail, a fellow student at Julian's.[38] Apart from Kennedy, who is known to have been working there in 1884, it is uncertain whether Lavery was accompanied in either year by any of the other Scots, although it seems likely.[39] Grez, where Corot painted in the 1860s, had supported an artists' colony since the mid-1870s, growing in importance as Barbizon had declined. Situated on the southern fringe of the Forest of Fontainebleau within easy reach of Paris, Grez was then a pretty, sleepy village of grey stone buildings. Its graceful mediaeval bridge, spanning the slow-moving River Loing, has been painted many times. Robert Louis Stevenson, who stayed at Grez for a period in the mid-1870s, described the bridge as '...a piece of public property; anonymously famous; beaming on the incurious dilettante from the walls of a hundred exhibitions.'[40] Lavery painted it at least ten times.[41]

PLATE 9
George Henry
Noon *1885*
Oil on canvas, 20 x 24
Lord Macfarlane of Bearsden

Whereas the village of Barbizon a short distance to the north had been home to mainly French painters, notably Millet and Rousseau, Grez was populated principally by Anglo-Saxons - young English, Scottish, Irish and American artists, many still students - and from the spring of 1882 by several Scandanavian painters. Most of them stayed at the Hotel Chevillon, where Madame Chevillon treated the artists 'as her children.'[42] The garden of the inn ran down to the river, which provided ideal opportunities for both painting and relaxation in the form of boating and swimming. Among the artists whom Lavery encountered at Grez were the American Alexander Harrison (1853-1930), the Irishman Frank O'Meara (1853-1888), William Stott of Oldham (1857-1900) and the Swede Carl Larsson (1853-1919). All were followers of Bastien-Lepage. The *plein air* paintings executed at Grez by O'Meara and Stott were important influences on the development of Lavery's work and on that of many of the Boys, including Hornel himself. Both men had studied in Paris and had been working in and around the village for a number of summers. O'Meara, who was to spend most of his short working life at Grez, became a close friend of Lavery. Stott's influential paintings *The Bathers* (1881: Munich) and *The Ferry* (c 1882: private collection) were exhibited at the Paris Salon and at The Fine Art Society in London in 1882. No doubt encouraged by Lavery, both O'Meara and Stott showed several paintings at the Glasgow Institute, including *The Bathers* in 1883 and O'Meara's *Twilight* (1883: private collection) and *Evening in the Gatinais* (c 1883: whereabouts unknown) in the following year. O'Meara's atmospheric *Towards Night and Winter* (1885: Hugh Lane, Dublin) was exhibited at the Institute in 1885.

These three distinct elements in the evolution of the Glasgow Boys - Macgregor and Paterson; Guthrie, Walton, Crawhall and Henry; and Lavery, Dow, Kennedy and Roche - were all brought together towards the end of 1884, when Lavery returned from France and decided to go back to Glasgow rather than to London. The blossoming friendship between Hornel and Henry was to add a vital fourth element. By the autumn of 1885, when the two artists met for the first time, the Boys were an established force in Scottish art, although they had to wait for another five years before being recognised as such by the majority of critics and the public at large. Indeed the initial phase of the movement, typified by the naturalist paintings of Guthrie and his friends executed in Lincolnshire and at Cockburnspath and by Lavery and the others at Grez, was drawing to a close. Macgregor, Guthrie and Lavery had each painted his masterpiece. Guthrie finished *To Pastures New* (Aberdeen Art Gallery) in 1883. Macgregor's *The Vegetable Stall* (National Gallery of Scotland) was completed in 1884 and Lavery painted *The Tennis Party* (Aberdeen Art Gallery) in 1885. It was Henry and Hornel who were to pick up the baton, leading the Boys towards a new decorative phase in their art and producing from around 1889 to about 1895 some of the most original - and controversial - work executed by any of the Boys.

However that was some three or four years in the future. Towards the end of 1885 Hornel, fresh out of art school, was eager to embark on his career as a painter. He set to work with a will, completing two major oils during the remainder of that year. *In the Crofts, Kirkcudbright* (private collection, pl.4) is similar to earlier naturalist scenes executed by Guthrie and Henry, such as Guthrie's *A Hind's Daughter* (1883: National Gallery of Scotland, pl.7) - in turn influenced by Bastien-Lepage and Melville - and Henry's watercolour *A Cottar's Garden* (Hornel Trust, pl.8), which he had painted earlier in the year at Cockburnspath and gifted to Hornel or one of the family. Hornel's autumnal tones of russets and browns, the single principal figure, the wooden fence to the right in the middle distance and the frieze of buildings in the background echo Frank O'Meara's *Towards Night and Winter*, which Hornel could have seen exhibited at the Glasgow Institute earlier that year.

PLATE 10
Potato Planting *1886*
Oil on canvas, 45 x 28
Private Collection

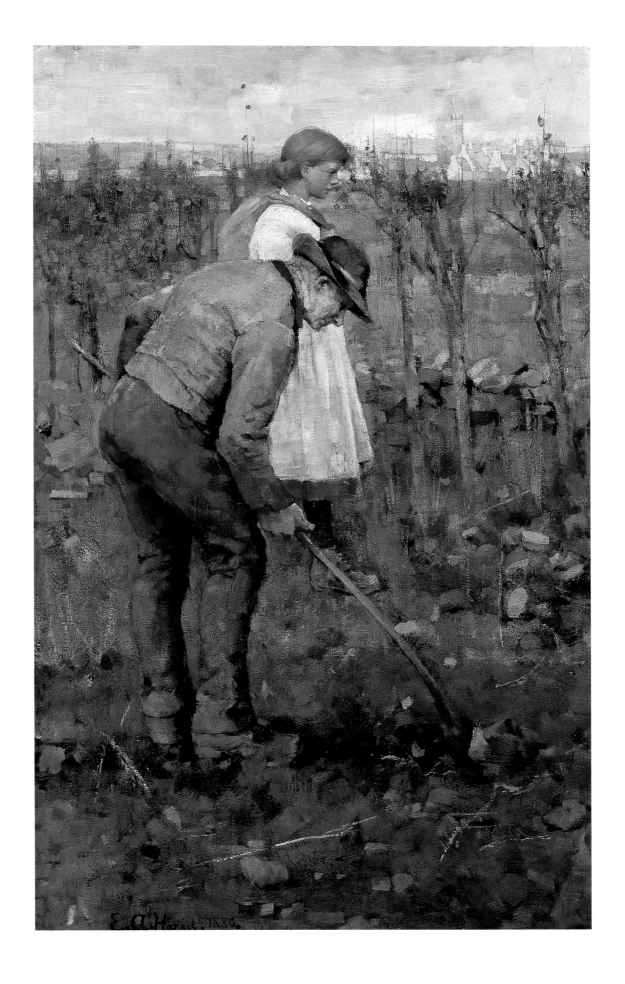

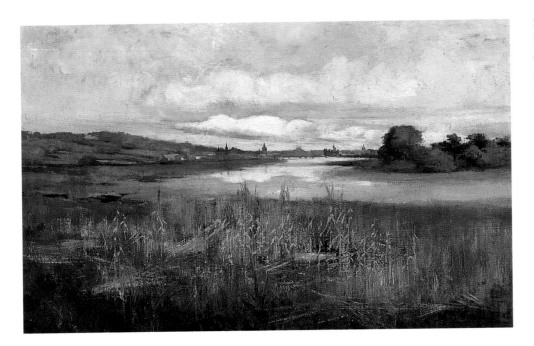

PLATE 11
**Distant View
of Kirkcudbright
from Janefield** *1886*
*Oil on canvas, 16 x 24
Private Collection*

In its technique *In the Crofts, Kirkcudbright* demonstrates the influence which Guthrie and Henry would have on Hornel's work over the next two or three years. Hornel's palette is lighter than formerly. The foreground and middle distance are broadly handled, the thickish pigment applied in places with a square brush. In the background the town's Tolbooth and the houses backing on to the High Street - the white-washed gable ends reflecting the light - are more precisely executed. Hornel exhibited the painting at the Royal Scottish Academy in 1886, together with *An Old Flemish Interior* (untraced), probably dating from his student days in Antwerp. Neither painting found a buyer, however, and Hornel re-exhibited *In the Crofts, Kirkcudbright* at the Glasgow Institute in 1888.

Resting (private collection, pl.5) shows certain similarities to Henry's *Noon* (Lord Macfarlane, pl.9). However both artists were seeking a rather different effect. *Noon* is not merely a picture of a girl sheltering from the heat of the noonday sun. By strongly contrasting the sunlit meadow with the dark canopy of the tree and the large shadow it casts on the ground, Henry was striving to paint the intensity and heat of the sun. For a twenty-one year old who had just left art college, Hornel was being equally ambitious. In *Resting* he is trying to convey mood. In a wooded glade a girl stands dreaming beside the slender trunk of a tree. She seems surrounded by the woodland, physically and spiritually enclosed in her own world. The horizon - such as there is - is right at the top of the painting. The world outside is excluded, except for the small patches of sky glimpsed through the trees. The figure of the girl is delicately executed. The rest of the composition is broadly handled with passages of impasto. Like *Noon* there is an emphasis on verticals and horizontals. *Resting* is the first of many similar works, depicting girls in woodland, a subject which Hornel was to make his own and which was taken up by other Galloway artists such as W.S.MacGeorge and Tom Blacklock. It may be that both *Noon* and *Resting* were painted at Kirkcudbright, possibly using one of Hornel's sisters as a model. However, given the likely time scale, it seems more likely that *Noon* was painted at Cockburnspath and Hornel saw it in Henry's studio. Hornel registered for his final term at the Academy in Antwerp on 11th May 1885.[43] If he remained for the full term, which lasted until the end of August, he would not have returned to Kirkcudbright until early

September, meeting Henry for the first time sometime that autumn, by which time Henry would have completed Noon.

Both *Noon* and *Resting* were exhibited at the Glasgow Institute in 1886. Henry wrote to Hornel:

> Pictures all gone now! I saw your 'Resting'. You had hammered it into the frame too tightly, as the slip was split a little and there being no time to repair, it went in in that condition. However if it gets no worse, it won't be noticed much. The drawing of the figure about the body seemed a little out, but perhaps I was wrong, that was what I felt about it.[44]

In a later letter about the hanging of the exhibition Henry commented:

> Your little picture is hung high, I am sorry to say, but looks very well...My own 2 pictures are very well hung. The Calves [Noon] hung low in large room near centre...It is hung in that good position, I understand, thru' no special wish of the Hanging Committee but got there thro' some fitting in, as it was on the point of being rejected...[45]

Henry was to take up Hornel's theme the following year in his watercolour *The Girl in White* (Kelvingrove, Glasgow), portraying a girl in contemplative mood standing beside the slender trunk of a tree on the edge of a dense wood, the lower portion of her dress reflected in a pool. He was a very accomplished watercolourist. Hornel on the other hand very rarely worked in watercolour - only very minor early works have surfaced at auction in recent years - but there are no clues as to the reason for his apparent rejection of the medium. However in 1885 he did execute at least one watercolour of some significance. *A Country Girl* (whereabouts unknown) depicts a girl sitting on a steep hillside under a tree. The figure is finely modelled, but the rest of the composition, particularly the foreground and the foliage of the tree, is very broadly handled.

By the end of 1885 the two artists were firm friends. Their relationship over the next ten years or so is charted in a series of over one hundred letters written to Hornel by Henry. Many are undated, but the majority of those can be placed in chronological sequence with reasonable accuracy. Unfortunately very few of Hornel's own letters have survived. Henry's chronicle the everyday life and work of the two artists, their hopes and anxieties, their varying fortunes and their apparent constant lack of money. They also provide a valuable insight into the evolution of the Boys as an artistic force and their struggle with the art establishment, both in Glasgow and in Edinburgh, as well as the various alliances, rivalries and petty jealousies inherent in any community of individuals.

The friendship between Hornel and Henry was centred on their painting and it is obvious from an examination of their work that, at least for seven or eight years, it was a close relationship. Henry spent periods working in Kirkcudbright, going there either on his own or along with some of the other Boys. During the second half of the 1880s the area around Kirkcudbright became one of the favoured painting grounds of the Boys. Hornel usually arranged accommodation for them and often allowed Henry to use his studio. Sometimes Henry would bring a model with him and accommodation would have to be found for her, which brought its own problems. In 1886 and 1887 Guthrie was a frequent visitor to Kirkcudbright. Occasionally Henry and he would come down from Glasgow on the spur of the moment: 'Guthrie & I called at your Studio, but found the door shut. We are on the moutch round the town. Could you call him and let us know when you are likely to be in. We leave again tomorrow evening.'[46]

Similarly Hornel would go to Glasgow and work alongside Henry, at first in the studio which Henry shared with Guthrie at 248 West George Street and then, when Henry moved to a new studio sometime in 1886, at 113 West Regent Street. On one occasion Hornel must have been worrying whether he would manage to get studio accommodation in Glasgow, because Henry wrote 'We will get digg' for you no fear.

You will be staying with Guthrie for a little when you arrive.'[47] The two friends invariably left unfinished work in the other's studio and were always writing, asking for canvases and other equipment to be sent through to them. Several times Henry wrote asking Hornel to let him have a sketch or a photograph of something, such as a particular tree or some berries, to assist him with one of his paintings, and probably Hornel did the same. When Hornel remained at home in Kirkcudbright, Henry kept him supplied in his letters with all the news and gossip of Glasgow.

Living and working in Kirkcudbright, but having access to a studio in Glasgow and being able to join the other Boys when he wished, afforded Hornel the best of both worlds. The peace and tranquillity of Galloway - its landscape, its history and its myths - were more conducive to work than the bustling city with its many distractions. In Kirkcudbright Hornel was not subjected to that level of interruption which Henry experienced in Glasgow, when an otherwise productive day could be ruined by friends or fellow artists calling at the studio. It was not that Hornel was cut off from other painters where he was. Galloway had its own circle of artists. Its most renowned sons were the Faed brothers, John, James and Thomas, who came from Barlay Mill, Gatehouse-of-Fleet. John, an Academician of the Royal Scottish Academy, lived locally at Gatehouse, while his better-known brother Thomas, a Royal Academician, was a successful genre painter in London. Other local artists included Hornel's friend W.S.MacGeorge, his brother-in-law William Mouncey, Tom Blacklock, Frederic Coles and Malcolm Harper, a banker in Castle Douglas, who was an amateur landscape painter. In 1886 they formed the Kirkcudbrightshire Fine Art Association with John Faed as President and Malcolm Harper as Vice-President, intending to hold an exhibition each year. The first such exhibition, restricted to the work of members, was held at Kirkcudbright the same year. In 1887 they held an open exhibition at Castle Douglas, followed by one at Dumfries in the succeeding year. The Association met with immediate success according to the Glasgow weekly *Quiz*, which reported in September 1887:

> Kirkcudbright is rapidly coming to be recognised as an art centre. The Fine Art Association of the county has just closed its first open Exhibition, at Castle Douglas, after a successful season...The School of Progress and Poverty - as a certain resolute band of our young painters is yclept - is in force at Kirkcudbright. George Henry is there, and Tom Morton is of the company...E.A.Hornel is also of the band. A native of, and resident in Kirkcudbright, since his election to membership in the Glasgow Art Club, he has become one of the brotherhood. He is hard at work, and his painstaking faithfulness to nature is laying the foundation from which true art is raised, as will be seen from those examples he will show here [Glasgow] during the approaching picture season...Rumour hath it that the sunny South of Scotland - that garden of our land - is made sunnier to artists' eyes by the smile of beauty. It may be questioned whether the artist is more fascinated by the scenery or the society of that favoured spot...Can it be that an alliance is imminent between the genius of the P. and P. School, and the beauty of the county - or the county family? The society journals do not yet say; but time will tell.[48]

The romance to which *Quiz's* correspondent alluded in his article may have involved one of Hornel's sisters, probably Annie, if various veiled references in Henry's letters are to be believed. The nickname 'The School of Progress and Poverty' - derived from the socialist slogan - was a rather apt one. Whether it referred to the Boys in general or only to the younger ones is uncertain. Billcliffe has suggested that the term may have been coined by Robert Macaulay Stevenson (1854-1952), one of the Boys who contributed to *Quiz*.[49] Certainly Henry and Hornel were always hard up, judging from the letters:

> Another call is on for the 'Review'. Stevenson to keep things dark and help you in the hour of trouble, as he says you did to him, sends you £1 which you will please forward without delay to the Treasurer. Don't for Gs sake spend it![50]

In a later letter Henry wrote 'Very pleased to hear from you. I didn't write a reply to your last note as I couldn't oblige you with the £.s.d.'[51] It was not until the turn of the century that Hornel was able to put money worries behind him.

In 1886 Hornel executed a number of paintings. *A Woodland Pasture,* exhibited at Kirkcudbright that year and at the Royal Scottish Academy the following year, and *A Weed Cutter,* also exhibited at Kirkcudbright that year and possibly at the Glasgow Institute in 1889, have not been traced. *Distant View of Kirkcudbright from Janefield* (private collection, pl.11) was probably started the previous year, but substantial alterations to his studio in the High Street at the beginning of 1886 had disrupted his work and caused him a few worries [52] It is a good composition, although in its handling Hornel is still feeling his way. The broadly-handled reeds and grasses in the foreground are well observed. He showed the painting at the Kirkcudbrightshire Fine Art Association's Open Exhibition in 1887, when the critic of the *Kirkcudbrightshire Advertiser* considered it 'one of the best of this artist's work we have seen.'[53]

At just under four feet high and over two feet wide *Potato Planting* (private collection, pl.10) is much larger than anything he had tackled before. Henry referred to it in his letters as 'the big one.' Considering that Hornel was twenty-two at the time and had left art school only about a year earlier, it is an accomplished work and demonstrates the progress he was making in his painting and his relatively rapid assimilation of the early style of Glasgow Boys like Guthrie, Walton and Henry. In subject matter and composition the influence of Bastien-Lepage is clear. It is a typical naturalist painting - the figures occupy most of the canvas, there is a strong vertical emphasis and the palette is restricted. Its execution, however, reflects Hornel's Antwerp training, as well as the influence of Guthrie and possibly O'Meara. The figures are well-modelled, although perhaps Hornel has not got the placing of the girl's legs quite right. Compared to the usual meticulous detail of Bastien-Lepage, Hornel's foreground is very broadly handled, a semi-abstract pattern of broad brushstrokes in low-toned browns, greens and orange. The middle distance too is broadly treated and the Tolbooth of Kirkcudbright and the River Dee on the horizon are almost dissolved in light. It is interesting to note that Hornel did not sign his naturalist paintings in the style affected by some of the Boys, such as Paterson, Guthrie, Lavery and Henry, using the square capitals of Bastien-Lepage - it was against Hornel's nature to do such a thing. *Potato Planting* was exhibited at the Glasgow Institute in 1887, together with two small works both titled *Souvenir of the Canee, Kirkcudbright* (untraced). It was also shown that year at the first open exhibition of the Kirkcudbrightshire Fine Art Association at Castle Douglas. Although the paintings did not attract any comment in the Glasgow press, the *Kirkcudbrightshire Advertiser* tore in to the two *Souvenir of the Cannee* in its review of the Institute:

> It is somewhat difficult to deal with Mr E.A.Hornel's three works. He is evidently in the throes of an attack of French 'impressionism,' and his emancipation from these unwholesome colour schemes, which he at present affects, will no doubt only be a matter of time. The sooner the better....From all descriptions of scenery extant it is evident that there is scenery about the Cannee which is like nothing in the heavens above, the earth beneath, or the waters under the earth. Mr Hornell may have painted these sketches from nature; no doubt he did; nevertheless they are not natural, and they are anything but pretty.

However the newspaper's critic approved of the large work:

> His 'Potato Planting' (509 - £50) is a canvas of considerable dimensions, and gives evidence of much promise if he succeeds in freeing himself from the enthralment of the foreign school. The figures in this picture are admirably drawn and posed, the old man in particular being firmly and skilfully handled.[54]

Understandably Hornel was furious at what he considered to be ill-judged criticism of his two small paintings. What made it worse was that it was voiced by a quality weekly

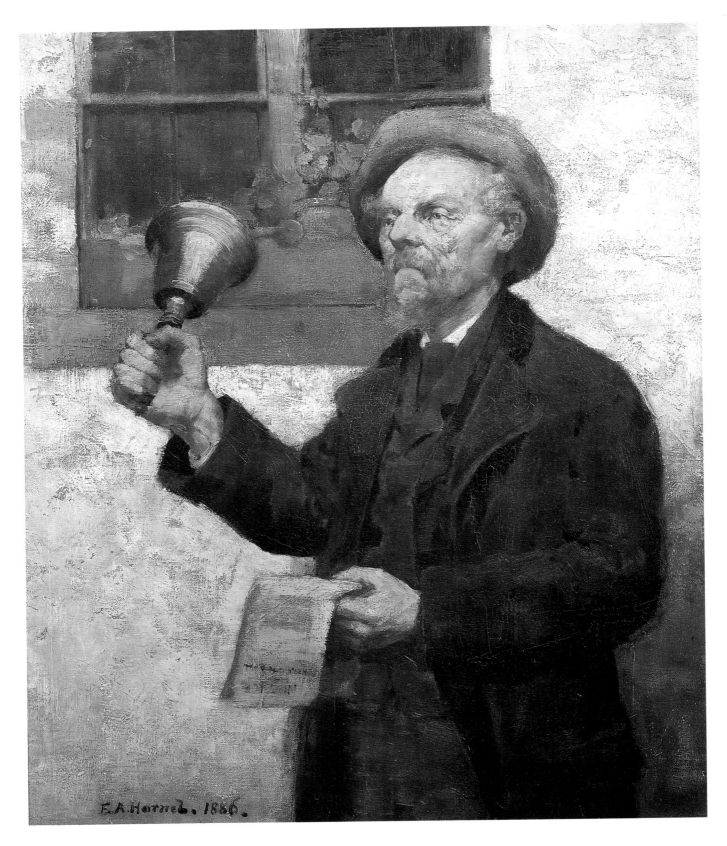

PLATE 12
The Bellman *1886*
Oil on canvas, 24 x 20
Flemings

newspaper on his home ground. He was all for hitting back, but Henry managed to persuade the youthful hothead not to react violently to the first piece of adverse criticism directed against him:

> Yours received. I have read the Article. What is there in it to cavil at? Nothing! These men know no better. It is your place, along with other chosen vessels, thro' years of determined persistence, painting the right thing, to convince and then teach them. Here we suffer, bearing with christian fortitude and resignation infinitely harder things said about us. This comes fresh upon you in a short time you will look at it calmly. The writer of the article, out of his chimerian darkness, and cesspool of a brain, has a faint glimmering of truth dawning on him when he says that the work 'Cannee in Nature must be unlike anything in the Heavens above, or in the Earth beneath.' Besides he speaks well of your big picture. Sit steady! If your friends rush in to print over it, it will only do great harm. My God, sir, if a man was to defend himself from all stupid things said about himself or his work, he would produce nothing. Life is too short for this kind of thing. And after all who the devil is this creature Maxwell, or any other critic, or his mangy sheet of a paper. Let him talk! The Earth will still continue to roll.[55]

However one of Hornel's fellow Galloway artists, Frederic Coles, did address a letter to the editor, titled 'The French School':

> ...If Mr Hornel or any other artist feels bound to paint effects unlike 'anything in the heavens above or the earth beneath' - unlike, that is, *even according to his own observation* - he is at perfect liberty to do so. He will narrow his audience, perhaps, but deepen the influence of Art, and, besides, will remain true to what we painters need nowadays more than ever to be reminded of - higher principle and aim in our work.[56]

It was all rather a storm in a teacup. However it does seem that John Maxwell, who was soon to take over from his father as editor-proprietor of the Castle Douglas-based *Kirkcudbrightshire Advertiser* and must have written the review, did have his knife in Hornel for several years. It was not to be the last piece of adverse criticism from Maxwell's pen directed against Hornel.

The Bellman (Flemings, pl.12) is a character study, a 'very fair portrait' of Francis Harris, ex-Sheriff's Officer and town crier of Kirkcudbright, who was known as 'The Old Cracked Bell'.[57] Superficially it is similar to the two portraits of the man in a red tunic, which Hornel executed during his period at Antwerp. In handling and tonality, however, it shows the influence of Guthrie, whose portrait *Old Willie, a Village Worthy* (Kelvingrove, Glasgow) was painted at Kirkcudbright the same year. Like Guthrie, Hornel has clothed his subject in rather sombre attire and set him against a light wall, but he has positioned the figure slightly right of centre and added a window in the top left corner to balance the composition. The painting demonstrates once again that there was nothing wrong with Hornel's draughtsmanship at this stage. It is well composed, the attitude struck by the bellringer is natural and his face and hands are carefully modelled. *The Bellman* was exhibited at the Royal Scottish Academy in 1887 along with *A Woodland Pasture* (untraced). Only one other formal portrait by Hornel is recorded, a 'capital' likeness of John Gibson, a solicitor and one-time town clerk of Kirkcudbright, who was secretary of the Kirkcudbrightshire Fine Art Association.[58] The portrait was exhibited in 1888 at the Royal Scottish Academy and at the annual exhibition of the Association (the painting was destroyed in 1944).

There seems little doubt that Hornel's progress during his first full year as a painter could not have been so rapid had it not been for the close contact he had with both Guthrie and Henry. The stimulus of working alongside these artists, even if for comparatively short periods at a time, must have been of great value to the young painter.

Hornel could with justification feel that he was well on his way. This seemed to be confirmed when towards the end of 1886 he was elected an artist-member of Glasgow Art Club on the strength of *Potato Planting*, which he had submitted to the Club in support of his bid for membership.

1 Registers of RSA Life Class, Royal Scottish Academy, Edinburgh

2 J W Herries, *The Art of E.A.Hornel, The Gallovidian Annual*, 1938, p.31

3 *The Bailie*, 30 November 1892

4 A S Hartrick, *A Painter's Pilgrimage Through Fifty Years*, Cambridge, 1939, pp.58-9

5 Sir James L Caw, *Sir James Guthrie*, London, 1932, p.31

6 David Martin in his book *The Glasgow School of Painting* (London, 1897, p.31) suggests that they met at Kirkcudbright

7 Records of births, deaths & marriages, General Register House, Edinburgh

8 Census records, General Register House, Edinburgh

9 *The New Associate of the Royal Academy: A Chat with Mr. George Henry, Black & White*, 9 February 1907, p.198

10 Percy Bate, *The Work of George Henry, R.S.A., The Studio*, 1904, vol.31, p.5

11 Glasgow School of Art, Annual Reports for 1875/76 & 1876/77

12 Glasgow School of Art, Annual Report for 1879/80 & Registers of Admissions

13 J Carfrae Alston, T G Arthur, A J Kirkpatrick & Robert Ramsey, *Fine Arts Catalogue*, International Exhibition Glasgow, 1888

14 Letter from George Henry to Hornel dated 17 March 1892 (Hornel Trust)

15 Frances Fowle, *Alexander Reid*, unpublished thesis, 1993, vol.1, p.86

16 William Power, *Glasgow and the 'Glasgow School', Glasgow Art Review*, vol.1, no.1, 1946, p.26

17 Undated letter from George Henry to Hornel regarding the RGI's annual exhibition in 1886 (Hornel Trust)

18 Caw, op.cit., p.29

19 Kenneth McConkey, *Impressionism in Britain*, Barbican Art Gallery exhibition catalogue, 1995, p.21; George Clausen, *Bastien Lepage and Modern Realism, Scottish Art Review*, September 1888, p.114

20 Kenneth McConkey, *The Bouguereau of the Naturalists: Bastien Lepage and British Art, Art History*, vol.1 no.3, 1978, p.371

21 Mrs Arthur Bell, *Robert Weir Allan and his Work, The Studio*, vol. 23, 1901, pp.230-1

22 L de Fourcaud, *Bastien-Lepage, sa vie et ses oeuvres*, Paris, n.d., p.4, quoted in John Milner, *The Studios of Paris*, New Haven & London, 1988, p.18

23 *Jules Bastien-Lepage*, Les Musees de la Meuse exhibition catalogue, 1984

24 Roger Billcliffe, *The Glasgow Boys*, London, 1985, p.19

25 Hartrick, op.cit., p.62

26 Billcliffe, op.cit., p.42

27 Caw, op.cit., p.11

28 Ibid., p.15

29 Ibid., pp.22-4; *The Bailie*, 5 & 26 July 1883

30 Agnes Mackay in her biography of Melville states that he was at Cockburnspath in 1883, whereas Caw in Guthrie's biography gives 1884 as the year that Melville first painted with the Boys at Cockburnspath

31 Iain Gale, *Arthur Melville*, Edinburgh, 1996, pp.21-30

32 Caw, op.cit., p.23

33 *The Scottish Review*, 3 October 1907, quoted in Agnes E Mackay, op.cit., p.65

34 James Paterson, *The Art Student in Paris, The Scottish Art Review*, October 1888, pp.118-120

35 Mrs Arthur Bell, op.cit., p.230

36 Walter Shaw-Sparrow, *John Lavery & His Work*, London, n.d. (1911), pp.40-1

37 Ibid., p.50

38 Julian Campbell, *Frank O'Meara and his contemporaries*, Hugh Lane Municipal Gallery of Modern Art, Dublin, exhibition catalogue, 1989, p.28

39 I am grateful to Ewan Mundy for drawing my attention to a watercolour of the village street at Grez executed by Kennedy in 1884

40 Robert Louis Stevenson, *Fontainebleau: Village Communities of Painters IV, The Magazine of Art*, 1884, p.341

41 John Lavery, *The Life of a Painter*, London, 1940, p.55

42 Fernande Sadler, *L'Hotel Chevillon et les Artistes de Grez-sur-Loing, L'Histoire Regionale Publiee par L'Informateur de Seine-et-Marne*, 1938, quoted in Julian Campbell, op.cit., p.18

43 Jeanne Sheehy, manuscript extracts of student registers, Academie Royale des Beaux-Arts d'Anvers

44 Undated letter from George Henry to Hornel, mainly relating to RGI exhibition in 1886 (Hornel Trust)

45 Undated letter from George Henry to Hornel, relating to RGI exhibition in 1886 (Hornel Trust)

46 Undated letter from George Henry to Hornel (probably early 1886) (Hornel Trust)

47 Undated letter from George Henry to Hornel, concerning elections to Glasgow Art Club in 1887 (Hornel Trust)

48 *Quiz*, 23 September 1887

49 Billcliffe, op.cit., note 8/28, p.310

50 Undated letter from George Henry to Hornel (the first issue of *The Scottish Art Review* was in June 1888, which absorbed most of the initial capital, so the letter may date from shortly thereafter) (Hornel Trust)

51 Undated letter from George Henry to Hornel (probably September 1889) (Hornel Trust)

52 Letter from George Henry at Cockburnspath to Hornel dated 11 February 1886 (Hornel Trust)

53 *Kirkcudbrightshire Advertiser*, 15 July 1887

54 *Kirkcudbrightshire Advertiser*, 4 February 1887

55 Undated letter from George Henry to Hornel (Hornel Trust)

56 *Kirkcudbrightshire Advertiser*, 11 February 1887

57 *Kirkcudbrightshire Advertiser*, 17 December 1886

58 *Kirkcudbrightshire Advertiser*, 20 July 1888

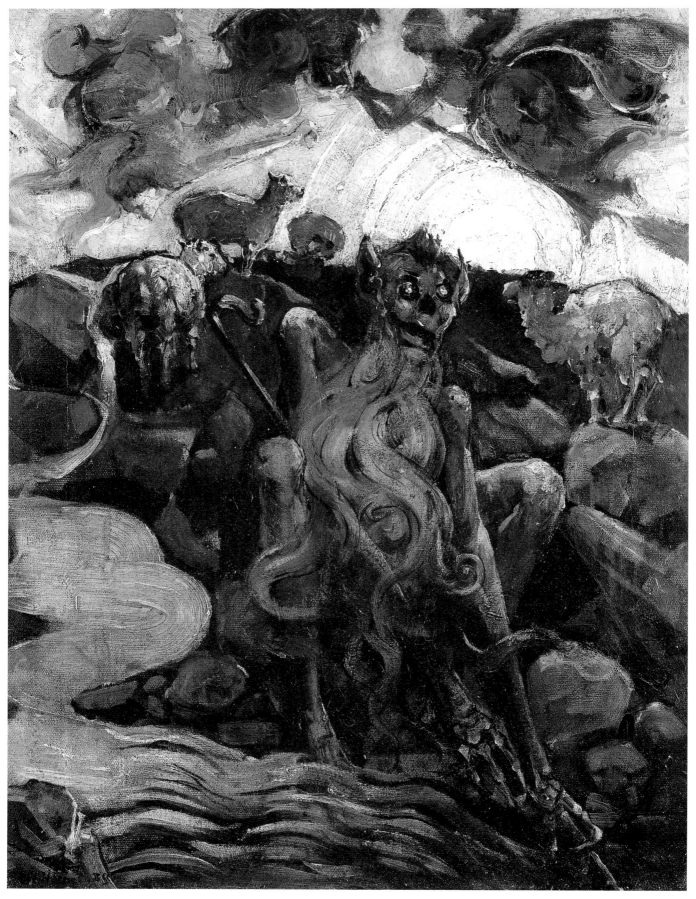

'A CLOUD NO BIGGER THAN A MAN'S HAND'
1887-1889

THE SIGNIFICANT PROGRESS WHICH HORNEL WAS MAKING MAY BE judged from the work completed by him in 1887 and the following year. *Mine Own Back Garden* (1887: Hunterian, Glasgow) is a somewhat unresolved composition, which, judging from the subject matter (and the title, if indeed it is Hornel's), may have been started at the end of 1885 or the beginning of 1886. With the exception of the upright spade, the foreground is broadly handled in a series of square brushstrokes. The painting is rescued from being rather dull by the play of sunlight on the tree trunk, the roses and the houses in the distance. The small dabs of pink and red representing the roses contrast with the very low-toned browns, greys and greens of the shaded foreground. *Sheep Grazing in an Autumn Landscape* (1887: private collection, pl.16) is an altogether more accomplished work. It is similar in conception and handling to Guthrie's *Pastoral* (c1887: National Gallery of Scotland), which may have been painted at Kirkcudbright or which Hornel may have seen in Guthrie's Glasgow studio.[1] In *Pastoral* Guthrie has moved away from Naturalism with its static quality 'towards space and air, and the ambiguity of movement half glimpsed on the periphery of vision.'[2] In his painting Hornel too has gone beyond the detailed representation of his previous work and adopted a somewhat decorative approach, concentrating more on colour and design than on form. The subject is broadly treated with fluid handling of paint. Most of the sheep are merely suggested by patches of colour.

Although Hornel's technique was rooted in his training in Antwerp, there is little evidence in the work he executed immediately after his return to Scotland to suggest that he had been influenced by contemporary Belgian art. His painting had followed the naturalist style of the Glasgow Boys, particularly Guthrie, Walton and Henry. However from 1887 his style was to change rapidly over a period of about eight years. There are a number of reasons for this dramatic transformation. First, the Boys' naturalist vein was running out. As we have noted, Guthrie, its leading protagonist, had moved on, although he was not to develop the style seen in *Pastoral*, his time being taken up more and more by portrait commissions. Macgregor too felt that he had to go beyond the confines of Naturalism, writing to Paterson: 'I don't think imitating nature is art, and pictures are better painted in the house from studies...I am perfectly sick of the Frenchy School and must put something into my work, some individuality in short.'[3] Many of the other Boys were also seeking to broaden the boundaries of their painting for one reason or another. Second, the close friendship between Hornel and the older Henry acted as a catalyst for mutual experimentation and development. They had the same aspirations, that same spirit which had inspired Guthrie and Walton seven or eight years earlier. Their relationship provided both men with support, stimulus, assistance and constructive criticism. Undoubtedly Hornel gained most from this interaction in the first two or three years. Later, however, without the presence of Hornel it is doubtful perhaps whether Henry would have produced such an important painting as *A Galloway Landscape*, which was begun, if not completed, at Kirkcudbright and in which there appear to be a number of Hornel-inspired elements. The landscape, archaeology and folklore of Galloway were to be important influences on the development of both men. Third, one or two outside influences were to have a bearing on the direction Hornel was to take.

One such external factor was the opening in Edinburgh in the second half of 1886 of the International Exhibition of Industry, Science and Art. The fine art section included an

(opposite)

PLATE 13

The Brownie of Blednoch *1889*

Oil on canvas, 24 x 18
Glasgow Museums:
Art Gallery & Museum,
Kelvingrove

important loan collection of nineteenth century French and Dutch paintings, organised by R.T.Hamilton Bruce, a prominent Edinburgh collector. Corot and the Barbizon artists and the painters of the Hague School were well represented. Although Hornel would have seen some examples of their work in the galleries of Glasgow, Edinburgh and Antwerp, it must have been very instructive for a young artist to have the opportunity of studying such a large body of paintings by two important schools. Also included in the loan collection were eight paintings by the little-known French artist Monticelli, whose work he did not know, but which made a considerable impression on him.

Adolphe Monticelli is very much an artist on his own; he does not fit into any school of painting. Born in 1824 into a modest family of Italian extraction in Marseilles, he studied at the local drawing academy before going to Paris, where he trained under Paul Delaroche for three years. Much of his time there was spent copying old masters in the Louvre. Apart from a further period in Paris from 1863 until the outbreak of the Franco-Prussian War in 1870, he worked in his home town of Marseilles. He died there a month or so before the Edinburgh exhibition opened.

Monticelli painted still life, landscape, portraits and genre, as well as very individual fantastic pieces, which included imaginary courts of love and *fetes galantes* inspired by the early-eighteenth century French painter Watteau (see pl.18). He was greatly influenced by the work of Eugene Delacroix and the Barbizon artist Diaz, which seems to have set free his great love for colour. Indeed as a colourist he was described in an otherwise hostile article in 1894 as the French equivalent of Turner.[4] His early work demonstrates an ability to draw well. Later, drawing and finish are totally subjugated by colour, the pigment applied in a thick, almost encrusted, impasto. Monticelli took 'a voluptuous delight in daring harmonies of colour.'[5] He used colour 'to express a personal mood or emotion, regardless of subject matter, [which] was unique in the 19th century.'[6] In his introduction to the catalogue of the Edinburgh exhibition the writer, poet and critic W.E.Henley wrote:

> With Monticelli the be-all and end-all of painting was colour. True it is that he has a magic - there is no other word for it - of his own: that there are moments when his work is infallibly decorative as a Persian crock or a Japanese brocade; that there are others when there is audible in these volleys of paint, these orchestral explosions of colour, a strain of human poetry, a note of mystery and romance, some hint of an appeal to the mind. As a rule, however, his art is purely sensuous. His fairy meadows and enchanted gardens are, so to speak, 'that sweet word Mesopotamia' in two dimensions; their parallel in literature is the verse that one reads for the sound's sake only - in which there is rhythm, colour, music, everything but meaning. If this be painting, then is Monticelli's the greatest of the century...[7]

Not surprisingly his painting provoked great controversy. In his native France he was considered to be a madman, his later work the result of strokes and paralysis, compounded by a fondness for *l'absinthe*. Some felt that he had a visual defect. On the other hand in Britain and America he was regarded much more favourably. Indeed in some quarters he was considered a visionary of modern art, many years ahead of his time. Certainly he influenced Cezanne, whom he knew, and also Van Gogh, and prepared the way for the development in France of expressionism in colour, anticipating the *Fauves*. In Britain Monticelli's work was championed by the London dealer Daniel Cottier, who lent three paintings to the Edinburgh exhibition, and, later, by the Glasgow dealer Alexander Reid. He became very popular, particularly in Scotland, where his paintings were purchased by collectors such as T.G.Arthur, William Burrell and W.A.Coats in Glasgow and the Edinburgh papermaker J.J.Cowan. In 1888 two of Monticelli's paintings were shown at Glasgow's rival international exhibition and a retrospective exhibition

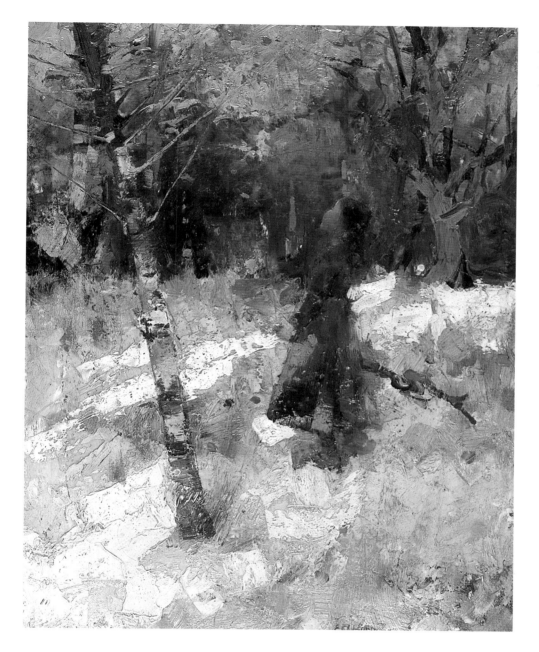

PLATE 14
Autumn *1888*
Oil on canvas, 17$\frac{1}{2}$ x 13
Private Collection

comprising seventy-five works was held at the Dowdeswell Gallery in London the same year. The interest in Monticelli continued unabated for about twenty years, mainly centred on Glasgow. Works were lent regularly to the annual exhibitions of the Glasgow Institute, although his paintings were never shown at either the Royal Scottish Academy in Edinburgh or the Royal Academy in London. Glasgow held another international exhibition in 1901, at which no fewer than eleven Monticellis were exhibited in the fine art section. Two were lent by William Burrell and four by W.A.Coats, who was reputed to have a large collection of Monticelli's work - sixteen are illustrated in the massive

catalogue of his collection published in 1904. It has to be said that it is difficult to comprehend one hundred years later what can only be described as 'Monticelli mania'. Today much of his work is consigned to the storerooms of national galleries, the original brilliant colour dulled by age and grime. However his oils are still being acquired by a small number of collectors worldwide; one Japanese collection has over one hundred works.[8]

No doubt Hornel would have visited the 1886 and 1888 exhibitions several times. It is just possible that he may also have seen the Monticelli retrospective at Dowdeswell's; there are a number of references in the Henry letters to projected visits to London by the Boys, but few details are mentioned and the letters themselves are undated. Hornel later acknowledged the influence on his painting of Monticelli, 'whom he studied for colour, and whom at his best he considers a great painter...'[9]

Hornel was also inspired by the paintings of Ford Madox Brown (1821-1893), who had been a student at the Academy in Antwerp almost half a century before him. Hornel described him as 'the greatest modern British colourist.'[10] In 1886 Madox Brown had shown *Don Juan found on the Beach by Haidee* (1878) at the Glasgow Institute and George Rae had lent Madox Brown's *An English Autumn Afternoon* (1852-3) to the international exhibition in Edinburgh. The following year eight of his works, including *Don Juan*, were exhibited in the fine art section of Manchester's Royal Jubilee Exhibition, held in celebration of Queen Victoria's accession to the throne fifty years earlier. For the spandrels of the dome of the specially erected Jubilee building Madox Brown had executed a series of eight huge figures, all oil on gold. 'So vast and dazzling a work...was the realisation of a lifetime's dream.'[11] It was probably this exhibition to which Henry referred, when he wrote to his friend: 'One word however, go and see Manchester Exhibition. It lays out all annual exhibitions in London or anywhere. Go at once, or by G-- you will regret it. There are cheap trips every fortnight nearly', adding 'A good hotel near the London & N.W.Rly Station is the Trevelyan (Temperance) you can start sober in the morning!'[12] The exhibition also included twelve works by Edward Burne-Jones and ten by Dante Gabriel Rossetti. No wonder Henry was so enthusiastic. In his article in *The Scots Pictorial* in 1900 Edward Pinnington records that Hornel considered Madox Brown's paintings in Manchester's permanent collection 'an inspiration and a feast, showing great power and grand colour.'[13]

Although it was to be almost two years before the rich colour which Hornel so admired in the work of Monticelli and Madox Brown was translated to his own canvases, Monticelli's immediate influence can be discerned in the manner in which Hornel and Henry were henceforth to handle their paint. In 1887 Hornel returned to the theme of woodland, which he had explored tentatively in *Resting* some two years earlier. At the Edinburgh International Exhibition he would have been able to study an abundance of scenes in the Forest of Fontainebleau by Barbizon painters such as Daubigny, Diaz and Rousseau, which would have provided plenty food for thought for a young artist. In *Pigs in a Wood* (1887: Andrew McIntosh Patrick, pl.15) Hornel goes beyond the mere depiction of a rustic scene with pigs grubbing around in the midst of a dense wood. He is more concerned with the decorative possibilities of the subject, particularly the treatment of the bark of the trees, the foliage and the undergrowth. The dry pigment is very broadly handled. Small splashes of dull orange suggest the autumnal foliage. An abstracted pattern of orange and green make up the ground cover of plants and fallen leaves.

Several of the Boys were interested in the decorative aspect of trees and woodland at this time. Walton's treatment of the trees and the cattle in the background in his major work *A Daydream* (1885: Andrew McIntosh Patrick), which he exhibited at the Glasgow Institute in 1887, may have been an influence on Hornel. Another influence may have been Frank O'Meara's *Evening in the Gatinais* (the old name for the southern part of the

Forest of Fontainebleau) with its frieze of slender upright trees stretching across the entire upper half of the canvas. It would have been well known to the Boys, because it was exhibited at the Glasgow Institute in 1884 and acquired by the Glasgow shipowner James Gardiner, a cousin of Guthrie. Gardiner lent the work to the Glasgow International Exhibition in 1888, the year in which O'Meara died of malaria at the early age of thirty-five. An obituary in *The Scottish Art Review* paid tribute to his influence on the Boys and went on to praise *Evening in the Gatinais*: 'Simple, broad, and true, it happily illustrates the aim of the younger painters of today - to combine realistic fidelity with decorative beauty.'[14]

A sense of design and pattern is evident in the strong verticals and the opposing undergrowth and thick canopy in Henry's *Landscape* (c1886: private collection); the dark wood is devoid of all life, human or animal. Although the subject is the same, the style and handling in Millie Dow's atmospheric *At the Edge of the Wood* (1886: Andrew McIntosh Patrick) is very different; the delicacy of the brushwork and the overall green tones give it a mystical feeling. The latter is probably one of the paintings which Henry praised in a letter to Hornel towards the end of 1885: 'Dow has 2 landscapes, the most beautiful things I have ever seen. I don't know of any other fellow who has managed to make one feel on seeing those pictures so much of the spirituality of Nature.'[15]

It is obvious that by this time Henry and Hornel were working closely together and were very much in tune with one another. From a number of letters to Hornel from Henry and other of his artist friends and from the amount of work and equipment which they left behind in each other's studio, it is fair to assume that, certainly in the early years, they spent extended periods painting together, mainly in Kirkcudbright but also in Glasgow. They were to develop a decorative quality in their work to a far greater extent than any of the other Boys, marking an important second phase in the evolution of the so-called Glasgow School. In *Scottish Painting: Past and Present*, Sir James Caw, who knew Henry and Hornel and was writing within twenty years of the relevant events, summarised their impact on Scottish art towards the end of the nineteenth century:

PLATE 15
Pigs in a Wood *1887*
Oil on canvas, 15^1/$_2$ x 11^1/$_2$
Andrew McIntosh Patrick

Hitherto an inherent part of the emotional and pictorial conception of Nature rather than an end in itself, this [decorative] element was now to be exploited for its own sake, and before long in the work of George Henry, E.A.Hornel, and their immediate following everything else became subordinate. And this, being accompanied by relaxation of the close study of values, which had been a prime factor in the earlier days, and a resurge of delight in brilliant colour, led to what promised to be a new type of picture in Scottish art. From a cloud 'no bigger than a man's hand' in 1887 or 1888, it grew with tremendous rapidity until, descending in a series of amazingly clever and arresting and in some respects beautiful pictures, it seemed for a few years after 1890 to fill the whole western horizon, and threatened to engulf the more solid achievement of the older group.

However Caw went on to add:

Then, having quickened but not annihilated the parent movement by its animation, freshness, and vitality, and leaving Mr. Hornel to pursue his course in trailing clouds of colour, it passed almost as quickly as it had come.[16]

To Henry and Hornel the expressive qualities of paint were as important as the subject. In much of Hornel's work of this period colour, pattern and texture are dominant and form assumes a secondary role. This can be seen clearly in *Kirkcudbright Stick Gatherers* (1888: private collection), in which the subject - two girls gathering firewood - merges with the abstracted woodland setting. The pigment is freely handled, a mosaic of reds, orange, browns, green, grey and black in a restricted range of low tones, demonstrating the influence of Monticelli.

Henry is working along similar lines in his smaller *Autumn* (1888: Kelvingrove, Glasgow), although in this case it appears as if the figure of the girl is *emerging* from her surroundings. Her face - half hidden by the shadow cast by the wide brim of her hat - and her neck are quite distinct. The rest of her body, however, is absorbed by the foreground, her clothes camouflaged by an abstract pattern of patches of colour, representing the green of the vegetation and the russet of the fallen leaves.

In his own version of *Autumn* (1888: private collection, pl.14), which is almost the same size as Henry's painting, Hornel has forsaken his recent preoccupation with the enclosing nature of a dense wood. A solitary young girl is standing in a clearing in a wood, looking up at the leaden sky. Her dark green coat contrasts sharply with the

PLATE 16
Sheep Grazing in an Autumn Landscape *1887*
Oil on canvas, 12 x 16
Private Collection

reddish-pink of the remaining leaves on the trees and the ground partly covered in snow. Hornel's handling - even of the figure - is at its broadest to date, the impastoed white of the snow put on with a palette knife. It is not only a very decorative piece; it also has a spiritual feeling about it. *Landscape with Girl and Sheep* (1889: Kirkcaldy, pl.17) is a similar painting, probably featuring the same girl. In this instance Hornel has brought her out into the open. Painted in profile as before, she sits on a gentle slope under a spreading tree. It is a beautifully composed pastoral scene. The thickish pigment in low tones of green, brown, blue and cream is broadly handled. In *Spring Time* (c1890: Kirkcaldy) Henry has treated a similar subject in a very decorative manner. The composition is almost two-dimensional. A study in light and shade, overall design is just as important as subject matter. Hornel exhibited *Autumn* at the Glasgow Institute in 1889, together with *The First Snow* (untraced) (have the titles been switched by mistake in the course of over one hundred years?) and *A Weed Cutter* (untraced).

Glasgow mounted its own International Exhibition of Industry, Science and Art in 1888, the first of four great exhibitions the city was to host over the following fifty years. It was to be a showcase for industry and commerce, for which Glasgow was renowned throughout the world, and for the arts. Civic pride demanded that it had to be bigger and better than those of Edinburgh in 1886 and Manchester in 1887, even if that involved a somewhat liberal interpretation of admissions![17] The Glasgow architect James Sellars designed a series of buildings in an eastern manner - a mixture of Moorish, Byzantine and Indian styles - to house the exhibition, which was sited in West End (now Kelvingrove) Park. It became known by a number of nicknames, including 'Baghdad by Kelvinside.'[18] Guthrie, Walton, Lavery and Henry each painted a large circular panel, containing an allegorical female figure representing Art, Agriculture, Science and Industry respectively, which were installed above the piers supporting the dome of the main building. As well as around two thousand industrial exhibits, ranging from heavy engineering to household goods, there was a large Fine Arts Section hung throughout eleven galleries.[19] Dow and Roche painted murals for the Sculpture Gallery and Hornel, Nairn and Peter Macgregor Wilson (c1856-1928) executed others for the gable ends of the Sculpture, Architecture and Photography Galleries. Sadly neither the murals nor the roundels survived the demolition of the largely wooden building when the exhibition closed at the end of October that year. However the art correspondent of *Quiz* visited the exhibition just prior to its opening in May:

> Last week we paid a visit to the International Exhibition, and had an opportunity of seeing the wall paintings in the galleries by Messrs. Roche, M'Gregor Wilson, Hornel, and Nairn. As they are scarcely completed yet, it would be premature to offer any opinions about them, except that they suggest here and there haste and possibly some inexperience in this class of painting. When the rooms are finally arranged with sculpture and pictures, we doubt not, however, that they will take their places in the general scheme of decoration, and add much to the beauty of the galleries; for, considering the limited time at the disposal of the artists, these frescoes seem, even in their present state, very creditable performances.[20]

A large majority of the Fine Arts Committee were collectors, who were expected to part with their treasures for some six months and to encourage others to do the same. In contrast to arrangements for the Edinburgh exhibition, a total of seven artists, including Guthrie and Macgillivray, were appointed to serve on the Committee, although it seems that this was not achieved without a certain amount of wrangling.[21] British art was well represented, including six works by Constable, thirty-one by Turner and no fewer than forty-three by David Cox. Surprisingly, there was not one by Allan Ramsay. Reflecting the current tastes of collectors, the Barbizon and Hague School painters were prominent, as they had been at Edinburgh two years earlier. Although there were eight works by

Henri Fantin-Latour, the Impressionists were represented by only one oil by Degas. With the exception of Robert Macaulay Stevenson (1854-1952), Melville, Grosvenor Thomas (1856-1923), Kennedy and Gauld, all the Boys exhibited, mainly in the sale section. Both Henry and Hornel sent in rather minor works, the former a watercolour *Head of a Young Girl* priced at £20 and the latter the oil *Pastoral* (untraced) priced at £10. Although the Boys submitted just under forty works out of a total of over two thousand, six hundred items, they attracted the attention of the critic of *The Art Journal:*

> There is in Scotland, and notably in Glasgow, a band of young painters who have broken from the traditions of the past and boldly struck into the road that is marked with the footprints of Bastien Le Page [sic]. Among these men are some of the ablest we have in Scotland. Their future lies all before them: several of them will, without doubt, do great things...For their earnestness, their devotion to Art for Art's sake, their lack of respect for what is merely respectable and popular in Art, these painters deserve the highest praise, and we feel sure that as the years roll on that bring the philosophic mind and lead to changed outlooks, the result will be good for Art in Scotland. Perhaps the ablest of 'the new school', as it is sometimes very absurdly called, who have already attracted attention, are James Guthrie, John Lavery, E.A.Walton, James Paterson, George Henry, and A. Roche.

In the course of an extensive review of Scottish art and artists the critic finished up by praising Walton, five of whose works featured in the exhibition: 'We must also speak in high terms of E.A.Walton's 'Pastoral' (James Gardiner, Esq.). This is the work of a man who has in him that spirit and sympathy - so difficult to define in exact words - that are essential elements in the temperament of all who are entitled to bear the noble name of artist.'[22] The Boys were beginning to gain recognition at last.

In February of the following year Hornel was asked by his friend Malcolm Harper, the Vice-President of the Kirkcudbrightshire Fine Art Association, to contribute an illustration to a book of poetry titled *The Bards of Galloway*. Other illustrations had been promised by a number of Galloway artists, including John and Thomas Faed, Tom Blacklock, W.S.MacGeorge and Hornel's brother-in-law William Mouncey. Harper himself acted as editor and contributed five of his own poems and an illustration. A Galloway man, Harper was the Agent of the British Linen Company's Bank in Castle Douglas. He was the author of several books about the region, as well as being a poet and an amateur artist, exhibiting a number of works at the Royal Scottish Academy and the Glasgow Institute. He knew Henry and Hornel well and they had helped him with his painting. He in turn was occasionally able to assist Hornel: 'How's your supplies getting on? If they're out & you want another loan say so.'[23] *The Bards of Galloway* was the first of a number of fine books to be published by Thomas Fraser, a successful Dalbeattie businessman. Fraser had a keen interest in literature and was an ardent book collector. Later Hornel and he became very good friends. Fraser's extensive library was purchased by Hornel in 1919 and over the following years Fraser was instrumental in building up Hornel's own impressive collection of books and manuscripts pertaining to Galloway and by and about the poet Robert Burns.

Hornel undertook to illustrate William Nicholson's poem in the Scots dialect *The Brownie of Blednoch*, which Harper thought was a good choice: 'It is a poem that will be noticed by the Reviewers & I hope your association with the Galloway Bard par excellence may help to give you a 'heeze' [hoist] up fames ladder also.'[24] Although 'indolence, indecision and thriftlessness' ruined his occupation as a packman, Nicholson had a love of literature and was a poet of some stature.[25] *The Brownie of Blednoch* first appeared in the *Dumfries Magazine* in 1825 and immediately became very popular, establishing Nicholson's reputation as a poet. It has been reprinted in many anthologies.

PLATE 17
Landscape with Girl
and Sheep *1889*
Oil on canvas, 12 x 8
Kirkcaldy Museums

In 1884 the painter and etcher William Strang (1859-1921) etched seven illustrations to *The Brownie of Blednoch*, which were issued as a small edition of prints.[26]

The poem tells the story of Aiken-drum, 'a wild and unyirthly wight [unearthly fellow]', who strikes terror in the hearts of everyone wherever he goes. Nicholson describes the grotesque 'shapeless phantom':

His matted head on his breast did rest,
A lang blue beard wan'ered down like a vest;
But the glare o' his e'e nae bard hath exprest,
 Nor the skimes [glance of reflected light] o' Aiken-drum,

 * * * * *

On his wauchie [clammy] arms three claws did meet,
As they trailed on the grun' by his taeless feet;
E'en the auld gudeman himsel' did sweat,
 To look at Aiken-drum.

However Aiken-drum is more to be pitied than feared. He is an unnatural, frightful creature, but not an evil spirit. All he wants is work, offering to gather the sheep into the fold or to thresh the corn in exchange for 'a cogfu' o' brose [wooden vessel full of porridge] 'tween the light and dark.'

The subject matter of the poem appealed to Hornel. It gave full rein to his imagination. His Aiken-drum is far more frightful than Strang's rather tame tall and thin, bald old man with a long beard. *The Brownie of Blednoch* (1889: Kelvingrove, Glasgow, pl.13) shows Aiken-drum, with his incandescent eyes, thin elongated limbs and long flowing beard, sitting on a hillside beside a roaring burn, minding the sheep. The moon, echoing the Galloway cup-and-ring markings, casts an eerie light on the scene. A witch on her broomstick flies across the sky. An unidentifiable creature darts through the dark clouds to the left. The sense of the supernatural is heightened by Hornel's thick impasto in dark tones of black, grey, blue and white. Originally the work was surrounded by a grained wood frame with carved into it the title 'THE BROWNIE' amidst Celtic symbols.[27]

The Brownie of Blednoch is a significant work by Hornel, the importance of which has tended to be overlooked. He took considerable pains with the piece, writing to Fraser:

> I send by this post my sketch of the Brownie. I have had some heavy work with it & have perhaps kept you waiting too long, but I wanted to get some new phase of the subject, apart from the old beaten track, & hope this when reproduced will be satisfactory.[28]

The work has a number of compositional elements - the profile of the hill, the sheep placed against the hillside, the winding stream and the flattening of perspective - which were to be used again in several works by Hornel and Henry over the next three years or so. It has been suggested that Hornel may have based his sketch on the sometimes macabre work of the Belgian artist James Ensor (1860-1949), but this seems unlikely.[29] No work by Ensor had been exhibited in Britain up to that time and even if Hornel had met Ensor, or seen his work, when he was a student in Antwerp from 1883 to 1885, Ensor had not then embarked on his series of grotesque masks and skeletons. Indeed there is good reason to believe that Hornel was not familiar with contemporary Belgian painting. It is obvious from letters written to him by Guthrie and Henry that, when Hornel was invited to exhibit in 1893 with Les XX, the Belgian avant-garde group of which Ensor was a founder-member, he did not know anything about Les XX and wondered whether he should show with them.[30] Had he seen the first exhibition of the group in Brussels in 1884, at which Ensor showed six works, surely he would have remembered such an exciting event?

However the painting does indicate that Hornel was well aware of Japanese art. The flattened perspective and the winding stream are two of the elements frequently seen in the Japanese print. Hornel's roaring burn bears some similarity to the waterfall in Hokusai's print *In the Horse-Washing Waterfall* (c1832). Whether Hornel could have seen this print is open to question. Certainly such prints were being purchased by collectors in Glasgow at that time. In November of that year Alexander Reid opened his new gallery in Glasgow with an exhibition of Japanese prints, which he must have brought back with him from Paris. As we shall see in a later chapter, Japanese art had become a potent influence on many Western artists, particularly in France and Britain.

The Brownie of Blednoch was illustrated again in Harper's book *Rambles in Galloway*, published by Fraser in 1896. The painting now in the possession of Glasgow Museums and the sketch which Hornel sent to Fraser appear to be one and the same. It was never exhibited during Hornel's lifetime.

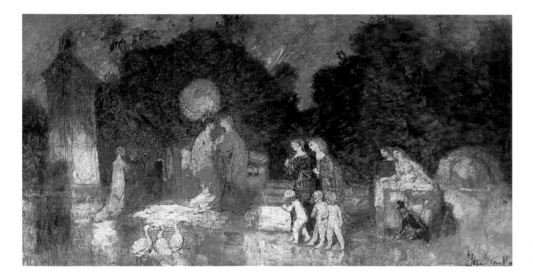

PLATE 18
Adolphe Monticelli
Scene in a Park *c1870*
Oil on canvas
Musee des Beaux-Arts,
Marseilles

1 Billcliffe suggests that Guthrie's *Pastoral* may have been painted in Northumberland - see Roger Billcliffe, *The Glasgow Boys*, London, 1985, p.203

2 James Holloway & Lindsay Errington, *The Discovery of Scotland*, National Gallery of Scotland exhibition catalogue, 1978, p.147

3 Letter from W.Y.Macgregor to James Paterson dated 11 July 1887 (Paterson Family), quoted in Billcliffe, op.cit., p.205

4 E.Bergerat, *Un Turner francais, L'Echo de Paris*, 24 June 1894, quoted in Aaron Sheon, *Monticelli, His Contemporaries, His Influence*, Museum of Art, Carnegie Institute, Pittsburgh, 1978

5 Arthur Symons, *The Painting of the Nineteenth Century, The Fortnightly Review*, March 1903, p.531

6 Aaron Sheon, op.cit, p.95

7 W.E.Henley, *Memorial Catalogue of the French and Dutch Loan Collection Edinburgh International Exhibition* 1886, Edinburgh, 1888

8. *Monticelli*, Bridgestone Museum of Art exhibition catalogue, Tokyo, 1995 (collection of Mr Tanimoto Hiroaki)

9. Edward Pinnington, *Mr E A Hornel, The Scots Pictorial*, 15 June 1900, p.173

10 Ibid., p.173

11 Teresa Newman & Ray Watkinson, *Ford Madox Brown and the Pre-Raphaelite Circle*, London, 1991, p.185

12 Undated letter from George Henry to Hornel, describing a trip he had made to exhibitions in London and the provinces (probably mid-1887) (Hornel Trust)

13 Pinnington, op.cit., p.173

14 Unsigned obituary tribute in *The Scottish Art Review*, vol.1, no.6, November 1888, pp.156-7

15 Undated letter from George Henry to Hornel (probably end-1885) (Hornel Trust)

16 Sir James L.Caw, *Scottish Painting: Past and Present 1620-1908*, Edinburgh, 1908, p.399

17 *The Bailie*, Exhibition Supplement, 27 June 1888

18 Perilla & Juliet Kinchin, *Glasgow's Great Exhibitions*, Wendlebury, 1988, p.21

19 *International Exhibition Glasgow* 1888, Official Catalogue of Fine Arts Section

20 *Quiz*, 20 April 1888

21 *Quiz*, 30 September 1887

22 *Scottish Art in the Glasgow Exhibition, The Art Journal*, 1888, p.276

23 Letter from Malcolm Harper to Hornel dated 9 February 1888 (Hornel Trust)

24 Letter from Malcolm Harper to Hornel dated 25 February 1889 (Hornel Trust)

25 Notes by Malcolm M'L Harper to *The Bards of Galloway*, Dalbeattie, 1889, p.249

26 David Strang, *William Strang: Catalogue of Etchings and Engravings*, Glasgow, 1962

27 See illustration in *Rambles in Galloway by Malcolm M'L Harper*, Demy Quarto Edition, Dalbeattie, 1896, p.134

28 Undated letter from Hornel to Thomas Fraser (April 1889)

29 William Hardie, *Scottish Painting: 1837 to the present*, London, 1990, p.98

30 For example, see letter from James Guthrie to Hornel dated 15 November 1892 (Hornel Trust)

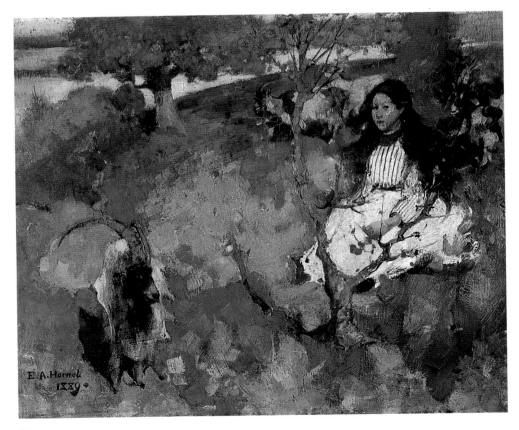

PLATE 19
The Goatherd *1889*
Oil on canvas, 15 x 17
Private Collection

'THE PERSIAN CARPET SCHOOL' 1889-1891

THE 'CLOUD NO BIGGER THAN A MAN'S HAND' OF 1887-88 BROUGHT forth a refreshing downpour some two years later. Taking inspiration from the lush undulating landscape and the colourful pastoral life of Galloway and from its folklore, Henry and Hornel produced a body of richly decorative paintings over the next five or six years, which must rank among their best. Colour becomes their prime consideration. However their use of colour is a very individual and personal one. They both possessed an intuitive sense of colour, which enabled them to conceive harmonies and contrasts which were very much their own. It is abstracted colour rather than observed colour. Similarly they assimilated in their own way the various influences to which they were subject - Galloway, Monticelli, the art of Japan and, later, Gauguin and the School of Pont-Aven - rather than slavishly following one or more of them. They were to be criticised for their lack of realism, their disregard for the facts of nature, especially in terms of form, colour and perspective. However they were much more interested in design, pattern and texture. Weaved into much of their work is a symbolism which is difficult to unravel at this distance.

In *The Goatherd* (1889: private collection, pl.19) Hornel's palette is lighter and his colour brighter than before. He has forsaken the dark background, building up his subject from patches of strong colour, harmoniously distributed across the canvas. It gives the appearance of a peaceful autumnal scene, albeit treated in a very decorative manner. However the young girl is far too well-dressed to be a goatherd and below the tranquil surface there is an unexplained tension between the goat in the foreground, the girl and the viewer. The small tree in front of the girl adds to the mystery, its two thin branches seeming to encircle her like the antlers of a giant beast. The influence of the Japanese print can be seen clearly in the bold disposition of flat colours, the placing of the girl behind the tree and the stylised profile of the tree itself with dots of colour for leaves or fruit.

The painting may have been suggested by *Girl with Goats* by the Hague School artist Matthijs Maris, which Hornel would have seen at the Glasgow International Exhibition the year before. On the other hand it may be his response to the richly coloured decorative style and symbolist qualities of Melville's influential *Audrey and her Goats* (Tate, London). Melville had started this large oil painting at Cockburnspath in 1884, but did not complete it - if indeed he ever considered it to be finished - until after his return from a visit to Paris with Guthrie and Walton in the spring of 1889. He did not exhibit this scene from Shakespeare's *As You Like It*, in which Audrey is courted by Touchstone, until 1890, when it was shown at the Grosvenor Gallery in London along with work by many of the other Boys. However it was well known that he had been working on the painting intermittently for six years and Hornel would have been able to see it in Melville's Edinburgh studio.

Whereas *The Goatherd* is essentially a static vision, *A Galloway Idyll* (1890: private collection, pl.20) has a wonderful sense of movement and rhythm. This delightful little picture may be based on a Galloway poem or legend, or it may be quite simply an evocation of joyful childhood. What the girls are doing can only be guessed. Perhaps the one sitting on the grass is singing, while the other is dancing, or the girl on the right may be chasing white butterflies, flicking at them with her deep blue handkerchief. However it does not really matter what is taking place. The subject is subordinate to the richness of

the colour and the overtly decorative treatment. The influence of Japanese art on Hornel is apparent. He has employed some of the same compositional devices which he first used in *The Brownie of Blednoch*, such as the flattening of perspective, the rounded hill, the snaking path and the animals - in this case goats - placed against the hillside.

Goats appear in many of Hornel's paintings from now on. Pittendrigh Macgillivray, one of the Boys, composed some verse on the subject of Hornel and goats:

HORNEL EXULTANT TO HIS GOAT ON THE GALLOWAY HILLS

B'Gode, I'll pent ye in style, ye B! As ye never were pented afore
Wi' colour and touch bloody nice, ye B! An' as fat as an Antwerp whore.
Ye're richt, said the Goat.

B'Heav'ns I'll lay it on thick, ye B! In a way that'll look mighty fine -
Monticelli's the fake for me, ye B! Sae to hell wi' y're glue pattin' swine.
Ye're richt, said the Goat.

My Gode, what's that on yer hide, ye B! Thae markins in broon an white,
They're Hellish like Celtic designs, ye B! In the study o' which I delight.
Ye're richt, said the Goat.

Here richt on the Galloway Hills, ye B! Wi thae markins whatever they be,
Ye're a magnificent thing o' the kind, ye B! An sae is baith Henry an me.
Ye're richt, said the Goat.

B'th Lord Harrie and Holy Mary, ye B! And deepest fecundity lipperin' owre,
B'th phallus that hings at yer wame, ye B! The stinkin buggers'ill glow'r.
Ye're richt, said the Goat.

When they see the fine stuff slab'ed on wi' the knife, ye B!
And feel it eat in like Hell,
And here in th' tune o'oor ringing Ko, ye B! An' noter th' gluepathic knell,
Am I richt, ye B!
Ye're richt, said the Goat.[1]

A.S.Hartrick recounted that this rather bawdy poem was sung or quoted widely.[2] Macgillivray and Hornel were friends, both prone to using strong language. As well as being a sculptor and painter, Macgillivray was a poet of considerable talent. Hugh MacDiarmid suggested in 1925 that he might be considered Scotland's greatest contemporary poet. He published privately two books of poems, titled *Pro Patria* (1915) and *Bog Myrtle and Peat Reek* (1922). Macgillivray could be a difficult man, a rebel like Hornel himself. It was not for nothing that he earned the nickname 'Macdevilry'.[3] In his poem *Anent the Scots Academy* written in 1897 and later included in *Bog Myrtle and Peat Reek* he fiercely attacked the Royal Scottish Academy (he was then an Associate!); a line runs:

'...We'll practise Art wi' less ado
Anent the Scots Academy...'

However that did not prevent him being elected an Academician in 1902.

Perhaps the most remarkable of the series of decorative paintings produced by either Hornel or Henry is the latter's *A Galloway Landscape* (1889: Kelvingrove, Glasgow, pl.21). Indeed it is probably the most original painting by any of the Boys. It combines a wonderful evocation of the spirit of Galloway - the beauty, richness and colour of its

PLATE 20
A Galloway Idyll *1890*
Oil on canvas, 20 x 16
The Robertson Collection

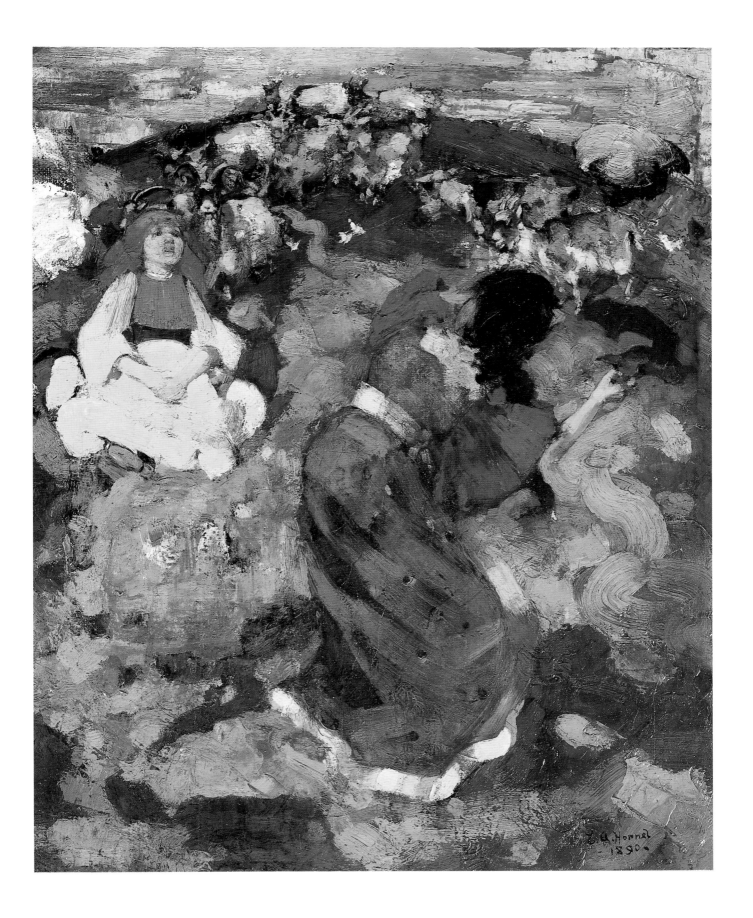

undulating, wooded countryside - with a decorative treatment rich in symbolism, which would seem to have much more affinity with the post-impressionism of Gauguin than with contemporary Scottish art. However there is no evidence that at this time either Henry or Hornel knew what was taking place at Pont Aven. There is no suggestion in the Henry letters that he accompanied Guthrie, Walton and Melville to Paris in the spring of 1889 (Henry and Hornel were not to visit Paris until 1891), although he might have learned of developments on the Continent from Melville on his return. Similarly, though Hornel kept up his friendship with Charles Mackie for many years, it was not until 1891 that Mackie met Gauguin in Paris. The dealer Alexander Reid is reputed to have known the French painter during his period in Paris in 1887, but it is doubtful whether either Henry or Hornel had any contact with Reid until 1890, when the Munich exhibition of that year was being organised (George Davidson was their Glasgow agent).[4] Thus the only conclusion that can be drawn is that Henry, with some assistance from Hornel, arrived at this style without being influenced by any developments in painting which were taking place on the Continent at the time.

A Galloway Landscape is almost two-dimensional. Colour is all important; the preoccupation with tonal values, so important some three or four years before, has been discarded. Henry's handling of the paint is very bold with much use of the palette knife. His treatment of the landscape is almost naive. The trees and the cattle are placed against the hillside with scant regard for perspective, similar to Hornel's positioning of the sheep in *The Brownie of Blednoch*. There is a feeling of design and rhythm in the contours of the hills and the winding burn, which appears to flow over the surface of the canvas itself. The burn was another compositional device probably borrowed from Hornel. In a letter to Hornel, Henry asked him: 'Could you do me a sketch of a bit of winding burn, also some shrubs and twisted trees or blossom. Do them in pencil, don't trouble however if you are busy at anything.' Although the letter is undated, it must have been written around the middle of April 1889, about the time Hornel sent off his Brownie oil sketch to the publisher, because Henry wrote in a postscript to the letter: 'I believe I am to be in 'Quiz'

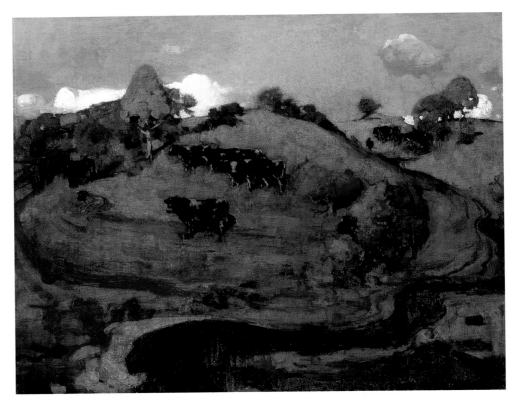

PLATE 21
George Henry
A Galloway Landscape
1889

Oil on canvas, 48 x 60
Glasgow Museums: Art
Gallery & Museum,
Kelvingrove

this week!' which would date it to just before 19 April 1889.[5] In *A Painter's Pilgrimage Through Fifty Years* Hartrick recalled:

> I have seen the spot where it was painted, a very ordinary field with a hill in it; but Henry introduced a blue burn, painted with a palette knife, around it; then put a stain over all, and it became an object of derision for the man in the street as well as for the Glue Pot School, but an ineffaceable memory for any artist who has ever seen it.[6]

Henry exhibited *A Galloway Landscape* and *Autumn*, together with *Cinderella* (whereabouts unknown), at the Glasgow Institute in 1890. Hornel showed *Girl with Goats* (*The Goatherd*), together with *Winter Fuel* and *Study of a Girl's Head* (both untraced). Not surprisingly the critics were rather dismissive of *A Galloway Landscape*; they hardly knew what to make of it. *The Scotsman* commented:

> Mr.G.Henry is the most pronounced of the 'impressionists' who exhibit. His 'Galloway Landscape' has been a great puzzle to many; others have treated it as a huge joke played upon a too credulous Hanging Committee. Impressionism has its place in art, but such vagaries of the brush as this landscape (which suggests a nightmare), even allowing that it has a certain tonal quality, will not tend to raise the School in popular estimation.[7]

The critics were also taking an interest in Hornel's work by this time. The *Glasgow Herald* considered that:

> Mr. E.A.Hornel is another Glasgow artist with the courage of his convictions, who earnestly seeks the light, even if we believe he has not yet found it. His 'Winter Fuel' (No.642) is marked by undoubted sense of colour and graphic force, and also, it must be added, by general inequality of execution. There is much in it to admire, and much also that we cannot regard as contributing to beauty either of form or effect. In No.743, 'Study of a Girl's Head', and in No.749, 'Girl with Goats', Mr. Hornel is less ambitious, and for that reason more successful.[8]

The critic of *The Academy* was quite enthusiastic:

> There is much, indeed, to quarrel with in Mr. Hornel's 'Winter Fuel'; but how exquisitely delicate is that face of the child to our extreme right, and what a lovely passage of colour is given by the combinations of pale green against grey introduced in its dress? In a less complex subject, 'Study of a Girl's Head', the same painter has dropped for the moment all eccentricity whatever, and produced quite one of the most artistic, delicate, and purely delightful things in the whole exhibition.[9]

Quiz summed it up well:

> Among the examples of our local artists which have been prominently placed here [Gallery IV], the pictures by Mr. George Henry and Mr. E.A.Hornel at once arrest attention, from their unlikeness to any other works in the exhibition. In whatever light these pictures are regarded, there can be no denying their originality of style, the peculiarly personal nature of their artistic aim, and method of expression. They certainly do not record impressions of nature which occur to the ordinary observer, but seem to be efforts to realise emotions and ideas suggested to highly imaginative minds by peculiar aspects and conditions of light, colour, and atmospheric effects in nature, in such a way as to produce artistic harmonies of tone, subtle combinations of sensuous colour and quaint design. The artists appear to be searching for some new form of expressing their sense of the beautiful by means of painting, in which the details and facts of nature will merely form a basis upon which the artist can construct the artistic creations of his own imagination and fancy. The work of Monticelli is an example of art expression somewhat akin to what these two young artists are attempting, and while for ourselves we cannot regard any of these pictures in the present exhibition as sufficiently definite in its aim, or complete in its form and execution, we cannot but respect the earnestness of purpose and admire much of the fine feeling for subtle beauty of tone and artistic combinations which these works manifest. We shall look with high anticipations for more perfect realisations of these ideals from these artists at no distant date.[10]

The critic of *The Academy* too felt that Henry and Hornel were showing considerable promise:

> ...we consider that each of them shows - amid much that is immature and not a little that is extravagant - a clearly personal and individual quality, which is rarer in contemporary art than it should be, and which, when found, is correspondingly delightful; ...we believe that if these two painters continue faithful to their artistic instincts, it will not be many years before they are producing work of true artistic excellence as well as individuality.[11]

Even the normally-hostile critic of the *Kirkcudbrightshire Advertiser* was being won round, impressed by favourable reviews from national critics (the newspaper reprinted several in its columns):

> However much one may differ from 'the Kirkcudbright School' in their methods of interpreting nature, we ought to admire the sincerity of its members in working out their ideal, and their determination to put on record their *own* impressions of what they see and feel independent of what others have seen and felt before them. In these days of commonplace and artificialism, individuality of style in any shape is welcome, and Messrs Henry and Hornel for their temerity in endeavouring to convey the impression nature has made on *their* minds are to be commended.[12]

Hornel, then only twenty-five years old, must have derived a certain satisfaction from these sentiments. Within five years of leaving art school he was being ranked alongside the older and more experienced Henry. Although there might be differences of opinion about the merits of his work, at least he was being taken seriously. The future seemed promising.

Cooperation between the two artists soon became collaboration. Neil Munro records the reaction of one of his fellow journalists, who was doing the usual round of artists' studios in Glasgow before one of the annual exhibitions of the Glasgow Institute:

> One day in 1889 or 1890, the 'regular art man' on a Glasgow paper came to me shortly before the exhibition season, somewhat distressed about two young fellows whose studio he had visited to see what they had intended to send to the Institute. He had found them collaborating on a big picture called 'The Druids', to which none of his time-honoured cliches could be adapted. Mysterious stuff! Careless draughtsmanship! No sensible story! No finish! And gobs of gold leaf! I kindly sympathized with him in the trouble such innovations gave the critics, and agreed that too many of the young painters about Bath Street for a year or two back had been losing their heads and taking their jobs too seriously.[13]

Munro must have been intrigued, because he went to see for himself. He later recalled:

> [Hornel] was with George Henry in collaboration, painting a whacking big canvas the first day I saw him in the late Eighties. It was called 'The Druids', and its aim was not information of any kind but sumptious decoration. Roger Fry, had he been there, would not have understood their language - it was loaded with words like 'Monticelli', 'chiaroscuro', 'values', 'glue-pots', etc., which meant little to me, and their Druid chant was a wild one called 'The Black Whale Inn of Askelon'. The hymn was almost an essential part of the technique of those young gentlemen; they were already *revoltes*, as you could see from their contempt for 'glue-pottics' and 'bleat', and their delight in a bold and juicy impasto. It was at that moment, and in that dingy studio, I think, Hornel found himself, though 'The Druids' was only an *ebauche* of the vision inspired by the hymn of freedom. No real kick in it! Fiona MacLeodish in its Celticism.[14]

The Druids: Bringing in the Mistletoe (1890: Kelvingrove, Glasgow, pl.22) depicts a group of priests in richly decorated ceremonial robes and insignia accompanying the mistletoe laden on the Caledonian wild cattle, proceeding in solemn procession - as if in a trance - down a steep hillside from the sacred oak grove. It is probably early on Midwinter's Day. The moon still looms on the horizon, but the early morning rays of the sun bathe the upper half of the scene in a brilliant white light. Mistletoe, venerated by the

Druids, was believed to have magical, as well as medicinal powers, particularly when found on an oak, which was considered to be a sacred tree. The gathering of mistletoe is still associated with the burning of bonfires, a vestige of the sacrifical ceremonies performed by the Druids.

Henry and Hornel took infinite pains to ensure that the scene was as authentic as possible. According to Robert Macaulay Stevenson they examined skulls which were reputed to be of Druids to ascertain their likely features and visited the Duke of Hamilton's herd of ancient Caledonian cattle.[15] Throughout his life Hornel was very interested in the archaeology, folklore and wildlife of Galloway. He acted for a time as the Secretary of the Kirkcudbrightshire Field Naturalist and Antiquarian Society.[16] In 1923 he was elected a Fellow of The Society of Antiquaries of Scotland. In 1886 a significant discovery had been made some five miles or so south-east of Kirkcudbright of mysterious groups of cups and cup-and-ring markings cut into the rock, which were reputed to have been made by the ancient Celts.[17] Galloway and Argyll are the two principal areas in Scotland in which such marks occur. They may have some connection with metal prospecting and smelting, or they may be related to sun worship or some form of astronomical observation.[18] Hornel searched for other markings in the rocks in the region. Hartrick has suggested that it was on one of these expeditions that Hornel got the idea for *The Druids*. On that occasion he took Hartrick and another friend to visit an old man named Sinclair, who knew where some of these markings were to be found. After they had seen them, they returned to Sinclair's cottage:

> ...he took from a shelf a small china bowl in which was a small bluish stone like a bean. Holding this in his hand, in a few minutes he seemed to go off in a sort of trance, and then began to describe, like a wireless announcer of to-day, a vision of a procession of priests with sacred instruments and cattle which somehow were connected with the cup-and-ring markings. I cannot remember the details of it; all I can say is that the vision appeared to be genuine, and that he was not drunk. After a time he became normal again, but would not talk any more on the subject.[19]

Whether intentional or not, *The Druids* is a fine early contribution to the Celtic Revival of the 1890s. Daring in conception, bold in execution and strong in colour, it ranks as one of the most important paintings by the Boys. The richly-vestured figures are superimposed against the hillside, forming an almost two-dimensional pyramid. The half-sphere of the moon in the background is reflected in the curve of the hill and the shapes of the priestly insignia, all echoing the cup-and-ring markings. The drama of the occasion is heightened by the use of gold leaf, laid on top of the paint layer. The carved wood frame of the painting, designed by the two artists and bearing Celtic motifs, is an integral part of the whole. As to which artist was responsible for the various elements in its execution, it is almost impossible to discern.

The Druids was exhibited at the Grosvenor Gallery in London in 1890, when the painting and the artists attracted a great deal of attention from the critics and the viewing public. Sir Coutts Lindsay and his wife Blanche had founded the Grosvenor Gallery in 1877 to show the work of the more progressive artists, whom the Lindsays considered were being unfairly ignored by the staid traditional exhibiting venues such as the Royal Academy. The gallery achieved instant notoriety with its first summer exhibition, when John Ruskin accused Whistler of 'flinging a pot of paint in the public's face' on seeing the latter's *Nocturne in Black and Gold: The Falling Rocket*, leading to the famous libel trial which effectively bankrupted Whistler although he won the action. Apart from Whistler, painters whose work had been hung at the Grosvenor included the Pre-Raphaelites Burne-Jones and Millais, the London-based French painter James Tissot and the Naturalists Bastien-Lepage, George Clausen and Henry Herbert La Thangue, as well as Academicians like Sir Lawrence Alma-Tadema and George Frederic Watts.[20]

However by the mid-1880s the Grosvenor was faltering. Now there were other venues where the progressives could exhibit their work, such as the New English Art Club founded in 1886, the re-formed Society of British Artists and the New Gallery, which had been established in 1888 by two of Lindsay's assistants, following a dispute with their former employer.

Clausen had suggested to Lindsay that he should feature the work of the emergent Glasgow Boys in the summer exhibition of 1890 in an attempt to regain some of the lost ground.[21] All the major figures sent work with the exception of Crawhall and Macgregor. For Lindsay it was rather a gamble, but the critic R.A.M.Stevenson, writing in *The Saturday Review*, felt that it had paid off:

> The Grosvenor Gallery has asserted its right to exist by producing a decidedly original and, in some respects, a very interesting exhibition this year. It is given up to Scotch art; but not merely to that rather greasy Academic Scotch art showing the lines of the brush in the long smears of paint with which we were already only too well acquainted. On the contrary, what is most noticeable at the Grosvenor Gallery this year is the work of a group of young Glasgow painters whose names are entirely unknown in the South, and who, if we are not mistaken, have never exhibited their pictures in London before. These Glasgow painters give freshness and importance to the show, and add that element of novelty which we have seen to be wanting at the Royal Academy and at the New Gallery.

Of course the Boys *had* exhibited in London before. Since 1887 they had been consistent supporters of the infant New English Art Club, although Hornel himself had not sent work. However the Boys had not been noticed by the critics until now. Billcliffe has suggested that it was the hanging of Melville's *Audrey and her Goats* (rejected by the Royal Academy that year) and Henry and Hornel's *The Druids* - two very controversial paintings - which had captured their attention on this occasion.[22] Certainly they caused a great stir. Stevenson went on to comment:

> We suppose the masterpiece of the Glasgow School at the Grosvenor Gallery would be considered 'The Druids' (173), due to the combined efforts of Mr. G.Henry and Mr. Hornel. This is a large square canvas, high over a pale view of Whitby (175), by Mr. Bright Morris. The Glasgow picture is very startling, and at first sight very ridiculous. But the eye becomes accustomed to its strange forms and hues, and by degrees grows to like them. A procession of Druids, in vermilion, emerald and gold, carrying the golden circular sickle and the mistletoe with them, descend in a sort of Tartar majesty - grim, tawdry, and savage - through a grove of oaks. Only the heads and trunks of the fierce priests are seen, glowing with crude colour. This strange work is painted broadly, in the spirit of decoration; it is really, perhaps, a fragment of a frieze. It is extraordinary, but it would be useless to deny that it is effective. In Mr. Hornel's 'Among the Wild Hyacinths' (163) all is sacrificed to colour; a green girl and a blue girl stand in a green glade, with a purple carpet of bluebells at their feet and a vista of rosy cloud behind them. This is extravagant, but essentially right and artistic. Less can be said in favour of 'Audrey and her Goats' (109), by Mr. Arthur Melville. This picture is needlessly huge, for the subject is very slight. Audrey's red head is relieved against a background of red foliage of the beech, regardless of the fact that she and her goats stand in a meadow of the freshest emerald grass of early May. That the goats have only one leg each is really unimportant, but that in the leafy world spring should thus lose itself in coppery autumn is a blunder.[23]

In *The Magazine of Art* Walter Armstrong expressed somewhat similar views:

> Turning now to the young Caledonians to whom I alluded at the beginning of this article, by far the most daring performance they have sent in is 'Bringing Home the Mistletoe,' ascribed by the catalogue to Mr. George Henry and Mr. E.A.Hornel. It is seldom safe to speak warmly in praise of a skied picture. 'Hangmen,' as a rule, are not absolute fools, and when they hoist a canvas up to the ceiling they are apt to have a reason for it. The Grosvenor committee, too, has done its work on the whole very well. But in spite of all

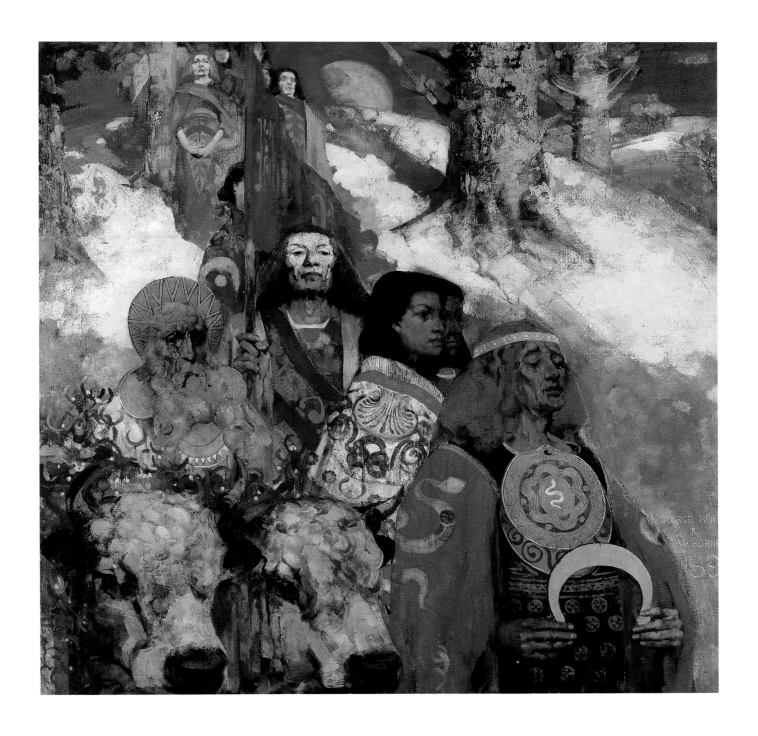

this I am not afraid to say that 'Bringing Home the Mistletoe' is a very promising production, and that its authors, or at least that member of the partnership who is responsible for the figures, should be looked after carefully in future. It is frankly decorative. The crimson and green and gold which are lavished upon it form its aesthetic *raison d'etre*. Mr. Arthur Melville's 'Audrey and Her Goats,' on the other hand, is neither decorative nor expressively true. Its general arrangement and constitution suggest that it was meant to be an ordinary *paysage etoffe*, but all that is contradicted by the colour. Strong reds, crude greens, a blue like the bunting of the blue ensign, are combined in arbitrary quantities and declare that, for their part, they are helping in a decoration. Clever as it is, this 'Audrey' is out of place in a picture gallery. It should hang in a room submissively arranged to suit it.[24]

PLATE 22
*George Henry &
E.A.Hornel*
The Druids: Bringing in
the Mistletoe *1890*

*Oil on canvas, 60 x 60
Glasgow Museums: Art
Gallery & Museum,
Kelvingrove*

Most of the criticism was in a similar vein, but not all. *Modern Society* considered that Hornel's *Among the Wild Hyacinths* (untraced) should have been better named 'Among the Wild Pigments', while the *Birmingham Daily Post* thought that the painting 'is not unpleasing in colour, though we should have taken it for jam roughly spread over the canvas' and went on to note that *The Druids* was 'mercifully hung rather high!'[25]

Among the visitors to the Grosvenor Gallery that summer were two Germans, Adolphe Paulus and the artist Walter Firle, representatives of the Munchener Kunstler Genossenschaft (Munich Artists' Brotherhood). They were in London to seek out work by British artists for inclusion in an international exhibition, which was to open later that year at Munich's Glaspalaste. They were so impressed with the Glasgow artists - their 'vigour of handling and richness of tone and colour' - that they invited them there and then to exhibit at the exhibition. Paulus and Firle travelled to Glasgow to view further work. Guthrie was responsible for most of the arrangements and he, Lavery and the dealer Alexander Reid travelled to Munich that September.[26] Virtually all the Boys, including Crawhall and Macgregor, who were not represented at the Grosvenor exhibition, sent work - a total of over eighty paintings - the majority of which had been shown in London. A number of other Scottish painters, including John Robertson Reid (1851-1926) and his sister Flora Macdonald Reid (1860-1938), as well as several of the *'Glue Pats'*, also were invited to exhibit.[27]

The Scots took Munich by storm; Sir James Caw described it as 'a veritable triumph.'[28] The exhibition was a revelation for the Germans, who had not heard of the Boys until then. A German critic Fritz von Ostini wrote '...it is really a complete and perfect work they have accomplished; it is in very truth a School of Glasgow which exists...' The Munich artists were especially impressed with the Boys' depth of colour: 'A surprising sense of splendour and power of colour, of a real, glowing passion for colour is peculiar to them...'[29]; 'Immeasurable is what can be learned from them, from their boldness in colour, their great intensity of feeling, their touching joy in what is beautiful.'[30]

Von Ostini went on to describe Hornel and Henry as '...perhaps the boldest colourists of the School of Glasgow.'[31] Hornel was represented by *Among the Wild Hyacinths, At the Oven* (untraced) and *Goats* (possibly *The Goatherd*, previously shown at the Glasgow Institute that year). Henry's exhibits included *A Galloway Landscape, Children in the Forest* (whereabouts unknown) and *Mushroom Gatherers* (private collection). However it was *The Druids* which attracted most attention: '...a glow of colour that even in these surroundings puts all others in the shade...The two artists have even ventured to

PLATE 23
George Henry &
E.A.Hornel
The Star in the East
1891

Oil on canvas, 78 x 72
Glasgow Museums: Art
Gallery & Museum,
Kelvingrove

use gilding in the picture, and its effect is splendid, just because the work is so great and peculiar in its naivete, so naive a means can be applied with excellent effect.'[32] Von Ostini wrote of Melville's *Audrey and her Goats*, which had been reviled by the critics when it was shown at the Grosvenor Gallery: 'Nothing greater could be imagined than the power of colour in this picture...[it] almost takes one's breath away at the first glance. And yet it is so full of poetry. A Hardumuth in Scotland!'[33]

Individual Boys had already won honours abroad. For example Lavery was awarded a Third Class Medal for *A Tennis Party* and Guthrie a *Mention Honorable* for *Un Verger en Ecosse* (*In the Orchard*) at the Paris Salons of 1888 and 1889 respectively. Lavery had also gained a Bronze Medal for *The Bridge at Grez* at the Paris International Exhibition in 1889. However it was the Boys' showing at Munich which brought them international acclaim for the first time. Several of the paintings were purchased for Munich's Pinakothek, including Lavery's *A Tennis Party*, which is now in Aberdeen. It is ironical indeed that the Boys, barely appreciated in their own country, had to go to Munich to be understood, something which was to be repeated some ten years later, when *The Four* - Charles Rennie Mackintosh, Herbert McNair and the Macdonald sisters - were lauded in Vienna and Turin, but treated with less than enthusiasm in Glasgow, where they had been given the nickname *The Spook School*. In his autobiography *Men and Memories* Sir William Rothenstein wrote 'I used to say of the Glasgow school, so much admired in Munich and Dresden, that their reputation was made in Germany!'[34]

The effect which the Boys had on contemporary German painting is summed up by Richard Muther, Professor of Art History at the University of Breslau, in his comprehensive *History of Modern Painting*, written in 1896:

And the powerful effect which was made when the Scotch gallery was opened in the summer of 1890 at the annual exhibition in Munich is remembered still. All the world then was under the spell of Manet, and recognised the highest aim of art in faithful and objective reproduction of an impression of nature. But here there burst out a style of painting which took its origin altogether from decorative harmony, and the rhythm of forms and masses of colour. Some there were who rendered audacious and sonorous fantasies of colour, whilst others interpreted the poetic dreams of a wild world of legend which they had conjured up. But it was all the expression of a powerfully excited mood of feeling through the medium of hues, a mood such as the lyric poet reveals by the rhythmical dance of words or the musician by tones. None of them followed Bastien-Lepage in the sharpness of his 'bright painting'. The chords of colour which they struck were full, swelling, deep and rotund, like the sound of an organ surging through a church at the close of a service. They cared most to seek nature in the hours when distinct forms vanish out of sight, and the landscape becomes a vision of colour, above all in the hours when the clouds, crimson with the sunken sun, cast a purple veil over everything, softening all contrasts and awakening reveries.

However he went on to add:

As the Scotch have made an annual appearance at German exhibitions since their first great success, the clamorous enthusiasm which greeted them in 1890 has become a little cooler. It was noticed that the works which had been so striking on the first occasion were not brought together so entirely by chance, but were the extract of the best that the Glasgow school had to show. And in regard to their average performances, it could not be concealed that they had a certain outward industrial character, and this, raised to a principle of creation, led too easily to something stereotyped. The art of the Continent is deeper and more serious, and the union between temperament and nature to be found in it is more spiritual. With their decorative pallet [sic] pictures this Scotch art approaches the border where painting ends and the Persian carpet begins. For all that, it has had a quickening influence upon the art of the Continent. Through their best performances the Scotch nourished the modern longing for mystical worlds of beauty. After a period of pale

'bright painting,' they schooled the painter's eye to recognize nature in her richer tints. And since their appearance a fuller ground-tone, a deeper note, and a more sonorous harmony have entered into French and German painting.[35]

Many in Britain at the time would have gone rather further than Muther and described Hornel's art particularly as totally akin to that of the Persian carpet!

Henry and Hornel collaborated on one further painting, *The Star in the East* (Kelvingrove, Glasgow, pl.23), which was completed in 1891. In contrast to the pagan theme of *The Druids*, it depicts a Christian message, the Angel announcing the birth of Jesus to the shepherds. *The Star in the East* is much larger than *The Druids*, but it is less impressive. The drawing is less assured. Perhaps because of its familiar story and the low-toned and limited colour range, it lacks the mystery and drama - the sheer visual impact - of *The Druids*. However it is a more ambitious painting. The two-dimensional, decorative qualities of the earlier work are emphasised further. The brushwork is bolder; in several passages the surface of the canvas is textured with a swirling pattern of thin pigment. *Quiz* reported that the painting had 'absorbed the entire time of these two devoted young artists for the past four or five months or so' and added 'It is certainly characterised by qualities calculated to shock conventional standards, but to say this, is only to take a negative view of the work, which, as an example of decorative treatment, combined with strength and individuality leaves the average 'picture' far behind, and places it in the higher category of art production.'[36] The painting was exhibited as *The Angel and the Shepherds* at the New English Art Club at London's Dudley Gallery the same year, the only occasion on which Hornel sent work. Not surprisingly it was the subject of 'a good deal of controversy.'[37] The general view was that it had failed on a number of counts. W.E.Henley in *The National Observer* compared the Boys unfavourably with Walter Sickert and his fellow artists:

But if the English group has made definite progress, the Glasgow painters belied the high hopes which their friends cherished for their future. They have not enslaved themselves to the method of Monet or Corot or Monticelli. But from the works of the Romantic School they have deduced a formula of their own, and to this they are resolutely bound...The most of them have at one season or another painted a good picture, and you would gladly spare them the tedium of repetition. Messrs. Henry and Hornel have failed more conspicuously than their colleagues, because they have attempted more. Their ambitious canvas entitled 'The Angel and the Shepherds', is entirely different in scheme from 'The Druids' of last year. It is thin in colour, confused in composition; and though it is obviously intended to be decorative, it woefully fails of its effect.[38]

Unlike *The Druids*, which was sold at the Grosvenor exhibition to the Edinburgh collector Robert Strathern, *The Star in the East* failed to sell. This was not entirely surprising as, priced at £500, it was the most expensive work by a wide margin. The painting became something of an embarrassment to the two artists. Henry wrote to Hornel:

I say things are getting very tight. I don't know how you are off down by, but it is pretty bad with me. The pinch is beginning to tell. Don't you think the White Elephant that was in the English Art Club might be sold. If Alex. Reid could sell it for £200, we might let him have £50. Twenty five % comm. seems to me good enough. What do you think. There is no use of the d--d thing taking up house room if a buyer can be found for it. Let us know by return your notion of the matter.

Henry added in a postscript 'I feel inclined to let it go for anything, no reasonable offer refused.'[39] It seems they were unsuccessful, because the following year Henry wrote in a postscript to a letter 'N.B. Most important thing last as usual! What do you think is the lowest price for 'Star' picture...We must part with it cheaply - or not at all. Give me an idea. I am prepared for anything - nothing can shock me now even to giving away with an ordinary 14x10.'[40] Reid eventually purchased the painting for £150.[41]

The two artists had collaborated on *The Druids* and *The Star in the East* on and off for a period of well over a year. At the same time they had been busy with their own work. Hornel was spending around eight months of the year in Kirkcudbright and the remainder in Glasgow, where he had been using a studio at 113 West Regent Street.[42] This was where Henry had his studio. Whether they were sharing the same studio is not clear (there was often a complex of studios at the same address), but it seems likely that they were. This close proximity to another artist at work was beginning to tell on Henry and about the middle of 1891 he moved out to Dunlop, a village in Ayrshire some fifteen miles to the south-west of Glasgow. He explained at the time:

[I intend] settling down here for a little time. I absolutely require to be near Glasgow to keep things going, as in a few months hence I shall have a heavier handful at home owing to various circumstances having occurred to my uncle in connection with his business. I require to make so much money in quarter or half year as the case may be, if I can do it by painting artistic things so much the better, if not - well so much the worse. I can live cheaper here also, tho' the place is not particularly fine for outside work...I have her [Nell, his model] down here, and expect in a few days to start and turn the boilers out at so much per week. I thought of coming to the old place, but as she was with me, I thought it better to come here instead.[43]

However at the end of that year Henry admitted to Hornel there was also another reason for his move to Dunlop:

Evidently, from your letter, you did not get along with MacGeorge. Nothing I suppose in the way of a rupture has taken place in your friendship, as that would be a thing to be regretted, tho' one would infer from the terms you call him, that a serious turnup had taken place. This fact, that after all it is impossible for 2 fellows to work together, at least for any lengthened period, was growing in upon me last year and all this spring. This

affair with MacGeorge only bears it out. It may do for a little time, but after the novelty wears off, one finds - thro' a thousand and one little things, that to produce anything, or get a favourable environment for, it is absolutely necessary to be alone where you work. This is one of the reasons why I am here this season.[44]

Henceforth they were to spend less time painting together, although they remained very close friends.

By this time Hornel was working at full stretch. *The Brook* (1891: Hunterian, Glasgow, pl.24) had been completed by the end of 1890 and was exhibited at the Glasgow Institute in 1891 (the opening had been brought forward to December 1890) along with *Among the Wild Hyacinths* (shown at the Grosvenor Gallery and in Munich) and *Butterflies* (untraced). *The Brook* displays a strong Japanese influence: the winding stream, the stylised trees, the posture of the girl standing on the left, wearing a *haori* jacket. The work is very broadly handled, the brushwork very varied. Form has been sacrificed to colour and pattern. Although it is a continuation of his preoccupation with girls in a landscape, Hornel's aim is not merely decoration. The painting is loaded with symbolism. It has the same air of mystery as *The Goatherd* of 1889, but with the addition of the dark blue winding stream - seen in *The Brownie of Blednoch* and Henry's *A Galloway Landscape* - dividing the composition into two halves, the girls on the right bank dressed in Western clothes and the girl on the left dressed in Japanese costume. Although it is often dangerous to speculate on the intended meaning of a painting, C.J.Allan has suggested in the guide to the Hunterian Art Gallery that the theme is that of 'innocence and experience, of the awakening conscience, and of the spiritual and carnal duality of life':

> The foreground girl, rather suggestively drawing a fruit to her open mouth, under a darkening sky, is redolent of images of Eve at the Tree of Knowledge. This impression is reinforced by the serpentine writhings of the tree-trunk, the outline of her skirt, and the brook itself, which separates her from the other girls. Of these, one observes her with frank attention, and will surely cross the brook herself one day. The other turns her gaze away, towards the most distant figure, who, bathed in light, sits Buddha-like in contemplative profile.[45]

There is a similarity in style between *The Brook* and work of the same period by Charles Mackie, such as his oil sketch of 1891 *The Bonnie Banks of Fordie* (Hunterian, Glasgow). Hornel and Mackie had been friends since student days and they were still corresponding.[46] Mackie had visited Kirkcudbright on a number of occasions and it is possible that they may have been exchanging ideas around this time.

Familiar by now with Hornel's colour harmonies, the critics in general viewed *The Brook* favourably. *The Magazine of Art* commented:

> Some of the most fascinating subjects in the exhibition are by Mr. E.A.Hornel. He exhibits a picture of girls 'Among the Hyacinths,' seen last year at the Grosvenor; but since then his art has developed, and he attains far greater potency of decorative colouring - colour of definite force, and excellently varied, laid in the most telling juxtaposition, patch by patch, like mosaic work - in 'The Brook' and 'Butterflies.' Similar subjects, and less powerful treatment upon similar lines, are visible in the contributions of Mr. Henry George [sic].[47]

The critic of *The Academy* considered that his only aim '...to develop the splendid technical possibilities of colour...has been excellently attained in 'The Brook' and 'Butterflies'...'[48] *The Evening Citizen* was not so sure: 'Two curious pieces of fantasy, 'Blowing Dandelions' (No.109), and 'The Brook' (No.114), maintain the reputation gained a year ago by Messrs. Henry and Hornel for 'Cinderella' and the 'Girl with Goats.' Both works are bizarre, mannered, and uncommon to a degree. They are at once plucky, powerful, and impertinent - and are possessed withal by a strange and almost

weird and uncanny charm.'[49] *The Brook* was purchased for £30 by Herbert McNair. It is tempting to speculate what effect, if any, this painting, and, for example, *The Druids*, may have had on *The Four*, who shortly were to develop their own mysterious symbolism in the early watercolours.

The Goatherd, Galloway (c1891: private collection) is similar to *The Brook* in terms of style and breadth of handling. Yet again the dark blue meandering stream is a feature. In its flat forms, harmonious colours and curving lines it is not too far from the style of the so-called Pont-Aven School. Working in Paris and at Pont-Aven, a small village on the River Aven less than five miles from the south coast of Britanny, Paul Gauguin, Emile Bernard and their circle had put aside the restraints of academic art and evolved between 1888 and 1895 a theory of painting called Synthetism. Drawing on sources as varied as the work of the Italian Primitives and the Japanese print, their aim was to create a synthesis between impressions of nature and abstract forms. Although they believed in the close observation of nature, Gauguin and his friends felt that the artist should allow the initial impression to mature in the mind and thereafter execute the painting in the studio from memory. Simplification, rearrangement, even distortion were allowed, so that the final work would accurately convey the artist's initial impression, even if it did not exactly reflect the subject itself. Features of Synthetism are its two-dimensionality, and rhythm and harmony of design in terms of line, colour and form. Design is more important than representation.

Whether Hornel could have seen at first hand the work of Gauguin and Bernard before the middle of 1891 is not known. However it seems likely that Hornel did visit Paris then in the company of Henry, Macgillivray, the architect John Keppie and possibly one or two of the other Boys. In a letter dated 12th May 1891 Henry wrote to Hornel 'We are not going South till end of month. It seems to suit Pittendreigh & Keppie much

PLATE 25
Woman and Child
1891
Oil on canvas, 18³/₄ x 20³/₄
Private Collection

67

better. Will it do for you as well?' In a later letter, which, though undated, appears to refer to the previous letter, Henry wrote 'We leave tomorrow (Wednesday) by the Caledonian from Central Station at 2 o'clock. This is the only train will suit the majority of the party...', adding in a postscript 'Bring enough £.s.d. to go on to Paris.'[50] On the back of the letter Hornel has scribbled in pencil the timetable for the train *returning* from Paris to London, which seems to indicate that they did go to Paris. Consequently there is every likelihood that at least they would have heard about, if not seen, what Gauguin was doing. *Woman and Child* (1891: private collection, pl.25) would appear to confirm this. In style it is very similar to the work being done by Gauguin and Bernard at this time. It is a rather expressive painting. The pigment is very freely handled, the rich colour applied both in broad flowing brushstrokes and in small patches. In several areas Hornel has given the surface a textured appearance. The pose of the woman and the little girl standing on the treeless hillside, bound together in the blustery wind by the long white shawl-like material billowing over their heads, the dark meandering stream, the winding path and the curve of the horizon all combine to give the painting a wonderful flowing rhythm. The drama is heightened by the appearance of the moon just above the horizon and the pink glow of the sunset reflected in the clouds.

1 The text is taken from the *Dumfries and Galloway Standard and Advertiser*, which in its issue of 21 September 1984 published a manuscript version of the poem discovered by the late L.L.Ardern, librarian at Broughton House. Billcliffe notes that the poem was written and privately published in 1888, but no printed version has been traced. However the date of the poem may be a few years later, because the author has been unable to discover any work with goats by Hornel before 1889.

2 A S Hartrick, *A Painter's Pilgrimage Through Fifty Years*, Cambridge, 1939, p.59

3 Jennifer Melville, *James Pittendrigh Macgillivray*, Aberdeen Art Gallery exhibition catalogue, 1988, p.7

4 Hardie records that S.J.Peploe's wife Margaret asserted that Reid knew Gauguin in Paris - see William Hardie, *Scottish Painting:1837 to the Present*, London, 1990, p.98

5 Undated letter from George Henry to Hornel (Hornel Trust); an article on Henry appeared in *Quiz* dated 19 April 1889

6 Hartrick, op.cit. p.61

7 *The Scotsman*, 7 February 1890

8 Newscutting Book (1890) (Hornel Trust)

9 *The Academy*, 22 February 1890

10 *Quiz*, 14 February 1890

11 *The Academy*, 22 February 1890

12 *Kirkcudbrightshire Advertiser*, 28 February 1890

13 Neil Munro, *The Brave Days*, Edinburgh, 1931, p.234

14 Ibid., p.268

15 Macaulay Stevenson manuscript notes; I am grateful to William Hardie for allowing me access to his notes

16 Newscutting Book (c1888) (Hornel Trust)

17 *Kirkcudbrightshire Advertiser*, 11 February 1887

18 Geoffrey Stell, *Exploring Scotland's Heritage: Dumfries and Galloway*, Edinburgh, 1986, p.164

19 Hartrick, op.cit., pp.60-61

20 Susan P Casteras & Colleen Denney (ed.), *The Grosvenor Gallery: A Palace of Art in Victorian England*, New Haven, 1996

21 Walter Shaw-Sparrow, *John Lavery and His Work*, London, 1911, p.61

22 Roger Billcliffe, *The Glasgow Boys*, London, 1985, p.293

23 *The Saturday Review*, 10 May 1890, p.565

24 *The Magazine of Art*, 1890, p.326

25 *Modern Society*, 24 May 1890; *Birmingham Daily Post*, 3 May 1890

26 Sir James Caw, *Sir James Guthrie*, London, 1932, pp.60-1

27 The author has been unable to find a catalogue of the Munich exhibition, but has used the list of works detailed in Billcliffe, op.cit., p.312, together with additional works mentioned in contemporary newspaper reviews

28 Caw, op.cit., p.61

29 *Scottish Pictures: What the Germans Think of Them, No.1, The Weekly News*, 20 September 1890 (translation of an article by Fritz von Ostini in *Munchener Neuste Nachrichten*)

30 *Scottish Pictures: What the Germans Think of Them, No.2, The Weekly News*, 27 September 1890 (translation of an article by Fritz von Ostini in *Munchener Neuste Nachrichten*)
31 Fritz von Ostini, op.cit.
32 Ibid.
33 Ibid.
34 Sir William Rothenstein, *Men and Memories*, vol.I 1872-1900, London, 1931, pp.176-7
35 Richard Muther, *History of Modern Painting*, vol.III, London, 1896, p.688
36 *Quiz*, 3 April 1891
37 *The New English Art Club, Literary World*, 17 April 1891
38 *The New English Art Club, The National Observer*, 25 April 1891
39 Letter from George Henry at Dunlop to Hornel dated 15 September 1891 (Hornel Trust)
40 Letter from George Henry to Hornel dated 8 July 1892 (Hornel Trust)

41 Records of Art Gallery & Museum, Kelvingrove, Glasgow
42 Undated letter from George Henry to Hornel (probably September/October 1890) (Hornel Trust)
43 Undated letter from George Henry to Hornel (probably July 1891 - he wrote a subsequent letter to Hornel from Dunlop on 1 August) (Hornel Trust)
44 Letter from George Henry to Hornel dated 7 December 1891 (Hornel Trust)
45 *A Guidebook to the Hunterian Art Gallery of the University of Glasgow*, 1991, p.56
46 There are at least seven letters, dated from July 1883 to December 1894, in the archives of the Hornel Trust at Broughton House
47 *The Magazine of Art*, February 1891
48 *The Academy*, 3 January 1891
49 *Evening Citizen*, 17 January 1891
50 Letters from George Henry to Hornel (Hornel Trust)

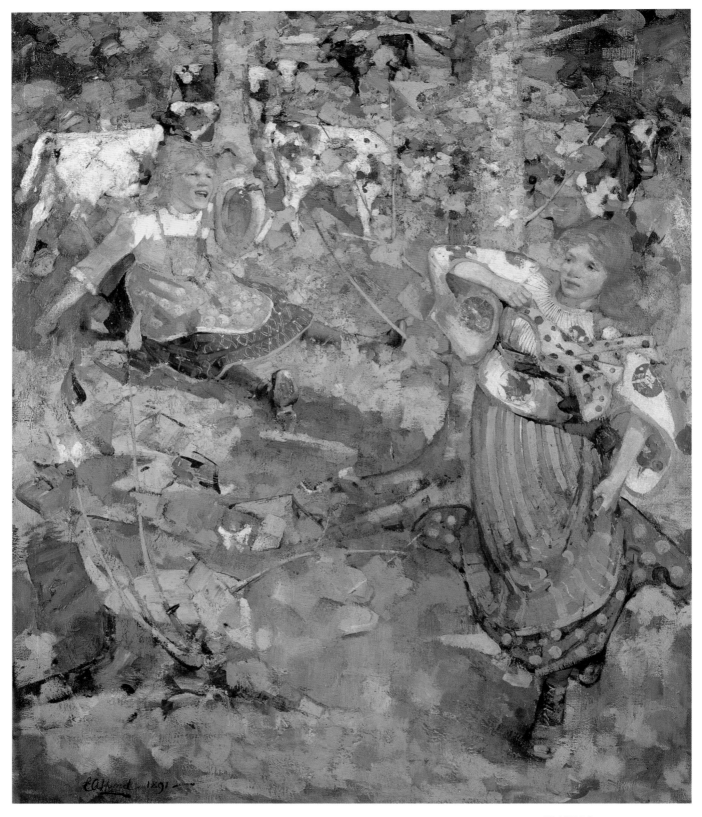

PLATE 26
Summer *1891*
Oil on canvas, 50 x 40
National Museums &
Galleries on Merseyside

'SUMMER'
1892

1892 WAS A MEMORABLE YEAR FOR HORNEL. HE WAS TO EMERGE FROM relative obscurity to become one of the most talked-about British artists of the year. Over a period of eighteen months or so he completed two major works: *Summer* (1891: Walker, Liverpool, pl.26) and *Springtime* (1891-2). When *Summer* was exhibited in Liverpool in the autumn it caused a sensation. Many of the public considered that it was a wonderful painting, but the vast majority were less complimentary.

Hornel sent two works to the Glasgow Institute that year. A small painting *In the Orchard* (untraced) portrayed girls in an orchard 'planted with impossible trees bearing impossible fruit.'[1] The *Glasgow Herald* describet it as '...a study of lovely colour, and furthermore of graceful line in the treatment of the figure... Mr Hornel's seeming chaos is really artistic harmony, its discords held together and finely attuned.'[2] However his main exhibit that year was *Summer*, which was his most ambitious painting to date and stands as one of his finest and among the most important executed by the Boys. It depicts two girls playing on a hillside. Looking on are a number of cows amongst the scattering of trees in the background. The girl on the right appears to be chasing white butterflies, perhaps flicking her gaily coloured handkerchief at them. Seated on the ground a little further up the hill, her companion seems to be singing or shouting. In terms of subject matter it is an elaborate re-working of the much smaller *A Galloway Idyll* of the previous year. *Summer* is a masterpiece of decoration, a riot of pattern and rich harmonious colour. Within a strong overall design the carefully executed figures contrast vividly with the broad handling of the abstracted foreground and the melange of fragmented images of cows and trees in the background. The flattened perspective and the high horizon of previous work is repeated. There is a fine feeling of movement, something which Hornel, in contrast to Henry, imparted in much of his work of the 1890s. The influence of Japanese art, particularly the Japanese print, can be seen in the design of the composition, in the curving pose of the girl on the right and in the decoration of the clothes she is wearing. It is an exuberant evocation of a carefree summer day.

Summer was exhibited at the Glasgow Institute in 1892. *The Dumfries and Galloway Saturday Standard* noted:

> Local artists are not so well or so numerously represented as at the Scottish Academy, yet one of them enjoys the proud position of having, in the opinion of most of the artists, the picture of the year, and the public seem decidedly of the same mind. At the private view, and at the conversazione...Mr Edward Hornel's 'Summer,' No.167, was the one work in the galleries around which a crowd was constantly gathered.[3]

However the paper did not report what the public actually thought of the painting. In general it was well received by the critics, although not entirely for the reasons Hornel might have wished. The *Glasgow Herald* described the work as:

> ...a conspicuous example of the new school, whose chief end is brilliancy of colour. This, at any rate, *was* the first aim of Mr Hornel and others, who, like himself, must be credited with single-minded devotion to their art. In 'Summer,' however, we find a distinct advance in the direction of beauty of form. The figure of the girl on the right of the picture, as she skips through the wood in the ecstacy of youth and the season of flowers, is indeed poetical as well as graceful. So much reveals itself without much examination, but the leading *motif* of the work - the carefully thought out relations of the chromatic colour scheme and its resultant harmony, the *soupcon* of mediaevalism which lifts these children

of the leafy glade above the common level of rusticity - only becomes manifest to the trained eye. The faults of the picture, as in its formal draughtsmanship, lie on the surface. They are the faults of archaeology rather than of art.[4]

The critic of the *Glasgow Evening News* wrote: 'Mr Hornel's 'Summer' is a Monticellian delirium of colour, and it is this aspect which first strikes one. But it is more than that. It is a bold and healthy man's impression of Nature. It suggests in an irresistible way the sweet influence of sunlight, and in a subtler way than Mactaggart's [sic], the mystery and poetry of childhood.'[5]

It was quite another story, however, when *Summer* was shown the same year at the Autumn Exhibition at the Walker Art Gallery in Liverpool. The Boys had been invited to show as a group at this important annual exhibition. Henry wrote to Hornel:

> However what I want to see you about is regarding Liverpool. Patterson [sic] has seen Rathbone and there is a chance of the boys getting a room to themselves if they send in a body. We are going to talk the matter over. I suppose you would be willing to show along with the rest. I am writing Kennedy on the same errand. I think we would also get a representative [on the hanging committee], or the hanging could be done here, and a diagram of the positions of the rooms sent to Rathbone. Please reply by return to the Club, if you are on.[6]

Whether the idea was initiated by the Boys themselves or by Philip Rathbone, the Chairman of the Arts and Exhibitions Sub-Committee of Liverpool Corporation, is uncertain. As a Liberal member of the Council (and subsequently an Alderman), Rathbone had been a dominant influence on the Walker Art Gallery from its inception in 1871. He was described later as the 'practical dictator of the Art and Exhibitions Sub-Committee, who admitted his knowledge and somewhat grudgingly trusted his judgements, though his choice of purchases oft-times brought opprobrium upon their heads from people, press and pulpit.'[7] A 'rare combination of the bohemian and the committee man', Rathbone visited most of the exhibitions and artist's studios every year during his term as Chairman, seeking out work for inclusion in the Autumn Exhibition.[8] Thus he would certainly have been aware of what was going on in Glasgow at the time and may have made the first approach. On the other hand it may have been James Paterson who broached the subject, having a connection with Liverpool through a local collector, who had purchased work by him.[9]

In any event it fell to Henry to do a lot of the running around. He wrote to Hornel in July: 'Negotiations have been opened with Liverpool regarding their show and the boys getting a room. The difficulty seems to be to get together sufficient pictures. However I shall let you know the result of Rathbone's reply in a day or two.'[10] Agreement must have been reached, because Henry was able to write at the end of August:

> However I got the Liverpool bis all settled up. I had an awful trouble about your own pictures, and the others that happened to be lying in Reid's place. Alex. went off with the key of the Beaux Arts, and I could not get in to send off the pictures - all the time the Liverpool Secy raised old Harry about things being late. At last old Reid got a key to open the rooms, but when I got Davidson's men to come for the pictures he refused to let them be taken away, saying he did not receive any instructions from Alex. he would not part with [sic]. However after a day or two worrying at him I got them off all right except one of Waltons that I got no instructions about, and dont know whether it belongs to Reid or not. But it can't be helped I did what I could, and it cost me a perfect mine in Telegrams and about the loss of a fortnight's time...[11]

In the same letter Henry went on 'I hear that you have got some stunning work and I am delighted. I hope that you will have something strong for Edinburgh. Guthrie was just saying so the other day to me, as he would like to get you run in. I hope so.' That year, much to his astonishment, Henry, along with Lavery, had been elected one of six new

Associates of the Royal Scottish Academy. It was hoped that Hornel's membership would follow.

Unfortunately the Boys' work was not concentrated in one room:

> A word about Liverpool. Guthrie was there. They seem to have got a scare over the Glasgow work. Stott [William Stott of Oldham, one of the hangers that year] has not been able to get us all together in the one room. He has got a number of us in a small room painted in dark grey-green colour and another he'd hung on the end wall of a large gallery the end painted the same grey colour. The rest are scattered all over the galleries. Poor Kennedy has suffered again. It's infernal somehow that he should always bear the brunt. His cow picture Stott swears was hung on the line by himself - but Stanhope Forbes (who by the way is cussing us as hard as he can) and the other Committee men hoisted it a little abun the line...[12]

Henry attached a rough sketch of the layout of both rooms. It is not surprising that some of the other artists were jealous that the so-called Glasgow School were being given such prominence and were anxious to frustrate the efforts of Stott, who was a good friend of the Boys.

The work of the Boys - in particular Hornel's *Summer* - became the subject of considerable controversy as soon as the exhibition opened. *The Liverpool Echo* set the tone:

> The battle is likely to centre this year chiefly around the remarkable productions of the 'Glasgow school,' a knot of young painters whose work, containing though it does distinct evidence of power and originality of conception, is marked by an eccentricity of treatment which many - probably the majority - of those who view their pictures will find very difficult of acceptation. The 'steepest' work of this school is undoubtedly Mr. Hornel's 'Summer,' (1,123), which was overheard to be compared by one spectator, not altogether unreasonably, to an old woman's patchwork quilt, while another onlooker, with even yet nearer approach to *vraisemblance*, remarked that at a little distance it might easily be mistaken for a landscape 'sampler' such as our great grandmothers were wont to work in their long winter evenings.[13]

The critic of *The Liverpool Courier* commented:

> [*Summer*] is one of the most prominent examples of the more wilfully eccentric Glasgow manner, of which it would seem that the aim is to adapt the decorative methods of the far east to the treatment of things occidental. Perspective and atmospheric values are lightly considered and everything is subordinated to the quest for a gorgeous colour combination, made more bizarre in effect by arbitrary use of dark lines like the leading of a stained window. The result is hopelessly unlike anything that our art has taught us to see in nature, for which reason grave doubt may be entertained as to the sincerity of the effort. It has not come as the result of earnest striving after truth, but rather the artist may be suspected to have said, 'Come, now I shall be Japanese, to show my cleverness.' The fact remains, however, that, as to colour, the picture is a remarkable one, and in this respect, too, the same artist's 'The Shepherdess' and 'Among the Hyacinths' justify their existence. The last in particular is as beautiful as any piece of Japanese colour; more it does not pretend to be.[14]

Weaned on the highly finished work of the Academy painters, the majority of Liverpool's citizens were totally unprepared for the 'mere daubs' of the Boys, which had no obvious story to tell. They simply did not know what to make of them. Their attitude to art was summed up well by the critic of *The Bailie*:

> The pictures of the 'Glasgow School' have fluttered the dovecots of Liverpool artistic circles. It is little wonder! Liverpool, much as it has posed as an artistic centre, is simply in its Exhibitions a reflex at second hand, of the Royal Academy. In the city by the Mersey, no independent school of art exists; its gods must bear behind their names R.A. or, at least, A.R.A., otherwise 'the rascal many' fails in reverence. No artist from north of

the Tweed, no matter what his merits or his method may be, can command in Liverpool, the tithe of the respect that is paid to the veriest dauber who can boast the wearing of the honours of the Royal Academy.[15]

The critic D.S.MacColl wrote in *The Spectator*:

Those Glasgow pictures differ in kind from most of the works round about them, and the simplest visitor sees so much. What is the difference? It is the radical difference between painting that is imaginative, and painting that is poor photography. It consists in this, that the artist has digested nature; that, instead of timidly walking around an object, making a try at it here, and a dab at it there, he has made up his mind what he wants from the object, what in the object impresses him or amuses him. Therefore, being thus clear, he can play with it, *make an image out of it*. He has formed for himself a clear image of a Tree, a Cow, a Field, a River; he takes of them a characteristic action and a pleasing colour pattern, and he plays with his images as a musician with notes. And this invention, this sport of fancy in the selection of the character and the action of the image, bring in the element of strangeness beside the element of likeness when a familiar scene is handled. Messrs. Henry and Hornel give us pastorals from Ayrshire, but they are also pastorals from Wonderland. That is what the puzzled citizen means when he says: 'Those cows are like cows out of a Noah's Ark.' Of course they are. The cows of a Noah's Ark have more of the stuff of Art in them than the cows of Mr. Sidney Cooper.[16]

Controversy became a crescendo of protest and abuse when it became known that *Summer* was one of four paintings in the exhibition which the Library, Museum and Arts Committee, of which Rathbone was deputy Chairman, had recommended should be purchased for the permanent collection of the Walker Art Gallery. During September and October arguments for and against *Summer* raged in front of the painting, in the newspapers and in the Council Chamber. Admissions to the gallery soared, prompting the comment that the price of £100 for the painting was well worth paying in return for the huge increase in the shillings taken at the door.[17] The local newspapers carried editorials on the subject and published many lively letters from readers. The comments were not all unfavourable by any means. Although the majority of writers could see neither meaning nor merit in the painting, a minority supported the purchase or the right of the Committee to decide on acquisitions without having to seek the approval of councillors who did not know anything about art. However when the Committee's recommendation was debated by the full Council on 5th October - a discussion which had, in the waspish words of Edinburgh's *Scottish Leader*, '...an eloquence akin to that which enlivens the civic debates at Leith...' - the councillors were totally opposed to the purchase with the sole exception of Rathbone.[18] The matter was referred back to the Committee for further consideration.

Much of the public debate was carried on in the columns of the city's satirical paper *The Porcupine*, in which, under the banner *Art and Insanity at the Walker Gallery*, 'Gamboge' immediately adopted the role of principal dissenter:

This is not a criticism; it is an indictment. Many admirable and faithful examples of the painter's art are hanging on the walls of the Gallery. These will receive their well-earned meed of praise...But there are blemishes which, in the interests of sane art, must be exposed. This is an age of shameless advertising eccentricity, and it is painful to confess that artists, both graphic and plastic, are among the worst offenders...The 'Glasgow School' of painters are not incompetent daubers. They are very clever young men, who have taken a lesson in advertising from the soap boiler and the quack medicine vendor. When the praises of the 'superior persons' have blown them into notoriety, they will begin to produce sane work and thus secure sane admirers.

The *Porcupine's* editorial ended:

I do not intend to deal seriously with the 'Glasgow school.' I have not the space, nor am I in the mood for the ponderous fooling which such a criticism would involve. Doubtless

Mr. Hornel's 'strawberry trees' - as I heard a child call them - his ruddy Summer landscape - does it depict a hot day in Mars? - and his truly precious calves, are the joy of the elect. Into such high and holy pleasures a common person, such as myself, cannot enter. I congratulate the Arts Committee on the rapidity of their artistic education. Last year they had progressed to the level of the 'Whistler Room;' this year they have bounded to the dizzy height of the 'Glasgow School.' What worlds, I wonder, will they conquer next year?[19]

The following week *The Porcupine* carried a cartoon of *Summer* with the various elements labelled for the benefit of the uninitiated![20]

The Porcupine continued to poke fun at the Boys - particularly Hornel - on and off over the next five or six weeks, typified by the following 'news report'[21]:

THE GLASGOW HORROR.
AN UNFOUNDED REPORT.

On Thursday the *Daily Post* placards posted all over the town bore two large lines as follows:-

THE GLASGOW HORROR.
TWO ARRESTS.

In some strange way a rumour immediately became current that the authorities had at last brought Mr. Hornel and Mr. Guthrie to book. It was even said that they would be brought before Mr. Philip Rathbone and the Bench next morning. Inquiries, however, revealed the fact that the *Daily Post* poster did not refer to the artistic misdemeanours in the Art Gallery, but to a murder committed in the city of Glasgow. We think it only right to give every currency to this explanation in the interests of Messrs. Hornel and Guthrie.

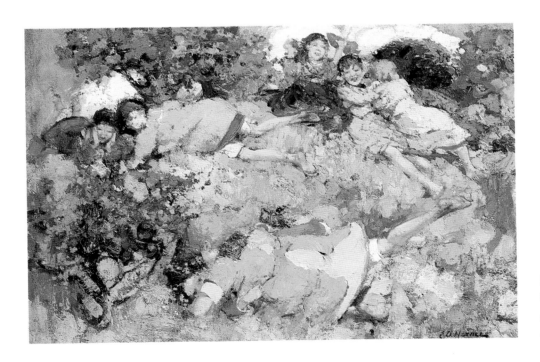

PLATE 27
Children at Play *1892*
Oil on canvas, 16 x 24
Flemings

The paper published a poem on the subject of *Summer* by a local wag, who called himself *A Bidston Philistine*:

> I'm a clever Artist's fad,
> A kaleidoscope gone mad,
> Folks gaze at me with merry gibes and scorn,
> For 'tis useless to dissemble
> That I very much resemble
> Slabs of malachite or chequered slice of brawn.
>
> People stare and raise their brows,
> And say, 'Bless us! are those cows?
> 'Well really now we never should have thought it
> 'That such startling greens and blues
> 'Could exist in bovine hues
> 'If our clever Mr. Hornel hadn't taught it.
> 'Sure Paul Potter's brain had reeled,
> 'Had he met such beasts afield,
> 'Their weird fantastic colours to espy;
> 'Whilst the eye of Sidney Cooper
> 'Would have gazed with awe-struck stupor
> 'As the blue and green and yellow herd swept by.'
>
> Though a faithful few are found,
> Yet my enemies abound,
> My pride and self-esteem have long departed;
> Let me seek some quiet spot
> Where the Philistine is not,
> For his flouts and jeers have left me broken-hearted.[22]

It is doubtful whether all the criticism and abuse had made Hornel himself broken-hearted. However it would require a strong character and a great deal of self-faith not to be depressed by this barrage. Certainly Hornel put on a brave face in public. *The Daily Post* reported:

> Mr. Hornel is by no means discouraged by the harsh criticism to which he is being subjected just now. He simply replies to his critics that they are not competent to express an opinion, and, therefore, their harsh remarks are unworthy of consideration. They have had this effect, however, they have led to the sale by him of every one of his unfinished works.[23]

The furore prompted the novelist and art critic George Moore to write a long, well-reasoned article in *The Speaker*, entitled *The Alderman in Art*. He argued that great art collections had always been built up by a succession of dedicated *individuals* and that public collections should be no different in this respect. A public gallery could not be managed by a committee of aldermen 'wise or foolish, ignorant or learned.'[24] His case was irrefutable, but the present cause was not helped by Moore getting some of his facts wrong. Liverpool artists themselves rallied to the aid of Rathbone. Seventeen of their number signed a memorial to the City Council, urging the purchase of Hornel's *Summer*, as well as William Stott's *The Alps by Night*, which was also a matter of contention.[25] Rathbone himself attempted to counter the barrage of criticism by letters to the newspapers and by giving a talk at one of the Walker Art Gallery's soirees, as well as a lecture at the Gallery on the work of the Boys (misleading his audience by describing the subject of *Summer* as 'two children frightened by a drove of black and white calves!')[26]

James Paterson also entered the fray, writing two letters to *The Porcupine* under the pseudonym 'Nemo Me Impune Lacesset'. However in the eyes of some of the other Boys he did more harm than good, attempting to distance the Boys from Hornel:

The virile examples of Mr. Hornel's brush must stand by themselves; it were as absurd to lay all the sins of Lord Randolph Churchill at the door of the Conservative Party, or Mr. Labouchere's divagations on Mr. Gladstone's shoulders, as to blame Mr. Guthrie, Mr. Roche, or Mr. Paterson with the supposed crudities of their friend.[27]

Henry was incensed by Paterson's letter, writing to Hornel:

I really dont want to appear harsh and unjust (I have been so often for the last 18 months or 2 years, but with one unforseen thing and another coming against me I have been almost off my head - considerate judgement was difficult to me) but I must say that my opinion is that Paterson sees what I mention at top of page [Hornel's membership of the Royal Scottish Academy] to be a contingency certain to take place, and is endeavouring to spoil your chances and better himself at same time...Macgregor called on me the other day...and Kennedy & he are stinking at 'Nemo' letter. None of us at the time knew the culprit but we all suspected Paw P. [Paterson]. Paw's name was the first that Guthrie mentioned. I hold that if one of the School discovers another in this way he be asked to retire from the gang. Kennedy & Macgregor are going to bring the matter up.

In the same letter Henry commented that Hornel's chances of getting into the Royal Scottish Academy had been improved by all the publicity:

Yes Ned this Liverpool bis is really first rate. They will buy your picture in the end. I think it is a beautiful working out of a plot. 'There's a divinity that shapes our ends etc.' You see if this picture is bought - even if not (look at the talk & publicity) what will occur at the Academy meeting you will have the pull on all other candidates.[28]

At the next meeting of the Council on 26 October the proposed acquisitions were tabled again. It boiled down to whether or not Hornel's *Summer* should be acquired for the permanent collection. The general feeling of the meeting was very much against both Hornel and his painting. One councillor felt that they 'ought not to permit themselves to be either wheedled or coerced to purchase such an eccentric abortion as Mr. Hornel's 'Summer' and it had been his hope that the experience of last Council's proceedings would prevent the application being made again.'[29] It appeared that the battle had been lost, until Rathbone made it a matter of confidence in the Committee, saying that he would resign if the recommendation was rejected. A majority of the Council felt that that was too high a price to pay and the acquisition was agreed.

Rarely had an artist been so vilified, rarely had a painting been so ridiculed. Hornel himself had decided to keep well clear of Liverpool, no doubt considering that his presence there would only inflame the situation.[30] However it had all come right in the end, as Henry, more in hope than expectation, had said it would. *Summer* was the first work by one of the Boys, excluding commissioned portraits, to be purchased by a public gallery in Britain (although already several had been acquired by continental galleries). The Boys were delighted. Guthrie wrote: 'Congratulations, my dear Hornel. Out of evil cometh good. All's well that ends well. Look at the 'Spectator' & the 'Speaker' last week. Let them boom away & curse the Aldermen etc.'[31] Henry, who had been very ill for some months and had just been diagnosed as having acute inflammation of the prostate, sent his congratulations: 'Being out of the world here [the family home in Glasgow] I have just heard that the Cor.n of L.rpl have bought your Summer. Delighted & only sorry you dont finger the rhino.'[32] The painting had been purchased by Liverpool for £100, but it seems from Henry's remark that this sum was used to meet Hornel's debts. Certainly both artists were still hard up, particularly Henry, who, because of his illness, was able to work only very sporadically at this time.

The whole affair had two positive results. It confirmed that for a 'Council as a body to debate matters of art criticism in regard to which the majority of its members have neither knowledge nor experience is about as unhopeful a proceeding in the art interests of the city as could well be imagined.'[33] It also made the public more aware of Hornel and his

PLATE 28
In an Orchard *1891*
Oil on canvas, 46 x 33
Private Collection
(overleaf left)

PLATE 29
The Dance of Spring *c1891*
Oil on canvas, 56 x 37$^1/_2$
Glasgow Museums: Art Gallery & Museum, Kelvingrove
(overleaf right)

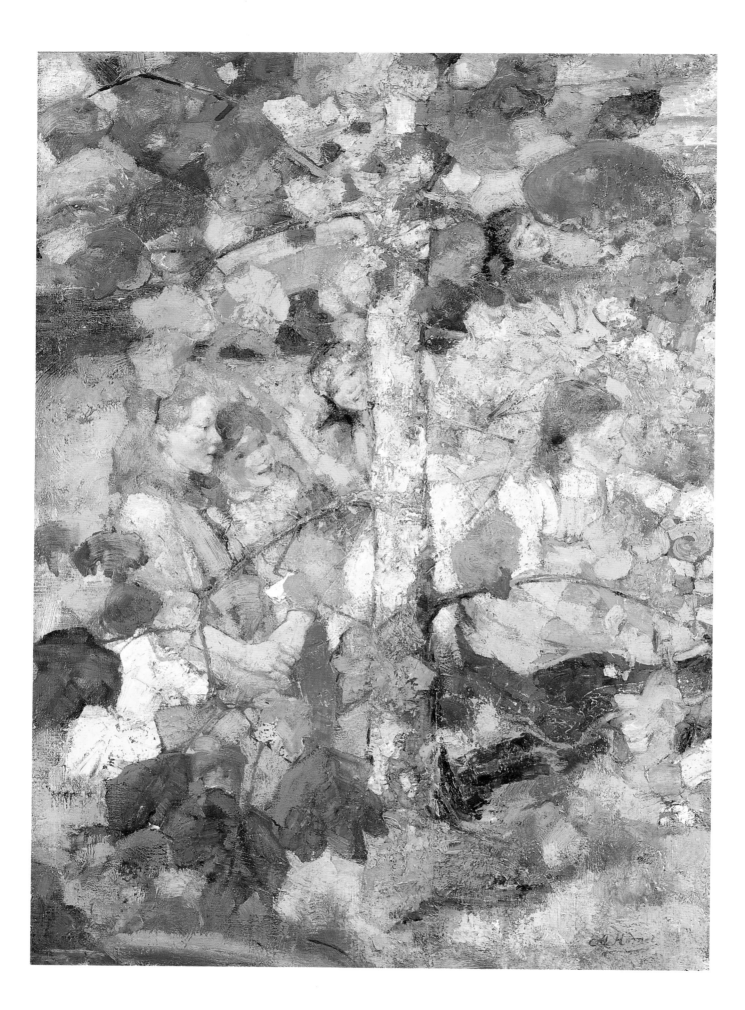

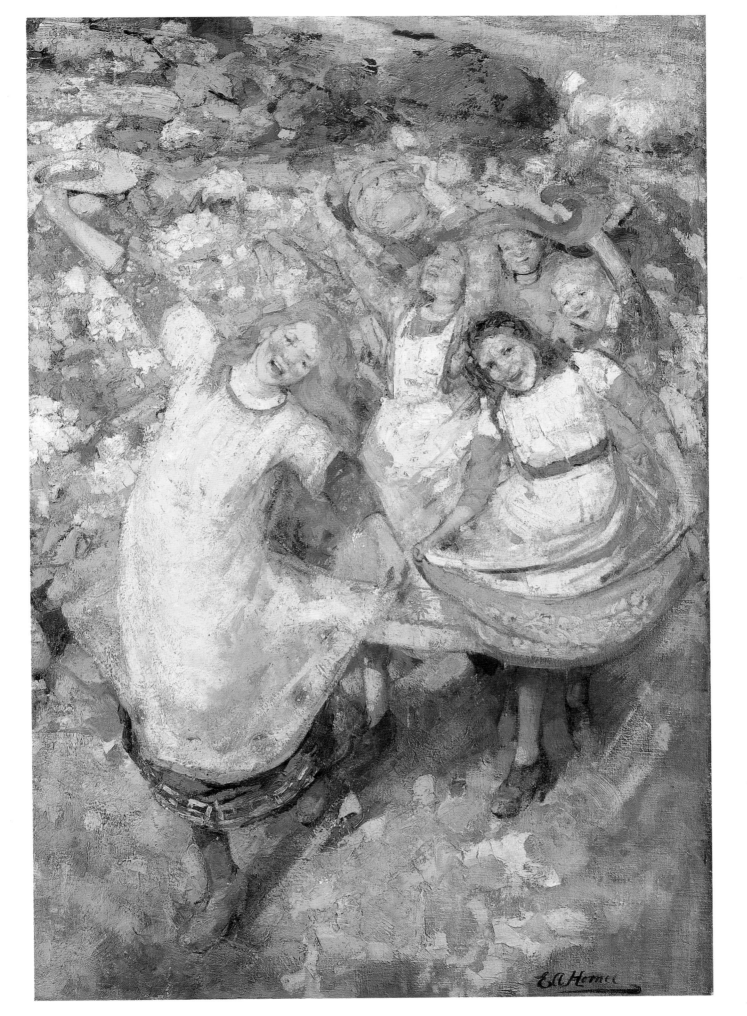

work. His standing as an artist did not suffer as a result of the controversy - quite the reverse.

The publicity surrounding *Summer* and Hornel's growing reputation as a 'progressive' painter led to an invitation from the Societe des XX in Brussels to show work at the group's exhibition in 1893.[34] It was an opportunity which Hornel nearly missed, because the formal invitation was addressed to his Glasgow studio while he was at Kirkcudbright. Henry, who normally forwarded any mail, had been ill for some time and the invitation was finally received by Hornel almost too late to accept.[35] As has been mentioned earlier, Hornel does not seem to have known about the group and consulted Guthrie and Henry. Guthrie, who had exhibited with the Cercle des XIII at Antwerp the previous year, urged him to accept:

> So if you can lay yr. hands on anything that is not specially required for the Grafton or R.S.A. you certainly ought to send to Brussells. A thing like that may help in all sorts of ways. It is a pity the L'pool picture can't go. Wd. it not be a scheme to ask for it? I think it would be a stroke. The picture is sure to be appreciated in Brussells & the L'pool people will think all the more of it.[36]

Les XX was formed in 1883 by a group of twenty Belgian artists, including James Ensor, Willy Finch, Fernand Khnopff, Theo van Rysselberghe and Willy Schlobach, who broke away from an exhibiting society called *L'Essor,* which itself had broken with the Belgian Salon. One of the moving spirits was Octave Maus, lawyer, man of letters and patron of the arts, who acted as the group's Secretary and organised the annual exhibitions. Maus was one of the founders of the weekly arts newspaper *L'Art moderne*, which did not shrink from ruthlessly criticising the work of the *vingtistes* when necessary. The aim of Les XX was to act as a forum for young avant-garde artists to show their work. Membership of the group changed constantly - Rodin and Signac became *vingtistes* - as did the emphasis of their work, which in the ten years of its existence embraced Impressionism, Neo-impressionism, Symbolism and the decorative arts. An exhibition was held each year from 1884 to 1893 at which twenty other artists from Europe, Britain and the United States of America were invited to show work alongside the members. Invited artists had included Whistler, Monet, Renoir, Seurat (in 1887 his *L'Apres-midi a la Grande Jatte* had caused as much of a scandal in Brussels as it had in Paris), Max Liebermann, John Singer Sargent, Cezanne, Gauguin and Van Gogh. Twelve British artists were invited, including William Stott of Oldham, Walter Sickert, Philip Wilson Steer, Walter Crane and Ford Madox Brown. In the exhibitions Maus tried to steer a course between tradition and revolution, which of course broadened the appeal and thus boosted attendances. Indeed the annual exhibition became one of the highlights of the social calendar in Brussels. Maus incorporated a lecture and concert series in the programme.[37]

At the Tenth Salon of Les XX in 1893 Hornel was in distinguished company. The *vingtistes* exhibiting included Ensor, Rodin and Signac. Invited artists included Emile Bernard, Gauguin's young friend and collaborator at Pont-Aven, and Henri de Toulouse-Lautrec. Britain was represented by Madox Brown, whom Hornel acknowledged as an influence, and Steer, as well as Hornel himself. He exhibited four works: *The Goatherd, The Cowherd, Butterflies* (lent by William Burrell: untraced) and *The Brook* (lent by Herbert McNair). It is just possible that *The Cowherd* may be the painting now known as *A Summer Day, Galloway* (c1891: private collection), which is very similar in composition and style to *Summer* (which Hornel decided not to send to Brussels, but to exhibit with other work by the Boys at the newly-opened Grafton Gallery in London). A critic commented on Hornel's use of colour 'in broad decorative areas in a way which has a relation to Japanese art and is strongly akin to Gauguin.'[38]

80

The same year Hornel exhibited *Springtime*, his other major painting of 1892, at the Royal Scottish Academy. The *Glasgow Evening News* carried a description of it before it was sent in:

Mr Hornel's largest picture represents a number of young country girls in wild, gleeful procession dancing by brightly-flowered bushes, with behind a landscape of uplands and hawthorn trees. In the foreground to the left is a tree with leaves outspread, and partly hidden by the foliage two or three more sedate-looking girls who watch their companions, so making a happy contrast.[39]

Springtime provoked a mixed reaction from the critics. The *Glasgow Herald* reflected the general feeling:

Mr Hornel, as we have seen in this and other subjects, subordinates draughtsmanship, atmosphere, everything to colour. The one excellence which he strives after is to him the single essential in a picture. He treats 'Springtime' as a phantasy, a glow of strong tints, which to the unskilled are a bewildering chaos, yet are they strictly apposite and thoroughly considered. If we contemplate Mr Hornel's art from his own, shall we say, restricted point of view (that is to say, as the decorative treatment of nature), it is unquestionably very fine; but, as we have insisted before, more is wanted in a landscape, and especially in the representation of child-life, than he gives us.[40]

Hornel must have been unhappy with the composition, which may have been as large as five feet high and six feet or more wide, because shortly afterwards he cut down the painting to a small extent at the top and the bottom and lopped off a sizeable section on the left. The canvas is known now as *The Dance of Spring* (Kelvingrove, Glasgow, pl.29). It is still not entirely successful, although Hornel has captured brilliantly the gaiety and the rhythm and twisting movement of the girls dancing down the hill. Unlike *Summer*, however, the figures are much more part of the landscape; as Billcliffe has pointed out, by the use of a closer harmony of colours and less emphasis on the linear elements of the composition, the girls seem to merge with the landscape, instead of forming a contrast with it.[41] The missing piece of canvas, which he may have reworked to some extent, is almost certainly the painting known as *In an Orchard* (1891: private collection, pl.28). Here girls, tree and background merge together in a brilliant mosaic of colour and pattern.

In the small *Children at Play* (1892: Flemings, pl.27), which Hornel exhibited at the Glasgow Institute in 1893, figures and background blend together in a riot of rich colour. When the work was shown at Liverpool the same year, Philip Rathbone joked in an address he gave at a soiree at the Walker Art Gallery: '...instead of being called 'Find the Cows' [referring to *Summer* the previous year], it might this year be termed 'Find the Kids'...'[42] It is Hornel at the height of his decorative style. The perspective has been

PLATE 30
The Picnic *c1893*
Oil on canvas, 16 x 20
Private Collection

flattened to the point where the work is almost two-dimensional. The pigment has been broadly applied in patches of strong flat colour. Line and form have been subjugated by pattern, texture and colour, but he has captured wonderfully the joyful exuberance of young girls cavorting on a hillside. Not surprisingly, however, reactions were mixed. The critic of the *Glasgow Evening News* loved it:

> E.A.Hornel has never been more Monticellian than in his 'Children at Play.' The picture is simply a chromatic *tour-de-force*, with something of the abandon of youth in sunshine suggested by the elfin children rolling on the hillside. It is the sort of picture the average public don't understand, because its qualities appeal to the cultured sense of colour on the one hand and to a certain indefinable sympathy with the honest expression of the artist's own temperament.[43]

All this did not impress the *Dundee Advertiser*, however:

> ...the modest little eccentricities which he calls respectively 'Children at Play' (13) and 'Landscape' (693). It will be an interesting puzzle for the visitor to discover without looking at the catalogue which is the landscape and which is the picture of the children.[44]

Children at Play was exhibited in Philadelphia the following year and in St. Louis, Chicago, Cincinnati and New York in 1895. A painting with the same title was shown at the IV Exhibition of the Vienna Secession in 1899. In the meantime, however, Hornel was not at home to read the Institute reviews. George Henry and he were on their way to Japan.

1 *Dumfries & Galloway Courier & Herald*, 3 February 1892
2 *Glasgow Herald*, 15 March 1892
3 Newscutting Book (1892) (Hornel Trust)
4 *Glasgow Herald*, 20 February 1892
5 *Glasgow Evening News*, 2 February 1892
6 Undated letter from George Henry to Hornel (Hornel Trust)
7 Edmund Knowles Muspratt, *My Life & Work*, London, 1917, pp.253-4
8 Edward Morris, *Philip Henry Rathbone and the purchase of contemporary foreign paintings for the Walker Art Gallery, Liverpool, 1871-1914, Annual Report & Bulletin*, Walker Art Gallery, Liverpool, vol.VI, 1975-76, p.64
9 Letter from James Paterson to Hornel dated 27 October 1892 (Hornel Trust)
10 Letter from George Henry to Hornel dated 8 July 1892 (Hornel Trust)
11 Letter from George Henry to Hornel dated 30 August 1892 (Hornel Trust)
12 Letter from George Henry to Hornel dated 9 September 1892 (Hornel Trust)
13 *Liverpool Echo*, 5 September 1892
14 *The Liverpool Courier*, 14 September 1892
15 *The Bailie*, 12 October 1892
16 *The Spectator*, 22 October 1892
17 *The Daily Post*, 6 October 1892
18 *Scottish Leader*, ?7 October 1892
19 *The Porcupine*, 10 September 1892
20 *The Porcupine*, 17 September 1892
21 *The Porcupine*, 15 October 1892
22 *The Porcupine*, 22 October 1892
23 *The Daily Post*, 10 October 1892
24 See George Moore, *Modern Painting*, enlarged edition, London, n.d., pp.160-74
25 *The Daily Post*, 27 October 1892
26 *Liverpool Mercury*, 10 October 1892
27 *The Porcupine*, 17 September 1892
28 Undated letter from George Henry to Hornel (October 1892) (Hornel Trust)

29 *The Daily Post*, 27 October 1892
30 Letter from James Paterson to Hornel dated 27 October 1892 (Hornel Trust)
31 Undated letter from James Guthrie to Hornel (October 1892) (Hornel Trust)
32 Undated letter from George Henry to Hornel (late October/early November 1892) (Hornel Trust)
33 *Liverpool Echo*, 27 October 1892
34 It seems unlikely that the fact that Hornel had attended Antwerp Academy played any part in the invitation extended by Les XX; in art matters there was rivalry at that time between Brussels and Antwerp and Antwerp Academy and the late Charles Verlat were not highly rated by Brussels or *L'Art moderne*
35 Undated letter from George Henry to Hornel (October/November 1892) (Hornel Trust)
36 Letter from James Guthrie to Hornel dated 15 November 1892 (Hornel Trust)
37 For a full account of Les XX see *Impressionism to Symbolism: The Belgian Avant-Garde 1880-1900*, Royal Academy exhibition catalogue, London, 1994; for a list of work submitted by British and American artists see Bruce Laughton, *The British and American contribution to Les XX, 1884-93, Apollo*, November 1967, pp.372-9
38 Quoted by William Buchanan in *Mr Henry and Mr Hornel visit Japan*, Scottish Arts Council exhibition catalogue, 1978, p.9
39 *Glasgow Evening News*, 12 January 1893
40 *Glasgow Herald*, 25 February 1893
41 Roger Billcliffe, *The Glasgow Boys*, London, 1985, pp.254-5
42 *The Porcupine*, 23 September 1893
43 *Glasgow Evening News*, 9 March 1893
44 *Dundee Advertiser*, 3 February 1893

'A REED SHAKEN BY THE WIND'
1893-1895

ON THE FIRST DAY OF MAY 1862 THE SECOND BRITISH INTERNATIONAL
Exhibition of Art and Art-Industry opened at South Kensington in London. Amongst the
vast panoply of Britain's industrial and commercial might and the large representative
collections of paintings of the British and continental schools was a display of Japanese
art. Drawn largely from the private collection of Sir Rutherford Alcock, the first British
Consul-General in Japan, it consisted of over six hundred items, including Japanese
prints, books, bronzes, lacquer-works, enamelled wares and porcelain. It was the largest
display of its kind yet seen in Europe and caused a great deal of interest, particularly on
the part of artists. It marked the beginning of *Japonisme* - a taste for things Japanese -
which took hold in Europe and America in the final decades of the nineteenth century.[1]

Yet less than ten years earlier Japan had been closed to foreigners for over two
hundred years, a feudal society isolated from the outside world except through a few
Dutch and Chinese merchants, who were allowed limited trading rights at Nagasaki in the
extreme south of the country. That isolation was broken in July 1853, when four ships of
the United States Navy - the so called 'Black Ships' under the command of Commodore
Matthew Perry - sailed into Edo Bay (now called Tokyo Bay). Perry demanded the
establishment of trade relations between the two countries. Although within Japan there
was considerable opposition to breaking down the barriers against the outside world,
there was even greater pressure to westernise the country. Consequently within four or
five years commercial treaties had been signed with America, Britain, Holland, France,
Germany and Russia. However the Japanese authorities were very reluctant to throw
open the entire country to foreigners. Instead they decreed that all non-Japanese (except
diplomats) should live within the confines of three 'treaty ports' - Yokohama, Nagasaki
and Hakodate. Kobe and Osaka were added shortly thereafter. With the dawning of a new
Meiji era in 1868, following the fall of the Tokugawa Shogun and the restoration to

PLATE 31
The Fish Pool *1894*
Oil on canvas, 17³/₄ x 14
Glasgow Museums: Art
Gallery & Museum,
Kelvingrove

power of the Emperor, Japan began the huge task of catching up with the West. In the initial decades of modernisation Britain was dominant, both on the trade and diplomatic fronts.

At the same time a cultural exchange developed between the two countries. Although relatively large quantities of Japanese lacquer-work and porcelain had been exported to Britain during the years of isolation, the international exhibition of 1862 created a demand for all things Japanese, which could now be more fully satisfied. London and Paris became the principal centres for Japanese art and artifacts. From the 1870s onwards it was probably unusual for an artist not to have any Japanese prints or other objects in the home or studio. Recognising the decorative qualities of Japanese motifs and objects, Western artists incorporated them into their own paintings, often without regard to their proper context.[2] Similarly Japanese artists wanted to know more about Western painting and copied Western styles, although in many cases this led to a degeneration of contemporary Japanese art. However it was not only artists who espoused *Japonisme*. Immediately recognised as a refreshing new art form, compared to the contemporary tired rivalry between the Greek and Gothic styles, it was quickly assimilated into the vocabulary of architects, furniture designers and painters more or less simultaneously.[3]

Japanese art during the period of that country's isolation came to be recognised in the West as one of the most perfect of all art styles. In a lecture on Japan in 1895 Hornel summed-up his feelings about her arts:

> The genius discernable in their *Kakemonos* [hanging scroll paintings] is to be traced in their articles of common use, nothing being too common-place to form the basis of some work of art. And this is perhaps one of the greatest achievements of the Japanese, the raising of the common-place into the region of art, and investing it with a charm at once the despair and envy of the European...beautiful creations in ivory, *cloissone*, and *Kakemono* full of dignified line and splendour of colour, the greatest impressionism the world has so far possessed, in which all useless details are laid aside, or made subservient

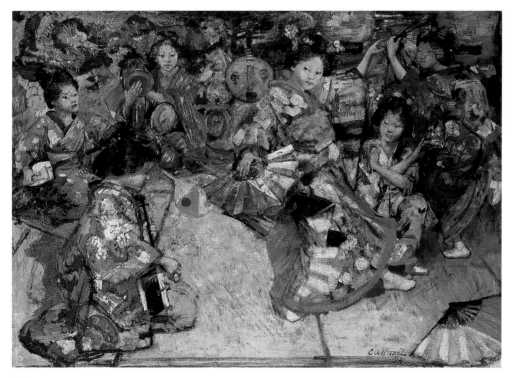

PLATE 32
Japanese Dancing Girls
1894

Oil on canvas, 26 x 36
Ewan Mundy

(opposite)
PLATE 33
In a Japanese Garden
1894

Oil on canvas, 24 x 20
Sheila MacNicol

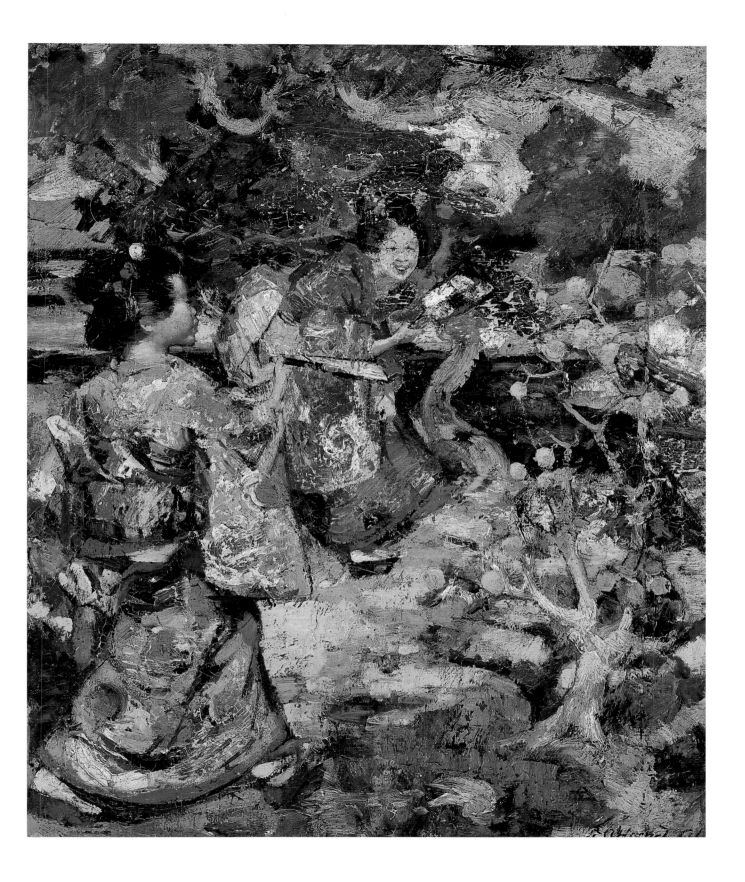

to the *motif,* giving you only the spirit and character of the figure, bird or flower portrayed. I know of no art which for directness or impressiveness can surpass the past achievements of the Japanese. To those who cavil at its lack of perspective, want of modelling, and in some instances its grotesque drawing, I would say that the possession of these elements do not necessarily make for Art...We in this country have been working too much on the surface, and in striving to realise Truth, have forgotten the Spirit. We in our search for Truth sometimes chanced upon Beauty, the Jap in the worship of the Beautiful attained Truth thereby.[4]

The art of Japan encompasses not only the fine and decorative arts, but also things such as the tea ceremony and garden design. However for most Westerners who had not been to Japan, her genius was expressed in the form of the Japanese print. The print was an important influence on the direction which Western art was to take in the latter half of the nineteenth century. It helped artists to break free from the restrictive conventions of the Classical tradition and the authority of the Old Masters. For painters such as Degas, Monet, Toulouse-Lautrec, Gauguin and Van Gogh - indeed for virtually all major late-nineteenth century artists - it changed the way they saw and represented Nature.

In Japan in the eighteenth and nineteenth centuries the print was very much a popular art, dealing with the every-day life of the middle and lower classes and intended for those sections of society. In Japanese it is called *Ukiyo-e,* a painting of the 'floating world' (that is, the changing or fashionable scene). The subject matter can sometimes be very coarse, but the manner in which it is depicted is rarely so. It can often be subtly humorous. Ranging between extremes of realism and stylisation, it is characterised by beauty and vigour in execution, a strong line, bright colour and usually a flattening of pictorial space. To Western artists the two most important masters were Katsushika Hokusai (1760-1849) and Ando Hiroshige (1797-1858), whose landscape prints in particular made an immediate impact when they reached Europe following the ending of Japan's isolation.

One of the first to appreciate the beauty and aesthetic value of Japanese art was the American-born painter James Abbott McNeill Whistler (1834-1903). It was he who opened the eyes of many British artists to Japanese art, including several of the Pre-Raphaelite Brotherhood, when he became the neighbour of Rossetti in Chelsea. Rossetti's brother records that in 1863 Whistler already possessed several books of Japanese woodcuts, several colour prints and one or two screens.[5] Whistler competed with artists such as James Tissot, Edouard Manet and Felix Bracquemond to acquire Japanese art and artifacts from La Porte Chinoise in Paris.

Although he was born in America, Whistler had a cosmopolitan upbringing and pursued his career as a painter in both London and Paris. In Paris he became friendly with many artists of the avant-garde, including Henri Fantin-Latour and Alphonse Legros - with whom he formed the *Societe des Trois* dedicated to their mutual support in both cities - Degas, Manet, Courbet and Monet. As well as Millais, Rossetti and their circle, he was the friend of the young Edward Poynter and George Du Maurier in London.[6] A little later he met the Neo-classical painter Albert Moore - both were to be an influence on the other - and the architect E.W.Godwin.

Whistler began his artistic career as an etcher. His *Thames Set* of 1861 demonstrates his early use of Japanese compositional devices. In his painting he drew inspiration over time from a wide range of sources, including the work of Courbet, Delacroix, Velazquez, Hals, Ingres and Gainsborough, as well as Japanese art, which he used selectively (for example, he never abandoned Western perspective). By the beginning of the 1870s he was achieving a synthesis of realism and formalism, creating a new kind of art, which came to be called Aestheticism. Simplicity in design and economy of expression were

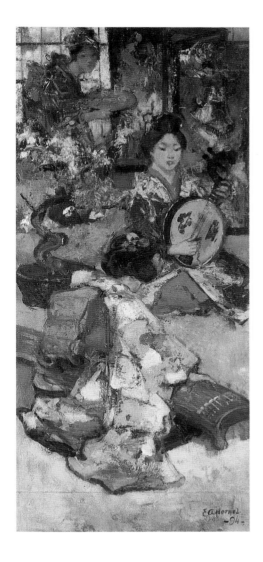

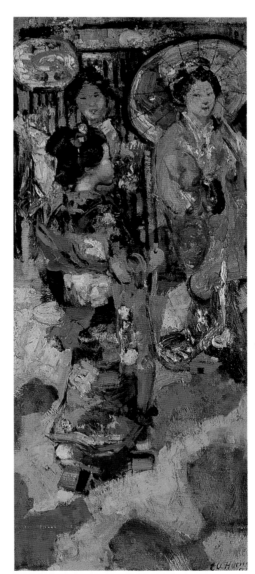

(left)
PLATE 34
Music in Japan *1894*
Oil on canvas, 24 x 16
Private Collection

(right)
PLATE 35
Japanese Tea Shop *1894*
Oil on canvas on board,
30 x 13
Private Collection

key elements in his painting. To Whistler painterly values - colour, tone, texture, composition - were much more important than subject matter.

In the later 1880s Whistler became one of the heroes of the young Glasgow Boys. For a time they were very influenced by his painting and his artistic principles, the latter propounded in his celebrated 'Ten O'Clock' lecture, explaining the difference between art and nature, which he first delivered in London at 10pm on 20 February 1885 before a distinguished audience, which included Oscar Wilde. Lavery, who met Whistler in 1887, wrote in his biography: 'Although we at Glasgow worked with a richer palette than Whistler, we recognized in him the greatest artist of the day and thought of his 'Ten O'Clock Lecture' as the Gospel of Art.'[7] Whistler's great regard for the art of Japan is underlined in the last phrase of that lecture: '...the story of the beautiful is already complete - hewn in the marbles of the Parthenon - and broidered, with the birds, upon the fan of Hokusai - at the foot of Fusiyama.'[8] A number of the Boys came to know Whistler when they became members of the International Society of Sculptors, Painters and Gravers, an exhibiting body established in 1897 with Whistler as President and Lavery as Vice-President, who was left to do all the work under the detailed direction of Whistler, then resident in Paris.

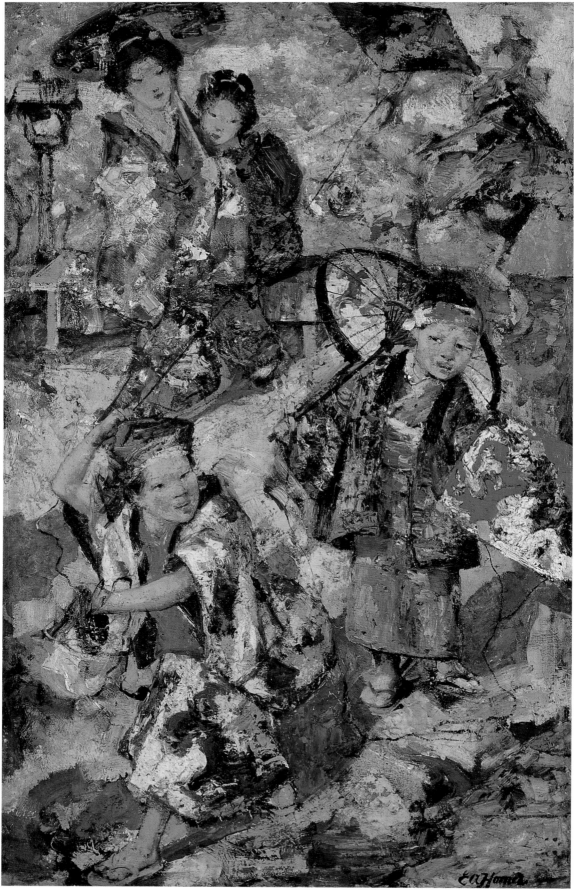

In Scotland - particularly in Glasgow - an interest in *Japonisme* had been present for some time. This was stimulated in part by an exhibition of Oriental art at Glasgow's Corporation Art Galleries at the beginning of 1882 and the publication the same year of *Japan, Its Architecture, Art and Art-Manufactures* by the Glasgow-born designer Christopher Dresser, who had visited the country in 1876-7. The greater part of that exhibition was made up of objects gifted by Japan to Glasgow. In an exchange initiated by Robert Henry Smith, Professor of Civil and Mechanical Engineering in the newly-established University of Tokyo, one of a number of Scots appointed by the Japanese to key training posts, over one thousand items of contemporary ceramics, furniture and other lacquer-ware, metalwork, textiles and paper were sent to Glasgow in 1878. In return Japan, recognising Glasgow's pre-eminence in many industries, asked the city to send to the Tokyo National Museum the following year a large number of samples of the region's industries.[9]

Several of the Boys owned items of Japanese art. An early photograph shows four Japanese prints pinned to the wall above the mantlepiece in Walton's rather basic studio at Cambuskenneth near Stirling. The Boys' art periodical *The Scottish Art Review* carried articles on *Kakemonos* and Japanese sword guards. At Glasgow Art Club's Grand Costume Ball in aid of the newly-created Scottish Artists' Benevolent Fund, which was held in the St. Andrew's Halls on 29 November 1889, Walton, dressed as Hokusai, became engaged to Helen Law, who came as Butterfly in homage to Whistler. Rembrandt, alias Lavery, commemorated their betrothal by sketching on the spot Hokusai and the Butterfly. Almost one thousand people attended the Ball. Neither Henry nor Hornel are included in the list of over six hundred who came in fancy dress. However we do know that they attended, because they were among the artists who provided instant portraits. The *Souvenir of the Grand Costume Ball* includes a plate of a sketch by Hornel titled *The Glee-Maiden* (the person in costume is not identified).[10]

Of course it was not only artists who were interested in collecting Japanese art and artifacts. A growing number of the public were purchasing objects associated with Japan, as is evidenced by the number of outlets in Glasgow selling such items. In 1888 *Quiz* carried an advertisement by the City Oriental Warehouse, offering Japanese goods suitable for Christmas gifts.[11] In 1890 Grosvenor Thomas, one of the Boys, was in partnership with W.B.Paterson, art dealer-brother of James Paterson, dealing in Japanese curios. The Royal Polytechnic Warehouse advertised a 'Grand Exhibition of Japanese and Oriental Wares' in time for Christmas 1892.[12] At the upper end of the market the art dealer Alexander Reid opened his new gallery La Societe des Beaux-Arts at 227 West George Street in November 1889 with an exhibition of Japanese prints, which he had brought back with him from Paris.

The influence of Japanese art and, in particular, the Japanese print on Hornel's work has already been noted. Thus it is no surprise that in 1893 Henry and Hornel decided to see the country and its art at first hand. Funds were to be provided by Alexander Reid, no doubt on the understanding that the two artists would each have an exhibition of their paintings at Reid's gallery on their return, by the Glasgow shipowner and collector William Burrell, who already owned work by Hornel, and possibly by one or two other collectors. Hornel gave as his reason for visiting Japan:

> 'A reed shaken by the wind;' for to those acquainted even slightly with Japanese art the words express the spirit and *motif* of its dainty achievements. Japanese art, rivalling in splendour the greatest art in Europe, the influence of which is now fortunately being felt in all the new movements in Europe, engenders in the artist the desire to see and study the environment out of which this great art sprung, to become personally in touch with the people, to live their life, and discover the source of their inspiration.[13]

(*opposite*)
PLATE 36
Kite-Flying, Japan
c1894
Oil on canvas, 30 x 19
National Galleries
of Scotland

Of course they were not the first British artists to venture to Japan. For instance the much-travelled topographical painter Frank Dillon visited Japan as early as 1876: he exhibited *The Festival of the Cherry Blossom, Osaka, Japan* at the Glasgow Institute in 1883. Mortimer Menpes, pupil and admirer of Whistler and, like Hornel, born in Australia, went in 1887. Alfred East, who had trained at Glasgow School of Art, followed in 1889 and Alfred Parsons in 1892. In those days it was a bold enterprise. Henry and Hornel were given a good send-off by *Quiz* in a humorous article (probably written by one of the Boys):

> The Inseparables of art. Also the Irreconcilables. The Twins of Table mountain a fool to them. As for the Gemini - bah! And they too are Stars. Erratic Stars. Of uncertain orbit. The newspapers reviled them. Art Club laughed at them. P.R.S.A. sneered at 'em. Instead of which they dont give a hang. And are Unashamed. Pursuing their piratical Impressionist career. With the Scots accent. And thick boots. George is an Ayrshire man. Trained in Glasgow School of Art. But gradually recovering. Painted Galloway Landscape once. *Tres Magnifique*! But terribly tough on the masses. Does female studies. Superb. See 'Mademoiselle' at Walker's show. Made A.R.S.A. last year. Otherwise very decent fellow. Confederate Ned born in Australia. At very early age. Place called Bacchus, Victoria. Suggestive but sober fact. No harm resulted. Came to Kirkcudbright when one year old. Took a steamer. Also parents. Here ever since. Except when studying in Antwerp. Principally Art. Scholar. Emersonian. Excellent *raconteur*. Pictures big. And brilliant. But beyond the comprehension of the gay throng. 'No form'. No moral. No story. No nothing. But simply art. And Colour. Inseparables sail for Japan. To-day. Paints with them. Also pipes. Away a twelvemonth. Lucky boys. *Bon voyage*! [14]

That other diarist of the artistic scene in Glasgow *The Bailie* was more matter-of-fact:

> The most notable event in local art affairs last week, was the leaving of Edward Hornel and George Henry, on Thursday and Friday respectively, for London, *en route* for Japan [they sailed from Liverpool]. Through methods of their own, Messrs Hornel and Henry have mastered a *technique*, not dissimilar in character from that favoured in the land of the cherry-blossom - let us call it Hokusai modified by Monticelli, and that they should resolve on a sojourn by the side of Lake Biwa, or on the slopes of Fusiyama, seems, therefore, quite in the nature of things. [15]

On the other hand the critic of the *Glasgow Herald* considered that the cause of art would have been better served had Hornel decided to go to Italy instead, getting in a sly 'dig' at him for his love of colour at the expense of line and form:

> Why Mr Hornel should seek inspiration in Yokohama or its neighbourhood we are at a loss to understand. It seems to us that he has already studied Japanese art to some purpose, and that a visit to Italy, a week or two spent in the churches of Venice and in its Academy, would not have been amiss...Such an experience would have satisfied him, if he does not already know, that there were great colourists in the past who were also influenced by beauty of line and form. [16]

Hornel's local *Dumfries Courier* probably summed-up the feeling of the 'gay throng', when it commented 'One shudders to think of the things they will bring back'! [17]

On 18 February 1893 the two friends sailed from Liverpool aboard the steamer *Pegu*, which was bound for Rangoon. Their large amount of luggage had probably been put on board at Greenock some four days earlier. They arrived at their immediate destination of Suez, at the southern end of the Suez Canal, on or about 5 March [18] From there they made the hot, tiring train journey to Cairo, where they remained for several days, staying at Shepheard's Hotel. The sea journey must have afforded Henry an opportunity to convalesce after his long illness, because immediately they embarked on a hectic round of sight-seeing, visiting the Pyramids and Heliopolis as well as Cairo's Turkish bazaar, Saladin's Citadel and the Sultan Hassan Mosque. In a letter to one of the Boys Henry described the interior of the Mosque as 'beauty of the highest order wedded to simplicity

 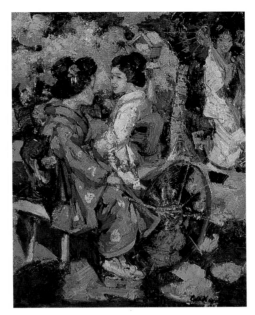

of design, and in these respects [it] far surpasses anything in architecture I have ever seen.' He also commented at some length on Egyptian women 'mostly all wear a veil...Giddy things! You are continually longing to pull this curtain, I might say, away from their faces and look upon their beauty.'[19] On or about 9 March they embarked on the steamer *Strathlyon* for the long sea journey to Japan. Mail was dropped off and collected at Singapore. Their arrival at Nagasaki was duly reported in the *Glasgow Evening News* of 21 April. Spring is the perfect time to arrive in Japan, as Hornel acknowledged: 'Scarcely has the cold and cheerless winter ended...or the last snow completely melted away, ere the plum bursts forth, the sombre quilted kimonos are thrown aside, the lighter and more gaily coloured costumes of spring substituted, and nature-worship reigns supreme.'[20]

Unfortunately there is very little information available as to where Henry and Hornel lived and what they did during their stay in Japan. Documentation is limited to five brief letters from Henry to Hornel while they were there, the text of a lecture on Japan by Hornel and an interview with Henry by the *Glasgow Evening News*. On their return they discovered that several of the letters they had addressed to a number of the Boys and to Alexander Reid, which might have proved illuminating, had never arrived (Reid complained to Henry on his return that Hornel had not written to him enough from Japan, although the latter maintained that he had sent him a letter every mail).[21]

For most of the period it appears that they lived and worked in the Tokyo area.[22] They were separated for part of the time. Opportunities to meet the Japanese were very limited, because government regulations restricted the movement of non-Japanese. The latter had to remain within the so-called 'concessions' - in other words, the Treaty Ports already mentioned. However for artists keen to see the real Japan that was hopeless. Hornel complained that 'every second man you encounter is a missionary, and your rest is chronically broken in upon by the uncongenial clang of the church bells, whose notes are as unmelodious and distressing as the music (so called) of the Japanese.'[23] To the unreligious Hornel this must have been particularly irritating! On the other hand the British expatriates were very hospitable, the members of the British Legation being particularly friendly towards them.[24] No doubt they participated in some of the artistic

activities in Tokyo. For example both were elected a member of The Photographic Society of Japan in recognition of their 'untiring energy for several days' hanging an important exhibition of photographs lent by the Camera Club of London.[25] Both of them had been keen on photography for some time and, like many artists of the time, used the medium as an aid when painting in the studio. There are a number of references to photography and cameras in Henry's letters, many requesting Hornel to send him photographs of, for instance, trees or berries. Certainly they had taken cameras with them to Japan, because Henry wrote asking Hornel to '...send down another dozen of Sud's plates...'[26] As we shall see, Hornel was to use photography to a considerable extent in composing his later paintings.

A way round the residence restrictions was to obtain employment with a Japanese national, which is what they did: '...losing sight of the dignity and reputation of the Glasgow School, [we] humbled ourselves and became servants to an alien Barbarian, a house-agent, for whom we were supposed to furnish plans of 'houses to let', and took a house outside the 'concession'.'[27] However Japan was in a state of change and unrest at the time and there was considerable anti-foreign feeling. Henry and Hornel were found out, as Henry explained to the journalist from the *Glasgow Evening News* on his return:

> ...an obliging but unscrupulous Jap (for a consideration) took us into his employment. It is a common 'fake,' but it is worked too often, and after a little the native newspaper men discovered us. They straightway began to write us down in their papers as 'foreign red-headed devils,' who were plotting the peace of the empire, and upheaving the whole social fabric outside the Concession. Being used to newspaper slating at home it didn't annoy us much at first, besides it was in Japanese, and that made it hurt less, although it looked dreadfully diagrammatic [sic] and scurrilous. Eventually, however, the thing got too warm; the entire native press of Tokio...jumped on us and our 'employer' to such an extent that he prayed on us to flit back to our legitimate bounds.[28]

Hornel sought the advice of Captain Brinkley, the editor of *The Japan Mail*, who was an expert on Japanese affairs. He wrote back:

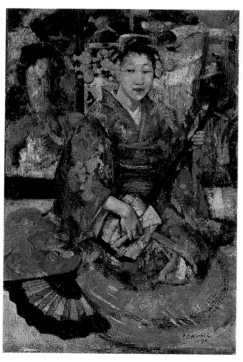

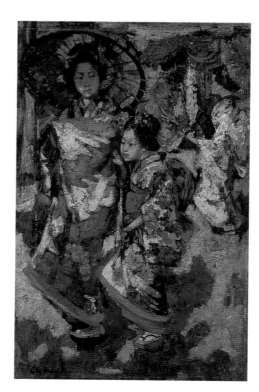

(left)

PLATE 39

A Music Party *1894*

*Oil on canvas on board,
30 x 14
Aberdeen Art Gallery*

(right)

PLATE 40

Two Japanese Girls *1894*

*Oil on canvas, 28 x 18
Hunterian Art Gallery,
University of Glasgow*

I have spoken about the matter at the Foreign Office, & they say you can get a six months' passport at any time by going the right way to work. The right way means that your nominal Japanese employer - for I presume that you are in nominal Jap. employ in order to live outside the settlement - must apply for a passport stating distinctly that he has given you six months leave & that it is necessary in the interests of the business entrusted by him to you - say scientific research - that you should travel during the six months. Then give yourselves a wide range of country in explaining your route (for the purpose of getting the passport written) & after that quietly use the passport as often as you please during the six months. Say nothing about coming back to Tokyo & leaving it again but simply use the passport each time of <u>going</u> away. I am sure you will have no difficulty if you adopt this method.[29]

It is not known for certain whether they followed this course, but it seems likely that they did, because Henry mentions in a letter to Hornel his wish 'for an extension in regard to the Passport, as I want to make a sketch or two now that the weather has got better.'[30] Certainly Henry wrote letters to Hornel from Kanazawa and from near Chiba and asked Hornel to meet him at Kamakura, all villages around Tokyo Bay, which must have been outside the concessions.[31]

Whether Hornel succeeded in his stated aim of experiencing the real Japan - 'to live their life' - is rather doubtful. Nevertheless, it was the ordinary Japanese, enjoying themselves in a lively manner in Ueno Park or in the nearby grounds of Asakusa in Tokyo, whom he remembered vividly:

...I associate and love to remember them, as a large and happy family, clattering along in the sunshine with smiling faces and no thought of the morrow, to spend the day 'mid plum or cherry blossom, or at night joyous and elevated with saki, amusing themselves with pretty geishas, dancing to the weird music of the samisen.[32]

It was this image that he captured so well in the paintings of Japan which he brought back home with him. Works such as *In A Japanese Garden* (1894: Sheila MacNicol, pl.33), in which the girls are energetically playing battledore, and *Kite-Flying, Japan* (c1894: National Gallery of Scotland, pl.36), in which a boy holding a kite has had to take evasive action when another rushes past absorbed in flying his one, have a wonderful feeling of life and movement. On the other hand *The Fish Pool* (1894: Kelvingrove, Glasgow, pl.31) depicts a group of children intent on a more placid pastime. This theme of children enjoying themselves, surrounded by nature at her most bountiful, dominates Hornel's art throughout his life. Whether he *liked* children is another matter; certainly in later life he had little patience with children. At this stage probably he did.

Hornel also recalled with pleasure the tea-houses and the geishas:

Not so staid and conventional...is the life of the tea-house, where, in spite of the ceremonies and etiquette observable, you have an abandon more to the taste of the European. A good tea-house is one of the most charming of places, where good nature and hospitality abound.[33]

However he found squatting on the floor for any length of time rather painful and the food was not really to his taste; sometimes he wished for a 'good old English beefsteak.' But it was the dancing girls who were the real attraction for him, even when the dancing was sometimes rather second-rate if 'redeemed by good looks and seductive winning ways':

Lucky indeed are you, if you can call her but for one brief hour, the giddy thing will dance but a short measure even then, and you sigh as she goes. Doubtless very annoying it is, and unquestionably costly, and you swear you will never do it again, but alas! vain are your resolves; you forget that you are human, and the bewitching enchantress has more of your hard-earned dollars ere the week closes.

Japanese Dancing Girls (1894: private collection, pl.32) captures the splendour and ceremony of the dance, the 'quaint posturing, dignified and refined movements, with

delicate and artistic and pretty manipulations of the fan.' The music, though, he thought was 'simply execrable, and with the instrumental accompaniment superadded, perfectly maddening.'[34]

On 19 May 1894, after spending thirteen months in Japan, they sailed from Yokohama on the German steamer *Nurnberg,* bound for Hong Kong.[35] Thereafter the trail goes cold. However they must have embarked on another steamer for Britain within a few days, because they docked at Southampton on or about 11 July.[36] Henry went to Glasgow. Hornel returned to Kirkcudbright. Several days later Hornel received a heart-breaking letter from his friend:

> I am undone. It has been a terrible time since I arrived in this town. After talking without a break for a space of two days and nights, I had to retire as the only sound I could make was a soft whisper. In these two days almost all the good of the voyage has been lost.
>
> I have just got my canvasses unrolled, and Oh Heaven's what a result - I feel very sick. With a few exceptions, they are simply one mass of cracks, and the full length portrait of the wee Kanazawa Geisha which I rolled up rather carefully with a clean piece of canvass facing it is utterly destroyed, and at present quite wet. I do not exaggerate when I say that really I dont know whether to start and finish the impression on the fresh canvass, or work on the old one as I have exactly two pictures, the one the reverse of the other of course. It is the same with some of the others. It is hard lines.
>
> If you have not as yet opened yours up - I dont know but I think it would not be a bad plan to heat the roll before the fire, before proceeding to unpack. Think over it![37]

It was a devastating blow, from which Henry took a long time to recover. It meant that he had no work for his planned exhibition. His position was made worse by the fact that collectors did not wish to purchase his other pictures, anticipating that his Japanese paintings would be available for sale shortly. He was virtually penniless. He was at a loss to know what to do.

Thankfully Hornel's paintings escaped any appreciable damage, possibly because he heeded Henry's warning or he may have packed them more carefully. For the remainder of the year he was busy in his Kirkcudbright studio, working-up his Japanese pictures in readiness for his exhibition the following spring at Alexander Reid's gallery in Glasgow.

He was also preparing the text of a lecture on Japan, which his architect friend John Keppie had persuaded him, against his better judgement, to deliver at Glasgow's Corporation Art Galleries. For some reason Hornel was then rather diffident about speaking in public. He was of a scholarly nature and consulted a number of books and periodicals on Japan, many borrowed from friends such as Charles Mackie, in order to supplement his own experiences and present a well-rounded account of that country.[38] On his return Henry had been pestered by many Glasgow societies to give a similar talk, but he had refused, because it would have interferred with his painting. The two friends had tacitly agreed that neither would do 'anything of the kind before the public...a private Club was quite another thing...' Consequently Henry was angry when he learned that Hornel had agreed to a Glasgow lecture, writing to him:

> I think you might have had the foresight to drop me a line telling me that you had arranged to do this, and not waited till I asked you if it was the case...I am sorry that there was not a little more frankness - that was all that was wanted - the fact of lecture or no lecture a mere bagatelle. However as it is over now we will let it drop.[39]

It is another instance of a gradual cooling of the close relationship between Henry and Hornel. Mention has already been made of Henry's view, expressed as early as the end of 1891, that working in close proximity to another artist was not beneficial to either. Not unnaturally they had spent some time apart in Japan, just how much is unknown. The fact

PLATE 41

Figures with Lanterns and Bridge *1894*

Oil on canvas, 23$^{1}/_{2}$ x 15$^{1}/_{2}$

George Smith Collection

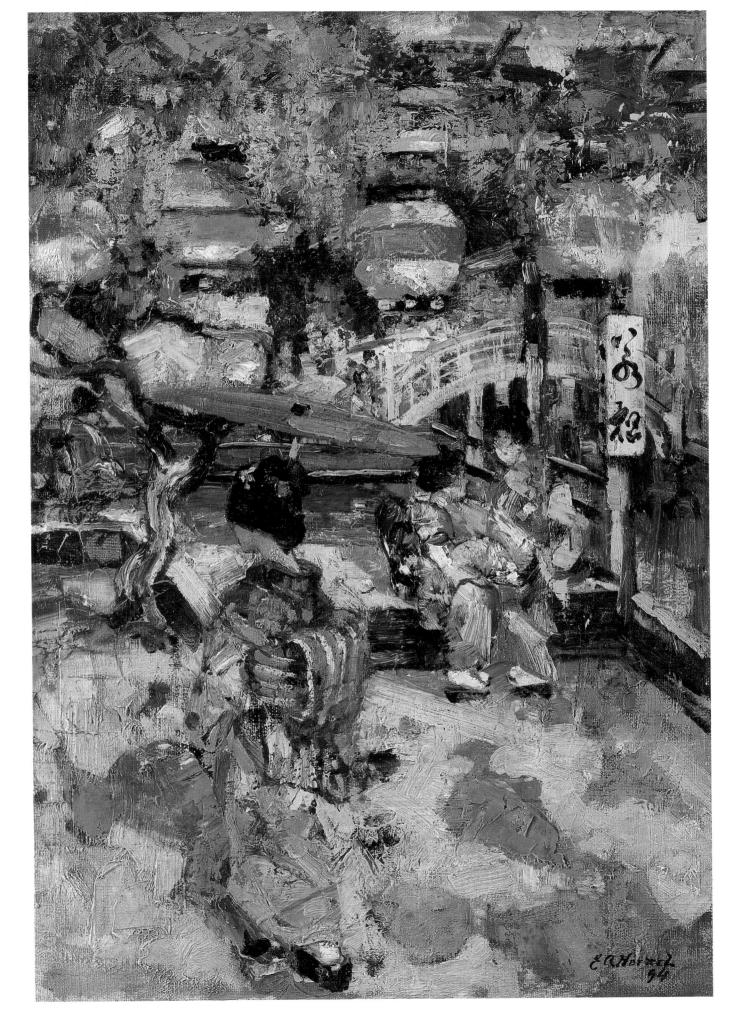

that Hornel's work was going very well, whereas Henry had been struck by disaster, confusion and acute depression, may have been an additional factor. For several years Henry had been using Hornel's Glasgow studio at 136 Wellington Street, but towards the end of 1894 or the beginning of 1895 he moved out, taking a studio at 2 West Regent Street.[40] The way things were going was noted in a gossip column about art and artists in the *Glasgow Evening News* in April 1895:

> Macfee - Hornel, one of your crowd, is to have a show of his Japanese pictures shortly, I see. They tell me it's to be his big bid for fame, and that in some respects it's a remarkable achievement.

> Megilpison - H'm, yes. Ned's a scorcher at colour. I've seen some of the stuff, and it sings. He's not painting with Henry now, by the way. They seem to have split partnership.[41]

The report is probably not too far from the truth. Certainly A.S.Hartrick's assertion that 'they had not spoken to one another all the time they were there [Japan]; and they never spoke to one another afterwards' is patently not the case.[42] They remained friends for some time. Henry's letters to Hornel continued well into 1896, albeit not on such a frequent basis as formerly. Of course the Boys in general - always a somewhat loose-knit band, despite the 'secret' moves to set themselves up as a brotherhood of artists with a distinct name and rules, which fill Henry's letters to Hornel of the early 1890s - were gradually dispersing, drawn in the main by the lusher pastures of London. Walton had left Glasgow for London in 1893. Guthrie and Lavery were to follow. Henry himself settled in London around the turn of the century.

On 9 February 1895 Hornel's lecture on Japan was delivered to a large audience in the Corporation Galleries in Sauchiehall Street, not by Hornel himself - he used the rather lame excuse of a near relative being unwell - but by John Keppie. A number of lantern slides, prepared by Professor W.K.Burton of Tokyo, were shown to complement the talk. The lecture and slides were repeated at the Walker Art Gallery in Liverpool, delivered on that occasion by his photographer friend Robert McConchie, and at the Bury Literary and Scientific Society. However Hornel himself could hardly avoid talking about Japan at a showing of the slides in his home town in the middle of March.

Hornel's exhibition of Japanese paintings opened at Alexander Reid's gallery at 124 St Vincent Street on 24 April 1895. Forty-four works were hung in ivory-coloured frames.[43] Unfortunately none of the paintings were given titles and consequently no catalogue was issued. However the *Glasgow Evening Citizen* recorded the flavour of the exhibition:

> They represent Japanese singing girls, Japanese dancing girls, Japanese fetes, Japanese amusements. Here are a half-dozen youthful Japs paddling about in tubs in the Bay of Tokio; there is a Japanese theatre; in one canvas a group of Japanese young ladies are represented indulging in a game of battledore and shuttlecock, in another two Japanese ladies inspect the silks exposed for sale in a Tokio shop, in a third a lady watches a group of boats putting out to sea, in a fourth the magnificent cherry blossom is displayed in all its lush luxuriance, all its wealth of bright, even blazing colour.[44]

The exhibition was a triumph for Hornel. It was the high point of his career. The critics, after first acknowledging that they had had reservations about his work in the past, were virtually unanimous in their praise. The *Glasgow Evening News wrote* 'If it does not convince all who have the instinct or the education to admire the genuinely artistic that here is one of the most magnificent displays of a single artist's genius ever brought together in Scotland, it will be curious indeed.'[45] *Quiz* thought them 'extraordinary, magnificent, sublime' and added 'Hornel has arrived!'[46] The *Glasgow Herald* commented 'A man who paints such pictures as these, with youth still on his side,

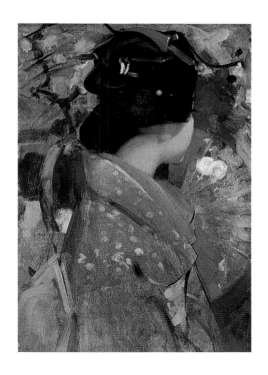

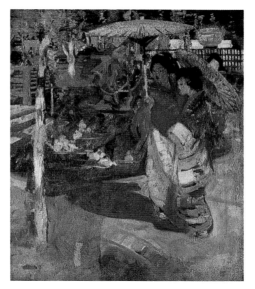

(left)
PLATE 42
George Henry
Japanese Lady with
a Fan *1894*

*Oil on canvas, 24 x 16
Glasgow Museums: Art
Gallery & Museum,
Kelvingrove*

(right)
PLATE 43
George Henry
In a Japanese Garden
c1894

*Oil on canvas, 30 x 25
Glasgow Museums: Art
Gallery & Museum,
Kelvingrove*

may be counted on to reach to higher things.'[47] David Martin, writing some eighteen months later in *The Studio*, considered that:

> The paintings commanded attention both from artists and public, and though...his previous work was of exceptional artistic value, the present is much finer, and reaches a higher level alike in qualities of colour, design, technique, and selection. It is evident from his pictures that of the many artists who have visited the land of the cherry, none have returned with a more comprehensive pictorial record of Japanese life.[48]

The paintings sold very well. A few days before the exhibition closed on 17 May *The Bailie* reported that only seven works remained unsold.[49] By the close all but one of the forty-four pictures had been sold.[50] Many ended up in important private collections, including those of Sir John Stirling Maxwell and William Burrell.[51]

David Martin had put his finger on the principal reason for the extraordinary success of the exhibition. The paintings are primarily a *pictorial record* of life in Japan, albeit charged with a wonderful vitality and excitement. Public and critics alike could understand what Hornel was trying to put across to his audience. Excellent though they are, the Japanese paintings are not as artistically challenging for the viewer as, for example, *The Goatherd, The Brook* or *Summer*. They are readily accessible, dealing with aspects of life with which most people are familiar wherever they may take place, and are executed in a style which most can appreciate. In addition, at that time the pictures had a novelty value in that they portrayed a far-off land, which was still unknown to the majority of the public.

Although Hornel has been clearly influenced by Japanese art in his design - for instance the decorative disposition of splashes of colour - the broad handling, the almost frenetic brushwork and the rich pigment are his own. *The Bailie* described it as 'Hokusai modified by Monticelli.'[52] Henry's Japanese work on the other hand - particularly the watercolours - is closer to Japanese art. It was only occasionally that Hornel adopted a more Japanese approach, as in the lovely *A Geisha, Nagasaki* (1894: Spink). He was principally interested in life and movement. Although it is impossible to judge the nature of the work that was destroyed, Henry seems to have preferred to paint intimate

domestic scenes. The latter's work is strong in terms of line and form, whereas Hornel concentrated much more on pattern, texture and colour.

Probably at the suggestion of Charles Mackie or Pittendrigh Macgillivray, Hornel contributed a Japanese drawing to the Autumn 1895 issue of Patrick Geddes's periodical *Evergreen*. Titled *Madame Chrysantheme*, it is a decorative piece depicting a geisha looking away across an ornamental Japanese garden. It is one of the few known drawings by Hornel. Fellow contributors included Mackie, Macgillivray, Robert Burns, John Duncan and James Cadenhead. An illustration of one of Hornel's Japanese paintings *Geisha* is included with work by most of the other Boys in volume VIII of *The Yellow Book*, published in January 1896.

1 The term *Japonisme* was coined by the French art critic and collector Philippe Burty in an article in May 1872
2 Tomoko Sato and Toshio Watanabe (ed), *Japan and Britain: An Aesthetic Dialogue 1850-1930*, Barbican Art Gallery exhibition catalogue, London, 1991, p.19
3 Robin Spencer, *The Aesthetic Movement and the Cult of Japan*, The Fine Art Society exhibition catalogue, London, 1972, p.6
4 Lecture written by Hornel and delivered in the Corporation Art Galleries, Glasgow on 9 February 1895
5 William Michael Rossetti, *Some Reminiscences*, I, London, 1906, p.276
6 Richard Dorment, *James McNeill Whistler 1834-1903, Whistler*, Tate Gallery exhibition catalogue, London, 1995, p.14-5
7 John Lavery, *The Life of a Painter*, London, 1940, p.108
8 Quoted in *Whistler, a Retrospective*, edited by Robin Spencer, New York, 1989, p.227
9 *Art for Industry, The Glasgow Japan Exchange of 1878*, Glasgow Museums exhibition catalogue, 1991, pp.9 & 14
10 Mitchell Library, Glasgow
11 *Quiz*, 2 November 1888
12 *Art for Industry*, op.cit.,p.39
13 Hornel's lecture
14 *Quiz*, 16 February 1893
15 *The Bailie*, 22 February 1893
16 *Glasgow Herald*, 25 February 1893
17 *Dumfries & Galloway Courier & Herald*, 21 January 1893
18 *Lloyd's List*, 6 March 1893
19 Undated letter from Henry to 'My dear A.', reprinted in *Glasgow Herald*, 21 October 1893
20 Hornel's lecture
21 Letter from George Henry to Hornel dated 13 July 1894 (Hornel Trust)
22 *Two Glasgow Artists in Japan, Glasgow Evening News* interview with George Henry, reprinted in *Kirkcudbrightshire Advertiser*, 20 July 1894
23 Hornel's lecture
24 Henry's interview with the *Glasgow Evening News*
25 *Photography*, 13 July 1893
26 Letter from George Henry to Hornel dated 6 October 1893 (Hornel Trust)
27 Hornel's lecture
28 Henry's interview with the *Glasgow Evening News*
29 Letter from Capt.F.Brinkley to Hornel dated 16 October 1893 (Hornel Trust)
30 Undated letter from George Henry at Inage near Chiba to Hornel (Hornel Trust)
31 Three undated letters, letter from near Chiba dated 6 October 1893 and from Kanazawa dated 13 January 1894 (Hornel Trust)
32 Hornel's lecture
33 Ibid.
34 Ibid.
35 *The Japan Weekly Mail*, 19 May 1894; *Lloyd's List*, 21 June 1894
36 Letter from George Henry to Hornel dated 3 December 1895 (Hornel Trust)
37 Letter from George Henry to Hornel dated 13 July 1894 (Hornel Trust)
38 See letter from Charles Mackie to Hornel dated 28 December 1894 (Hornel Trust)
39 Letter from George Henry to Hornel dated 17 October 1894 (Hornel Trust)
40 Undated letter from George Henry to Hornel (Hornel Trust)
41 *Glasgow Evening News*, 20 April 1895
42 A.S.Hartrick, *A Painter's Pilgrimage Through Fifty Years*, Cambridge, 1939, p.61
43 *St Louis Suburban House Journal*, 14 September 1895
44 *Glasgow Evening Citizen*, 25 April 1895
45 *Glasgow Evening News*, 25 April 1895
46 *Quiz*, 2 May 1895
47 *Glasgow Herald*, 4 May 1895
48 *The Studio*, vol.IX, 1896, p.208
49 *The Bailie*, 15 May 1895
50 *St Louis Suburban House Journal*, 14 September 1895
51 Frances Fowle, *Alexander Reid*, unpublished thesis, 1993, pp.114-5
52 *The Bailie*, 22 February 1893

CHAPTER EIGHT

'THE MUSIC OF THE WOODS'
1895-1906

BY THE MIDDLE OF MAY HORNEL WAS BACK AT KIRKCUDBRIGHT, NO doubt delighted with the success of his exhibition at Alexander Reid's gallery in Glasgow.[1] The *Kirkcudbrightshire Advertiser*, at one time somewhat critical of his painting, greeted his return with fulsome praise, congratulating him on 'the splendid achievement in Art which lately called forth such high eulogium from the Glasgow Press.'[2]

It was probably around this time that he moved into the former Custom House just across the Old High Street from the family home. The house, owned by a family trust, had been unoccupied for a couple of years.[3] Now that he was thirty, he possibly felt that he needed to be on his own. His studio adjoined the house, which made it more convenient. It seems likely that it was then that Elizabeth, known as 'Tizzy', went to keep house for him.[4] She was the eldest unmarried sister, five years older than he was. He had a reputation for being a heavy drinker and Tizzy probably felt that he needed looking after. Hornel was never to marry and Tizzy ran the household, acted as hostess when he entertained and was a constant companion until his death over thirty years later.

However during 1896 and the following year there may have been close friendship, if not romance, in the air. Hornel became friendly with the artist Bessie MacNicol, one of the 'Glasgow Girls', a bright, spirited girl of uncertain health, five years his junior. She was very much a 'New Woman' of the period. They could have met in Glasgow or during a visit to Kirkcudbright, when she may have been accompanied by a younger sister Jessie.[5] Bessie MacNicol wrote nine letters to Hornel, from which it seems their relationship blossomed into a close, relaxed friendship centred on their art. She admired Hornel's work - his rich colour and painterly style - and probably was influenced by him, as she was by several of the Boys. Certainly her palette became lighter and brighter after contact with Hornel.[6] Her letters detail everyday occurrences - what she was doing and what was happening in Glasgow relating to art and artists. Hornel sat for his portrait, painted in his studio at Kirkcudbright. It portrays him with palette and brushes at the ready in front of a *kakemono*, which he had brought back from Japan. Bessie MacNicol exhibited the picture at the Royal Glasgow Institute in 1897. Hornel must have put on weight since his portrait, because on receiving a photograph of him she wrote 'For goodness sake do not eat so much or drink so much beer till you come to town or the boys will be saying my portrait of you is emaciated!'[7] After the exhibition she gifted the portrait to Hornel. The letters mention the possibility of Hornel gifting a painting in return. In due course he gave her one of his Japanese works, a picture depicting a kite-flyer, which may have been *Kite-Flying, Japan* (National Gallery of Scotland). Whether there was anything more in their relationship than a close friendship can only be guessed. Without Hornel's letters to her it is impossible to tell what *his* true feelings were. In one of her letters she asks him 'By the bye what do you mean by our 'gay festivities' that you spoke to Konky [Robert McConchie] about? Do you mean our somnambulating walk to the Doachs?'[8] In another letter she told him 'I have been very good & behaving myself as I never have done before - I have not yet done hearing of my terrible misdemeanours in working in your studio Ned. If the people chaffed me I could take it, but it comes to pure scandal - or I should rather say not pure. One vile brute said he had the best authority for what he insinuated...You see I do not care who knows the absolute truth but garbled accounts & added-to-stories are the devil's own work to combat.'[9] Perhaps it was rather

foolish in those days to work unchaperoned alongside a male artist in his studio, however innocent the relationship. Whatever there was between them, it withered away towards the end of 1897. She wrote in her last letter to him, obviously depressed through illness: 'Merry Xmas to you! I have not written for some time...How are you getting on with your work Ned? About mine I say nothing because you did not like it from the start. You should have told me that & not have said you liked it very much - you sweep!'[10] In 1899 she was to marry Dr Alexander Frew, who for a time had given up practising obstetrics and gynaecology to become a painter and whom she had known for a number of years. Ironically, this gifted artist died in childbirth in 1904.

In Kirkcudbright Hornel began to take more interest in local affairs. He was convenor of the town's Decorations Committee for the Jubilee celebrations in 1897, commemorating Queen Victoria's sixty years on the throne. He became a member of the Town Council in November that year and was particularly active on the Museums Committee. However he resigned from the Council two years later in protest at the disputed action of the Provost concerning the town's pavements.[11] It all seems to have been a storm in a teacup, but Hornel took such things very seriously. He also resigned from the Committee of the local horticultural society at the same time. He tried to revive the traditions of the town's Incorporation of Shoemakers at a time when shoemaking in Kirkcudbright was in decline. At a meeting in his studio in 1888 he had been accepted as a member of the Incorporation in view of his family's long connection with the craft. He was elected Deacon in 1891, a post he held until he went to Japan in 1893. W.S.MacGeorge, who surely could have had no connection with the craft, was introduced as a member in 1891. Similarly Tom Blacklock was elected a member in 1897. Over the next few years one or other of Hornel, MacGeorge and Blacklock served as Deacon.[12]

During this period Hornel exhibited widely both in Britain and abroad. At an exhibition in Barcelona in 1894 Charles Kurtz, the director of the Art Department of the Saint Louis Exposition and Music Hall Association, had seen some of the Boys' work and had persuaded them to exhibit in St Louis the following year. On that occasion all the Boys, with the exception of Lavery and Henry, together with Hornel's brother-in-law William Mouncey and the English painter William Nicholson sent a total of one hundred and fifteen works. Thirty-seven pictures by a large selection of Danish artists were also exhibited. Hornel showed nine paintings, including four Japanese works, some of which were for sale.[13] Although Crawhall, Gauld and Hornel had shown work at the annual exhibition of the Pennsylvania Academy of the Fine Arts in Philadelphia the previous year - Alexander Reid lent two of Hornel's earlier paintings, *Children at Play* and *Pastoral* - the St Louis exhibition introduced a large body of work by the Boys to an American audience for the first time. The exhibition went on to the Art Institute in Chicago and the Cincinnati Art Museum, ending up in New York. Judging from

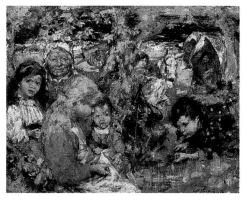

PLATE 44
The Gipsy Camp Fire
1897
Oil on canvas, 25 x 30
Private Collection

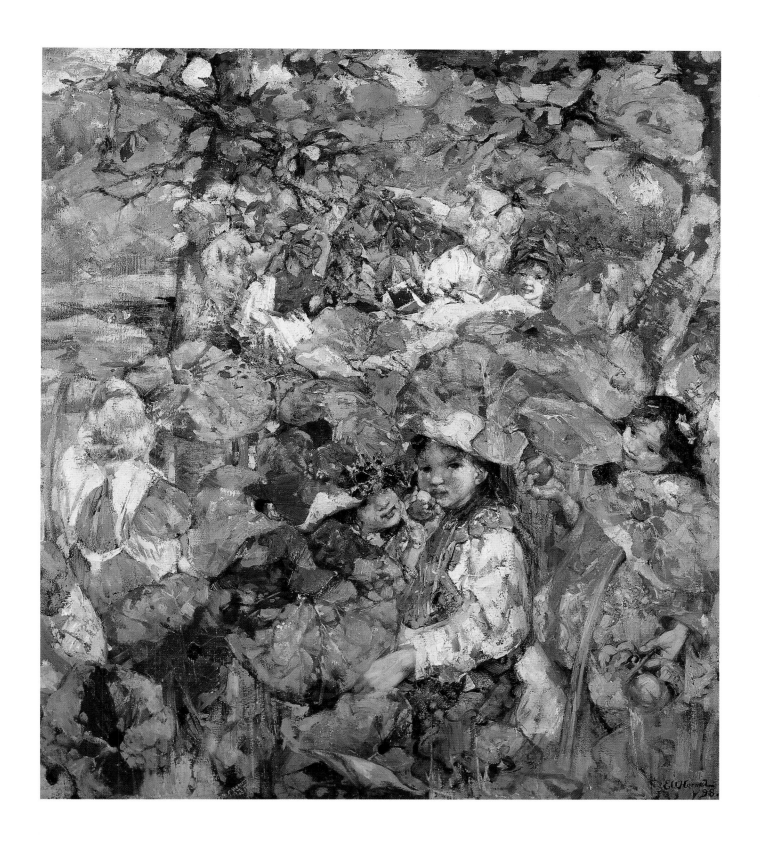

PLATE 45
In the Orchard *1898*
Oil on canvas, 46 x 40
City Art Centre, Edinburgh

contemporary newspaper reports, there seems little doubt that Hornel's work attracted most attention. The *St Louis Life* commented:

> Entering Gallery A. [in which the work of nearly all the Boys was hung] one is dazzled at first by the sight of Hornel's canvas [*May Day*] hanging on the wall opposite the entrance. There is something about the work of Hornel that impresses one like the music of a full orchestra; each of his pictures is a tremendous harmony filled with vibrating and resounding chords of color. His earlier paintings somewhat suggest gorgeous tapestries; his later works are more like splendid compositions in stained glass, in which the coloring often gives the effect of precious stories.[14]

May Day was an earlier work and may be the painting titled *Springtime* (possibly after it was cut down), which Hornel had shown at the Royal Scottish Academy in 1893 and which is now known as *The Dance of Spring*. Only the critic of St Louis' *The Mirror* sounded a note of dissent, when he wrote 'Hornel may have painted with some idea behind his brush but he hid his idea under the paint.'[15] Following an immediate challenge by Kurtz, the critic commented:

> As to Hornel's art, I may say that it is true he is a superb colorist, and that his achievements in tone are really remarkable, but it is none the less true that he appeals only to the esoterics in art. To the initiate he certainly must tell a story, convey a message, else his work is valueless. The message, the story, is unconceived by the ordinary patrons of the galleries...[16]

Unfortunately the high praise he had received from most of the critics did not translate into sales.[17] Kurtz wrote to him the following year 'I regret that we did not sell some of your pictures in America last year, and I trust that fact will not cause you to withhold sending us something this year.'[18] Hornel sent over *Butterflies* and four Japanese paintings in 1896 and *Autumn Sunshine* in 1897.

In Britain Hornel exhibited *Entrance to a Japanese Temple, On the Seashore* and *Primrose Bank* (all untraced) at the inaugural exhibition in 1898 of the International Society of Sculptors, Painters and Gravers in London's Knightsbridge. The International, as it came to be known, had been founded the previous year by Whistler, who was elected its first President. It was intended that the artists invited to exhibit at the International should represent the best of non-Academy art and be drawn from a wide range of countries. Within a few years most of the Boys, with the exception of W.Y.Macgregor, had been elected members. However it never really fulfilled the promise of its first exhibition. It was perceived initially as an exhibiting society for Whistler and his followers. After his death in 1903 the International eventually settled for a position somewhere between the Royal Academy and the New English Art Club. Along with many of the Boys, Hornel was to exhibit at the International sporadically over the years, remaining a member until around 1923.

From 1895 to 1899 was a period of transition for Hornel. He continued to execute a number of Japanese subjects, but in the main he reverted to the decorative paintings of girls in the Galloway countryside. At first it was a rather uneasy time for him on a number of counts. He was finding it difficult to recreate in his current work the excitement and vitality of his earlier Japanese pictures. Indeed in some cases his painting degenerated into a bewildering fusion of figures and background, lacking the intuitive colour harmonies that inspired his earlier work. Alexander Reid wrote to him in October 1896: 'I do not care for the pictures you have sent (that is comparatively). If I am not to have all your pictures I can only take the best (that is those I think the best) or none.'[19] Hornel missed the mutual support, exchange of ideas and objective criticism, which the relationship with Henry had provided in similar circumstances in the past to the benefit of both men. It was noticeable that Henry's work had suffered through the absence of Hornel and there is no reason to suppose that it was any different in Hornel's case.[20] He

must have expressed doubts about his work, because a friend in Edinburgh cautioned him: 'You must stick to your own style of painting for really the battle is won in recognition from those who are able to appreciate, though the vulgar herd do not understand green cows.'[21] Despite the overwhelming success of his Japanese exhibition it appears that he was still experiencing financial difficulties. The editor of the *Dumfries Courier* wrote to him in September 1897 that he had decided not to buy one of Hornel's Japanese paintings and asked 'Could you not raise the wind by writing on art? The L'Pool Daily Post might pay you a guinea a column for a few articles, and the Daily News might give £2.2/-, whereas the Dumfries Courier & Herald might get the length of 10/6d a column for one or two on local art.'[22] His financial position does not seem to have improved by March the following year, when he wrote to his friend Thomas Fraser:

> Many thanks for your kind letter. The picture 'Resting' is in Edinburgh (not Glasgow) & is not yet sold. The size of it is 30 inches by 25 inches. The price in Catalogue is £65. I hope your friend will see his way to buy it, as it would be a great consideration to me at present. Try your best with him.[23]

In fact the painting was not sold at the exhibition at the Royal Scottish Academy and Hornel decided to try his luck at the Walker Art Gallery's Autumn Exhibition in Liverpool. In the midst of all this he seems to have suffered a fire at his studio in Kirkcudbright towards the end of 1896 and some work was damaged or possibly destroyed.[24]

Somewhere along this rather difficult road Hornel decided that the way forward was to seek a style of painting which would not only meet with the approval of the critics, but also attract the interest of the public or at least the ordinary collector of art. Back in 1895 the critic of *The Mirror* in St Louis had defined the problem, when he wrote that Hornel, marvellous colourist though he was, appealed 'only to the esoterics in art...the message, the story, is unconceived by the ordinary patrons of the galleries.'[25] If he was to make anything of his career as a painter, he had to broaden the appeal of his work. The beginnings of a change in style can be seen in *In the Orchard* (1898: City Art Centre, Edinburgh, pl.45), probably the painting *The Old Orchard*, which was exhibited at the Royal Glasgow Institute in 1899. It portrays seven girls (at least!) playing in an orchard. They merge with the trees and the lush ground vegetation to form a mosaic of greens, red, pink, orange, creams and black. The colour is relatively low key, when compared to his

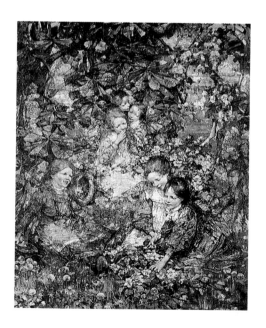

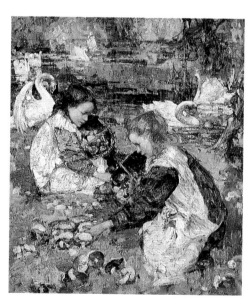

(left)

PLATE 46

Spring *1903*

Oil on canvas, 60 x 48
McLean Museum & Art
Gallery, Greenock

(right)

PLATE 47

Gathering Mushrooms
1901

Oil on canvas, 30 x 24
Private Collection

103

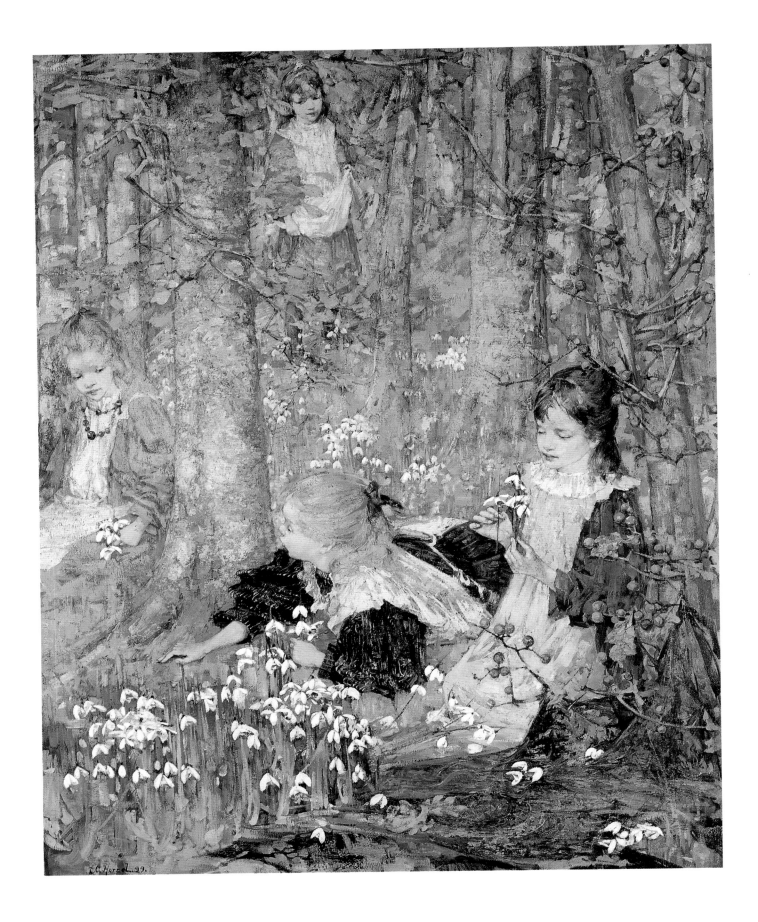

work of the first half of the 1890s, and, although pattern and texture are still all-important, the girls' features are more carefully drawn.

Among the paintings he executed in 1899 are *The Old Shawl* (private collection), which he showed in 1899 at Glasgow Art Club along with *Water Lilies* and a large painting titled *Echo* (untraced), which was given the place of honour in the biennial exhibition of members' work, and *Fair Maids of February*, now known as *The Coming of Spring* (Kelvingrove, Glasgow, pl.48), exhibited at the Royal Glasgow Institute the following year. Both works confirm this change in style. Subject matter again assumes importance. Although still concerned with design and decoration, Hornel's portrayal of the woodland scene in both cases is closer to Nature than his previous work. For the time being he had forsaken the hot reds of the 1890s for a cooler palette of greens, browns, orange, creams, white and blue. The figures of the girls are well modelled and are placed naturally within their setting. For the first time since he adopted his early decorative style in 1887, line and form take precedence over pattern, texture and colour.

The critics were virtually unanimous in their praise of the new work. Reviewing the exhibition at the Art Club, the *Glasgow Evening News* commented that he 'no longer runs riot in colour merely for the sake of colour; he has grown immeasurably in self-restraint and sanity. His pictures this year are not mere Japanese puzzles in colour. He is on the right road.'[26] Similar sentiments were expressed by the *Glasgow Herald* regarding *Fair Maids of February*:

> This canvas marks the artist's highest development until now. It has the decorative feeling and the glow of colour which we associate with his name, but it is not entirely decorative. Three girls among the snowdrops of the early year are drawn and outlined with precision. Nothing is wanting in form or grace...Altogether a picture of rare beauty...[27]

Fair Maids of February was purchased by the Corporation of Glasgow for £400, a fairly substantial sum in 1900. There had been some prior discussion about a major painting by Hornel being acquired for the civic art collection. Thus he had been 'far from pleased' when he had learned that *Fair Maids of February* had been hung at the Institute's exhibition in one of the smaller rooms rather than the main gallery, which he thought would spoil his chances of a sale. He wrote to J.A.Paton, the Superintendent of the Corporation Galleries, to alert him:

> Although perhaps a wrong principle to go on, considerable importance has been always given to a good place in the large gallery, as compared to the small rooms, and I had hoped to have secured a place there. This, however, will not I trust affect the question with the Corporation, and that they will judge the picture on its merits, not from its position on the walls. I am not boasting, or placing too much importance on my picture, when I say, if all the pictures in good places on the line in the big room are better than mine, it is a much stronger exhibition than usual. I thought I would let you know; of course this note is merely 'entre nous' - I am quite in the dumps today - will see you on Wednesday.[28]

The position in which pictures are hung in an exhibition - the importance of the room and whether or not they are hung 'on the line' - can be an emotive subject. Henry's letters to Hornel contain many such references, reflecting euphoria or smug satisfaction on the one hand and dejection and perceived insult on the other. Being a member of the hanging committee is a difficult and somewhat thankless task, as Hornel himself must have found out when he acted as one of the three hangers for the Institute's exhibitions in 1905 and 1916.[29]

Thomas Corsan Morton, Hornel's friend and fellow Glasgow Boy and one of the hangers that year, must have been somewhat relieved to learn that the Corporation *had* bought the painting. He wrote to Hornel:

(opposite)
PLATE 48
The Coming of Spring
1899

Oil on canvas, 59 x 47$\frac{1}{2}$
Glasgow Museums: Art
Gallery & Museum,
Kelvingrove

I was delighted to hear, when I came into town this morning, of the fortunate issue of our hopes. More power to your elbow. You have now supplied, next to London, the two most populous cities of the Empire & I hope that the other large centres of industry will follow suit. This purchase should not only encourage other cities to buy, but should help your sales with private buyers, & entitle you to put an extra saxpence or twa on the prices. The prophet will also, doubtless, get more honour in his own country.[30]

Morton's hopes for his fellow artist were soon to be realised. The *Glasgow Evening News* was right, when it had remarked that Hornel was 'on the right road.' His return to a style of painting which was based on line and form and a greater concern for naturalistic truth, while retaining the overall decorative framework, immediately found favour with a broad range of collector. Paintings such as *The Lily Pond* (1900: Drambuie, pl.49), *Gathering Mushrooms* (1901: private collection, pl.47), *Girls with Goats* (1903: private collection), *The Secret* (1903: private collection), *Spring* (1903: Greenock, pl.46), *Easter Eggs* (1905: Drambuie), *The Music of the Woods* (1906: National Gallery of Scotland, pl.52) and *Sea Shore Roses* (1906: City Art Centre, Edinburgh, pl.53) established his wider reputation and quickly changed his financial position to one of some affluence. It is almost as if Hornel had come full circle. He began painting under the influence of Bastien-Lepage. In his work of the early 1900s - his 'elfin' children playing in woodland carpeted with flowers - there are echoes of *Le Pere Jacques* by Bastien-Lepage (1882: Milwaukee Art Museum), albeit in Hornel's very individual decorative style and without the deep symbolism of the French artist. It is possible that Hornel may have seen *Le Pere Jacques* when it was exhibited at the London gallery of Tooth and Sons, who had purchased the painting at the Paris Salon of 1882. By 1889 at the latest it was in a private collection in America. It was illustrated in the *St Nicholas Magazine*, a journal for children, in 1887.[31]

By 1908 his work had been acquired by the civic galleries of Bury, Bradford, Brighouse, Huddersfield, Leeds, Manchester and Rochdale in addition to those of Liverpool and Glasgow.[32] When Liverpool purchased a second work by Hornel in 1905, *The Captive Butterfly*, there was hardly a murmur of dissension on that occasion. It is interesting to note, however, that neither the National Gallery of Scotland nor the Tate Gallery acquired anything. Obviously the prophet was not to 'get more honour in his own country' as far as the national galleries were concerned. It was left to the noted collector Sir Hugh Reid, Bt., who at one time owned no fewer than twenty-five works by Hornel dated between 1885 and 1906, to gift three major works: *Autumn* (1904) to the Tate Gallery in 1928 and *Kite-Flying, Japan* (c1894) and *The Music of the Woods* (1906) to the National Gallery of Scotland in 1934.[33]

Hornel continued to exhibit with the Boys at international exhibitions and a number of his paintings were acquired by public galleries overseas. He showed *Butterflies* and *Interior at Tokyo* at the first Pittsburgh International Exhibition of Contemporary Painting and Sculpture at the Carnegie Institute in 1896. He was to send work to Pittsburgh at irregular intervals until 1922. When Charles Kurtz moved from St Louis to the Albright Art Gallery in Buffalo, New York, he organised an exhibition of paintings by the Boys in 1905, which subsequently travelled to Chicago, St Louis and Philadelphia. Hornel's *Easter Morning* was purchased by Kurtz for the Albright Art Gallery and St Louis acquired *Primroses* (1905). The Boys' work ended up in Toronto, where it was shown at the inaugural exhibition of the Toronto Art Museum. Hornel's *The Captive Butterfly* (1905) was the first painting acquired by that museum, now called the Art Gallery of Ontario. At the Triannual Salon of Ghent in 1906 the Belgian Government purchased *A Spring Idyll* (1905). *A Summer Idyll* (1905) was acquired by the Art Gallery of South Australia in Adelaide in 1907.

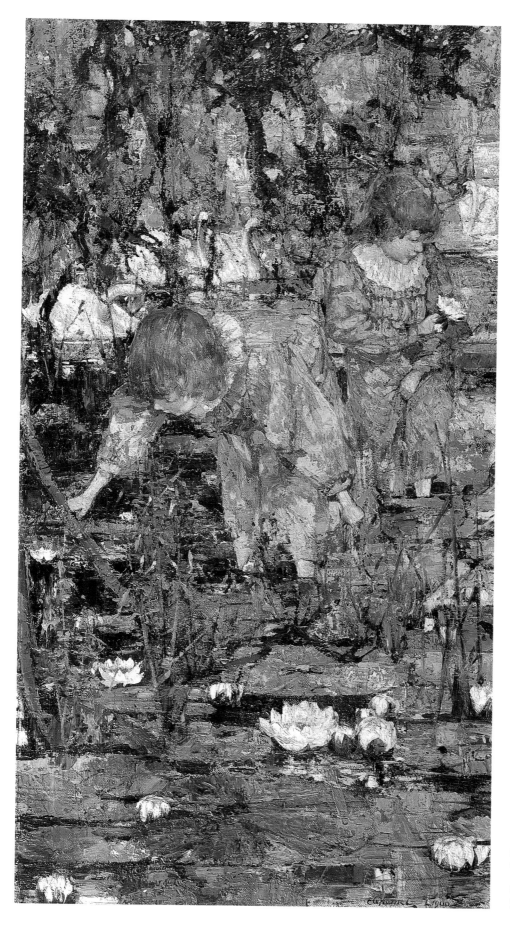

PLATE 49
The Lily Pond *1900*
Oil on canvas, 37 x 19
The Drambuie Collection

107

Around the turn of the century Hornel had begun to use photography as a major aid in relation to drawing and composition. Delacroix had recognised the importance to artists of the photograph as early as 1853 and many artists since then had used photography to some extent.[34] Degas, for instance, was using photographs about 1860 or 1861, but it was not until around 1880 that he was able to render correctly in his work a running horse, after having seen the 'instantaneous' photographs produced by Eadweard Muybridge.[35] Lavery admitted that he used photographs as early as 1879.[36] Paterson was a keen amateur photographer.[37] As has been mentioned in the previous chapter, Hornel had been interested in photography for some time. Kodak brought out the portable camera in 1888 and it may have been this which triggered his enthusiasm. Henry wrote to him in November 1891, bemoaning the relatively short spells of good weather when an artist could work out of doors and adding 'You must be jolly well off with your camera?'[38] One of Hornel's close friends in Kirkcudbright was Robert McConchie, known as 'Konky', who was a very good photographer.

Hornel was not a natural draughtsman and in the early years he used his camera in place of a sketchbook. It appears that he very rarely executed preliminary sketches; only a handful of student drawings have been uncovered.[39] From about 1900 onwards, however, he used photography not only as an aid to drawing, but also as a method of composition and of obtaining the correct tonality when painting faces and limbs. Hornel left behind a huge cache of glass photographic plates of young girls in various poses and studies of hands, etc., taken both in Kirkcudbright and on his subsequent overseas journeys. Some of the plates can be identified with figures in specific paintings.

The Kirkcudbright girls came from a number of local families. Rose, Edith and Maud Poland, the young daughters of a gamekeeper at Torrs Farm, appear in many of the photographs.[40] Hornel would pose the girls, chaperoned by his sister, either singly or in groups, get the light as he wanted it and then have them photographed, usually by McConchie. In those days this did not present any problems or raise any eyebrows, as it would do today. Parents were delighted to allow their daughters to be photographed and painted by a much respected artist and it was very convenient for Hornel.[41] Most children are not able to stay still for long and make poor models for a painter at the easel. Besides, Hornel had little patience with children according to Mrs Effie McNeillie, who came to Broughton House as a housemaid in 1917 at the age of seventeen.[42] Using perhaps a number of photographs on a 'mix and match' basis, Hornel would work out his composition and sketch in on the canvas in brown or black paint the outline of the figures and other principal features. He worked up the faces of the figures in the studio and usually completed the painting *en plein air*. Normally faces and limbs are delicately executed with little evidence of brushwork, as if he had transferred the photographic image on to the canvas in colour. In general the rest of the painting is broadly handled. However Hornel was still very concerned with the decorative effects of pattern and colour and in some instances, such as *The Music of the Woods* and *Sea Shore Roses*, the foreground is richly detailed. The snowdrops, the primroses or the wild hyacinths in the woods flanking the Buckland Burn or the white and gold burnet roses on the sandhills of Brighouse Bay are beautifully painted to form a carpet of colour. In other work the bright yellow gorse, the whitethorn bushes or the spring blossom of the trees form an almost abstract backdrop of dazzling colour.

At the beginning of 1901 Hornel and Tizzie moved into Broughton House, just across the street from the old Custom House. His purchase of this rather grand house reflected Hornel's growing confidence and the dramatic improvement which was taking place in his financial position. Set back from the street behind wrought iron railings and a raised paved forecourt, Broughton House is a large, handsome house of five bays, rising to two storeys with attics and basement, eminently suitable for a successful artist and gentleman.

For a brief period it was the town house of the Murrays of Broughton and Cally. The house was built shortly before 1740 by Thomas Mirrie, a mason, and purchased in that year by Alexander Murray. Following Murray's death in 1751 it passed to his son James, who sold it in 1756, partly to finance the building of Cally House, the neo-Classical mansion near Gatehouse of Fleet designed by Robert Mylne.[43] In 1910 Hornel added a large gallery and studio, designed by the architect John Keppie, a close friend of his over the years. The gallery has an elaborate stone fireplace, which reaches to the ceiling, and wood-panelled walls topped by a plaster frieze based on that of the Parthenon. The large west-facing garden extends almost to the River Dee. The rounded hills dotted with trees, so typical of this part of Galloway, can be seen on the other side of the estuary. It is easy to imagine that it was looking at a scene such as this that inspired Henry to paint *A Galloway Landscape* and Hornel to execute his early pastoral idylls. Hornel designed and planted part of the garden in a Japanese style. He was a very keen gardener and was to be elected a Fellow of the Botanical Society of Edinburgh in 1927. A number of letters from friends and contacts preserved in the Hornel archives deal with bulbs, plants and gardening in general. Although the planting has changed over the years, traces of Hornel's garden can still be seen, such as the old magnolia tree, the two small ponds, one with stepping stones in the Japanese manner, and here and there a number of objects of oriental origin and other items collected by Hornel. Broughton House was to remain his home until his death in 1933. Tizzie continued to live in the house until she died in 1950. Bessie MacNicol's portrait of him hangs in the dining room to this day.

In March 1901 Hornel was elected an Associate of the Royal Scottish Academy, the last of the major figures of the so-called Glasgow School to be so recognised. Much to the consternation of his friends and his fellow artists from the West, Hornel declined the honour, writing to George Hay, the Secretary of the Academy:

> I beg to thank the President Council and members of the Academy for the unexpected honour they have so generously offered me, but deeply regret my inability to accept it. I am deeply sensible of the position I have taken up in art matters, and decline the Associateship therefore on principle, with no feelings of animosity, but with every good wish for the continued prosperity of the Academy and its members.[44]

In a letter to his friend, the publisher Thomas Fraser, he was more forthright:

> Many thanks for your letter of congratulation. It will not surprise you to learn that I have declined the honour of Associateship. I have been very happy as plain Hornel & I mean to remain such as far as these trumpery affairs are concerned. I am much more concerned

about my work. I am not built right someway for wearing Purple & fine linen. This decision will no doubt surprise some, gratify others & disappoint few. I am quite indifferent.[45]

Probably part of the explanation for Hornel rejecting the Academy lay in the undue time that he had had to wait for Associateship (to which several artists alluded in their congratulatory letters). After all he had been one of the handful of Boys who had put Scottish painting (albeit *Glasgow* painting) on the international map in the first half of the 1890s. George Henry had become an Associate in 1892. Even W.S.MacGeorge, who, although a fine painter, cannot be regarded as being in the same league as his friend, had been elected to the Academy in 1898. Of course at that time originality was low down the list of attributes looked for in prospective academicians. The principal reason, however, was that Hornel, ever the rebel, had no great love for academies and academicians (or indeed for Edinburgh, where he felt that he had wasted three years undergoing a purely academic training). He had not been a particularly consistent exhibitor at the annual exhibitions of the Royal Scottish Academy and certainly the Academy had not been of any help in his career so far. Of the seventeen works he had shown between 1883 and 1900 only one had been sold (and that purchased by his mother in 1883).[46] Thus, insensitive to the feelings of his artist friends, a number of whom were themselves Academicians and had supported him in his election, he chose to turn his back on the Academy. The decision must have seemed puzzling, if not unbelievable, to friends and colleagues, many of whom had written immediately to congratulate him. The reaction of Alexander Roche was probably typical:

> I wish you had considered your friends a wee bit more before taking action...now that you have thrown the honour back and given but slight reason...you have put us in an awkward position with regard to other candidates from the West, and certainly not improved the relations between the two sides of the country, not to speak of the natural resentment of the friends of the bona fide candidates.[47]

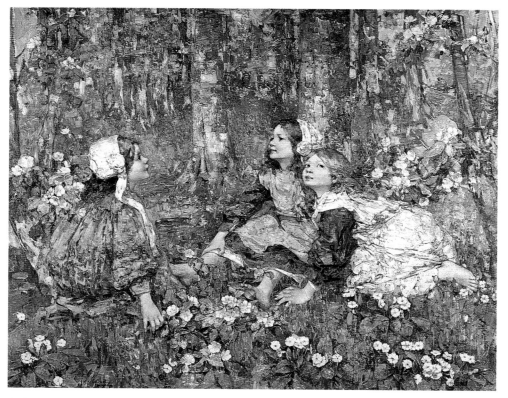

PLATE 52
The Music of the Woods
1906

Oil on canvas, 48 x 60
National Galleries
of Scotland

However it was Guthrie who felt Hornel's rejection most keenly. He had been a good friend to Hornel and it was he who had in all good faith entered Hornel's name in the Academy's Nomination Book, proposing him for election. Guthrie, obviously hurt and angry, wrote to him:

On my return I found your letter, to which it was necessary to give every consideration before replying. I feel your letter to be a specially kind one, but I should not be frank if I did not own that it causes me keen regret. There is much truth in what you say as to my fruitless outlays in this R.S.A. matter (& those of others with me) but I have never had this so clearly proved as it is by your action, for our justification cd. only have come in results brought about by the inclusion of such men as yourself. Had you given opportunity I should have asked you to reconsider your decision, & would have gone into this more fully - but since you have acted without regard to the effect, in this respect, upon your friends in the Academy, & since the matter is now public property, it would be useless to discuss it.[48]

Guthrie tendered an explanation and apology for the embarrassment suffered by the Academy at a Council meeting at the beginning of April, when 'after some conversation on the subject in course of which it was unanimously held that Mr Guthrie's explanation was an ample exoneration of his having nominated Mr Hornel and that some change in the method of nominating artists in future was needful the matter was allowed to drop.'[49]

Only fellow rebel Pittendrigh Macgillivray applauded Hornel's action:

Bravo! my dear Hornel. I think you have taken the right course. Were it not for considerations, which make me less free in action than I wish, I would be with you. I have no special objection to the Academy as such, but the bulk of the members have no idea what such an Institution ought to be and so far as I can judge reform is hopeless. It would take too long to write all I have to say in the subject, and I merely write to let you know that a friend upholds your act for a variety of reasons.[50]

Hornel's action was clearly both an embarrassment and a blow to the Academy, which, although it would never have admitted it, needed men like Hornel. It also isolated Hornel from most of his fellow artists and the mainstream of Scottish painting. There are few letters from fellow artists after 1901 in the Hornel archives. This sense of isolation was taken a stage further when around the same time he gave up his Glasgow studio at 136 Wellington Street. Walton tried to get him back into the fold in 1905, inviting him to exhibit again at the Academy and assuring him that 'the men here had no unfriendly feeling towards you and that your works would still be very acceptable,' but to no avail.[51] Hornel would never show at the Academy again. Even within the small circle of painters in Galloway he cut himself off in one way or another from several of his old friends. He had never liked Tom Blacklock. He had fallen out with his brother-in-law William Mouncey before the latter's death in 1901 and later he fell out with his companion from student days W.S.MacGeorge.

Although Hornel had rejected the Royal Scottish Academy, he did join a number of exhibiting societies. D.Y.Cameron persuaded him to stand for membership of the Society of Oil Painters.[52] He exhibited as a member in 1904 and 1905. In the latter year he joined The Society of 25 English Painters, which despite its title also included the Scottish painters D.Y.Cameron, James Whitelaw Hamilton and George Houston among its members (later it shorten its name to The Society of 25). Hornel showed three paintings at the Society's first exhibition in 1905, continuing to exhibit on and off until at least 1924. He also exhibited over the years as a member of the Royal British Colonial Society of Artists, which was founded in the late 1880s as the Anglo-Australian Society of Artists and included in its membership a handful of Scottish painters..

Hornel's self-imposed exile in Kirkcudbright did not have an immediate effect. Indeed the first five or six years of the new century had witnessed a marked increase in

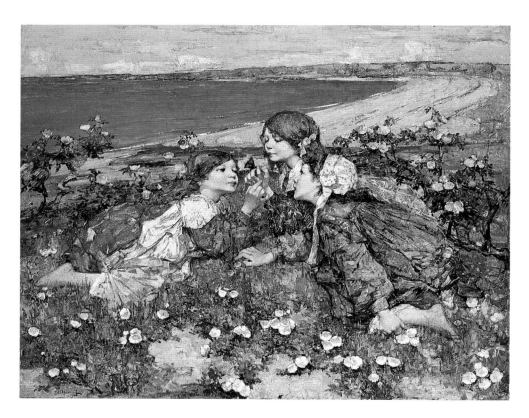

the popularity of Hornel's work. He had one-man shows at Alexander Reid's gallery in Glasgow in 1901 and again in 1903. In 1902 Reid mounted an exhibition of work by Hornel and fellow Glasgow Boy David Gauld.[53] His paintings had been acquired for many public and private collections throughout Britain, as well as a number of overseas collections. He never looked back. His work continued to sell well and he became a comparatively wealthy man. Over the years he used part of the proceeds of his sales to buy up properties in the town, ending up owning a significant portion of the High Street.

1 *The Bailie*, 15 May 1895
2 *Kirkcudbrightshire Advertiser*, 10 May 1895
3 Burgh of Kirkcudbright, Valuation Rolls
4 In a letter dated 24 December 1896 the artist Harry MacGregor wrote *'Remember me to Miss Hornel'* (Hornel Trust)
5 Ailsa Tanner, *Bessie MacNicol*, unpublished manuscript
6 Ailsa Tanner, *Bessie MacNicol (1869-1904) Glasgow Girls*, Edinburgh, 1990, p.194
7 Undated letter from Bessie MacNicol to Hornel (Hornel Trust)
8 Undated letter from Bessie MacNicol to Hornel (Hornel Trust)
9 Undated letter from Bessie MacNicol to Hornel (Hornel Trust)
10 Undated letter from Bessie MacNicol to Hornel (Christmas 1897) (Hornel Trust)
11 *Kirkcudbrightshire Advertiser*, 6 & 20 October 1899
12 Minute Book of Shoemaker Incorporation, Kirkcudbright (Hornel Trust)
13 Catalogue of the Art Department, Saint Louis Exposition and Music Hall Association, 1895

14 *St Louis Life*, 14 September 1895
15 *The Mirror*, 12 September 1895
16 *The Mirror*, 19 September 1895
17 *St Louis Life* of 26 October 1895 records that Hornel sold *On the Balcony, Yokohama*, but this seems to have been contradicted by Charles Kurtz, who presumably must have known what was sold at the exhibition he had organised.
18 Letter from Charles Kurtz to Hornel dated 20 May 1896 (Hornel Trust)
19 Letter from Alexander Reid to Hornel dated 21 October 1896 (Hornel Trust)
20 Letter from Bessie MacNicol to Hornel dated 9 December (almost certainly 1896) (Hornel Trust)
21 Letter from W.R.Macdonald to Hornel dated 21 September 1897 (Hornel Trust)
22 Letter from J. McGavin Sloan to Hornel dated 6 September 1897 (Hornel Trust)
23 Letter from Hornel to Thomas Fraser dated 12 March 1898 (Hornel Trust)

24 Letter from Bessie MacNicol to Hornel dated 9 December (almost certainly 1896) (Hornel Trust)

25 *The Mirror*, 19 September 1895

26 *Glasgow Evening News*, 3 November 1899

27 *Glasgow Herald,* 3 February 1900

28 Letter from Hornel to J.A.Paton, the Superintendent of the Corporation Galleries of Art, dated 28 January 1900 (Glasgow Museums, Archives of Art Gallery & Museum, Kelvingrove)

29 *The Bailie* 22 February 1905 and 20 September 1916

30 Letter from Thomas Corsan Morton to Hornel dated 8 February 1900 (Hornel Trust)

31 Archives of Milwaukee Art Museum, Milwaukee, USA; illustrated *St Nicholas Magazine*, vol.XV, no.1, November 1887, p.5

32 G.Baldwin Brown, *The Glasgow School of Painters*, Glasgow, 1908

33 Letter from Sir Hugh Reid dated 16 June 1928 (Tate Gallery archives); National Gallery of Scotland, *Catalogue of Paintings & Sculpture*, Edinburgh, 1957

34 Aaron Scharf, *Art & Photography*, London, 1968, p.90

35 Ibid., p.158

36 John Lavery, *The Life of a Painter*, London, 1940, p.42

37 Roger Billcliffe, *The Glasgow Boys*, London, 1985, p.164

38 Letter from George Henry to Hornel dated 4 November 1891 (Hornel Trust)

39 It is known that his sister destroyed a number of things following his death, which may have included sketches, etc.

40 In conversation with Mrs Peggy Miller and with Robert Lyall, Kirkcudbright, 19 March 1996;

41 In conversation with the late Jock Mitchell, Kirkcudbright, 29 November 1995

42 In conversation with Mrs Effie McNeillie, Kirkcudbright, 15 May 1993

43 I am grateful to Mr J.E.Russell of Gatehouse of Fleet for information relating to the early history of Broughton House

44 Letter from Hornel to George Hay, Secretary of the Royal Scottish Academy, dated 22 March 1901 (RSA Archives)

45 Letter from Hornel to Thomas Fraser dated 25 March 1901 (Hornel Trust)

46 Royal Scottish Academy Sale Books (RSA Archives)

47 Letter from Alexander Roche to Hornel dated 28 March 1901 (Hornel Trust)

48 Letter from James Guthrie to Hornel dated 26 March 1901 (Hornel Trust)

49 Minutes of Council Meeting of RSA on 2 April 1901 (RSA Archives)

50 Letter from James Pittendrigh Macgillivray to Hornel dated 26 March 1901 (Hornel Trust)

51 Letter from E.A.Walton to Hornel dated 8 January 1905 (Hornel Trust)

52 Letter from D.Y.Cameron to Hornel dated 9 November 1904 (Hornel Trust)

53 Frances Fowle, *Alexander Reid*, unpublished thesis, 1993

Broughton House
from the garden
The National Trust for Scotland

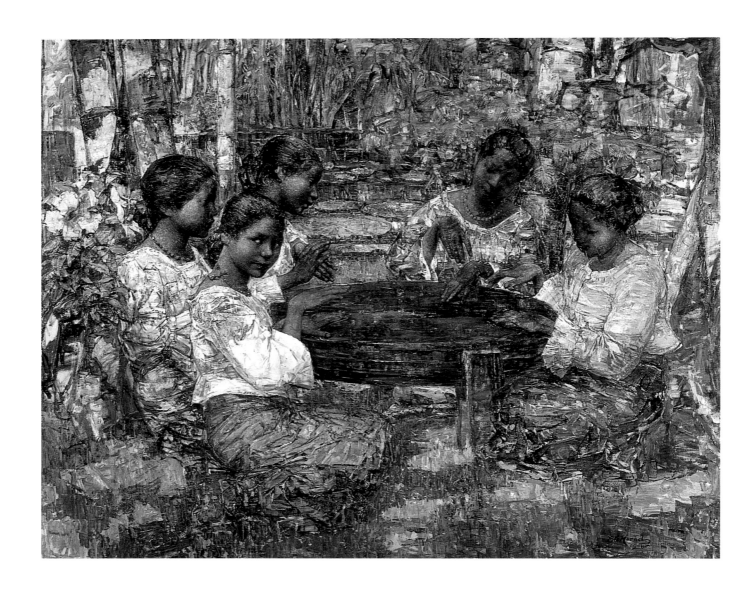

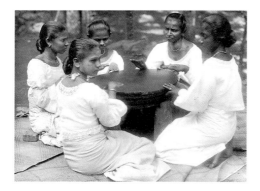

PLATE 55
Tom-tom Players, Ceylon
1908
Oil on canvas, 48 x 60
Manchester City Art
Gallery

PLATE 56
Tom-tom Players, Ceylon
Taken from glass
photographic plate,
one of many Hornel brought
back from Ceylon 1907

THE LATER YEARS
1907-1933

ON A WINTRY DAY EARLY IN 1907 HORNEL AND TIZZY SAILED FROM Liverpool for Ceylon.[1] They were going out to Colombo to visit their cousin James Hornell, who was the Government Marine Biologist there, particularly concerned with Ceylon's pearl fisheries. They also planned to see some of the island. Their departure had been timed not only to escape a month or two of the Galloway winter, but also to avoid the oppressive heat of Colombo in March. Their cousin had earlier warned Hornel about the heat and had advised him to 'bring a good sized umbrella & have a strip of red flannel sewed in to the middle seam of your coats - a strip about 3 inches broad, to protect the spinal cord from the sun's rays. Red is the best...'[2] Whether they went to that length is not documented! In Ceylon they visited the pearl fisheries with their cousin, went to the old fortified town of Galle in the south of the island to see the lace-makers and journeyed to the central highlands to visit Kandy and the tea plantations. From Ceylon they went on to Australia, visiting Bacchus Marsh in October that year, where both Hornel and Tizzy had been born. *The Bacchus Marsh Express*, reporting the visit of a local-born 'landscape artist of good repute', commented that Hornel had great praise for the art gallery in Adelaide (which owned one of his paintings), but was not impressed with that of Melbourne (which did not!).[3] Hornel did not do any painting in Australia; it was purely a holiday for his sister and himself. They returned to Colombo in November, where he had left all his canvases and painting materials, and got back to Kirkcudbright just before Christmas 1907.

Hornel had worked hard in Ceylon, although he had found it impossible to paint at the pearl fisheries because of 'the heat and the smell of the oysters left on the shore to rot...'[4] He wrote to his friend Thomas Fraser 'I have been very busy making the most of my opportunities here and laying down a fair amount of work. As I do not intend to finish anything here, I have a tremendous lot of studies...'[5] Probably they were oil sketches on panel or canvas, because it was not his custom to sketch in pencil or watercolour and no studies from his months in Ceylon have been uncovered. He also brought back a large number of glass photographic plates of Sinhalese life. Almost certainly his major paintings of Ceylon were executed with the aid of those photographs. The figures are very well drawn and the treatment of the faces is identical to that in his Galloway paintings of the previous seven years or so, when he was working from photographs. In some instances the faces are akin to a photographic image, when compared to the broad handling of the rest of the painting (pls.55 & 56), which led *The Art Journal* to comment:

> 'Tom-tom players, Ceylon'...shows a group of dusky Cingalese girls in a tropical woodland
> of palms and lotus blossom, grouped around a circular instrument, whose brown answers to
> their skin. Charming use is made of rose, of pale blue and green, but the faces are not
> persuaded into a unity. Brush and palette-knife work do not accord.[6]

Hornel had expected exotic colour in Ceylon and was surprised to discover an overall grey-green coolness. He explained to his friend E.Rimbault Dibdin, the director of the Walker Art Gallery in Liverpool, that this effect was due to 'the absence of verdure, the fact that the trees are almost all evergreens, whose dark, glossy leaves reflect the cold light of the sky, the lack of flowers - for though there are gorgeous flowers, they are all at the tops of trees and are not in evidence - and the intensity of the light.'[7] It made Hornel long to see his own garden again: 'Flowers have been so scarce here, that I go home with

double interest in my garden, & I daresay you would smile if you could hear all the great schemes Miss H. & I are evolving for Broughton House & its garden...From letters from home, my garden has being doing marvels. The Peonies were magnificent, & my Wisteria which I have longed for many weary years to see in bloom, took advantage of my absence & made a royal show. I hope soon to be amongst them all again.'[8] However the coolness of the Ceylon landscape was counterbalanced by the bright colours of the clothes worn by the lace-makers, the tea pickers, the water carriers and the tom-tom players. The Sinhalese appeared to him to be a pleasant, friendly, if somewhat lazy people.

He exhibited his paintings of Ceylon in London, Liverpool, Manchester and Glasgow in 1908 and early 1909. The critic of *The Studio* enthused over them:

> *Lace-Making in Ceylon* comes with all the inimitable charm of this master of decorative art, with new tints, fresh combinations, increased directness, bewildering confused orderliness, cunning distribution of unwonted greens, blues, browns, greys and yellows, so related and inter-related, so held together by a deft arrangement and apportioning of black as to secure a colour harmony such as only a veritable wizard of the palette could bring about.[9]

However the Ceylon work does not represent anything new in Hornel's *oeuvre*. It is a change of scenery, but it is not a change of style. It is a continuation of his Galloway work of the last eight years or so. That is not to suggest that the paintings of Ceylon are not good. Indeed they are well executed, charming and decorative.

Around this time there appears to have been talk of Hornel being elected to the Royal Academy in London. In one of his letters to Fraser from Ceylon he wrote: 'I have seen a great deal in the papers about my election to the R.A. but I am afraid it is mere gossip. However it does no harm, it doesn't give me Swelled Head at any rate. I have never been approached on the subject at any rate, & do not anticipate any movement in that way. We'll see how matters drift when I return.'[10] This indeed must have been 'mere gossip'. Hornel had exhibited at the Royal Academy for the first time that year, showing the wonderful *The Music of the Woods*, now in the National Gallery of Scotland. It would have been hypocritical of him to reject the Royal Scottish Academy on a point of principle and then embrace the Royal Academy. Whether he had any aspirations in that direction can only be guessed, but thereafter he exhibited at the Royal Academy each year up to 1917. He was elected an honorary member of the Society of Scottish Artists in 1911.

When his Sinhalese vein had been worked out, Hornel reverted to his images of girls in the varied landscape around Kirkcudbright. On its own each painting is rather delightful. It is only when they are taken together that a certain repetitiousness can be seen developing in his work. He now had a rather narrow range of themes - girls in woodland, girls by a pond, girls on a headland above the sea, girls on the sea shore - which he was to exploit to a point bordering on triteness. Quite simply Hornel had run out

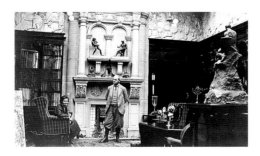

(left)
PLATE 57
Hornel and Tizzy in the garden at Broughton House
Hornel Trust

(right)
PLATE 58
Hornel and Tizzy in the Gallery at Broughton House
Hornel Trust

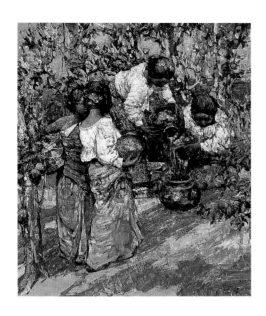

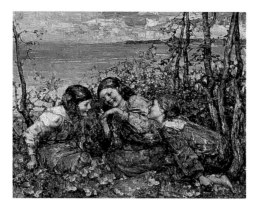

of ideas. By about 1910 he had said all he had to say in terms of his art. In this he was no worse than the majority of the Boys, such as Henry, Gauld or even Lavery, who also seem to have lost the inspiration and verve of their earlier work or had turned to the relatively lush pastures of portraiture. Hornel, isolated from the mainstream of art and now reliant on photography as an aid to drawing and composition, was adopting a somewhat mechanical approach to his painting. It is not difficult to understand this. There was little incentive to change an apparently successful formula. It seems that he had little difficulty in selling his work. A notebook details thirty-three paintings executed in 1911, a number of which bear the same or similar titles.[11] They sold for prices ranging from £10 to £400 either to individual collectors or to the Glasgow dealer George Davidson, who mounted exhibitions of Hornel's work in 1909 and 1912 (Hornel appears to have dropped, or been dropped by, Alexander Reid). In total they realised £2,385, a considerable sum in those days. There is no reason to believe that 1911 was an exceptional year. Often Hornel painted virtually the same subject several times, differentiated only by the colours of the season or the size of the canvas. Several are reverse images of other paintings. His use of photography, as opposed to painting from life, led in some instances to the figures being grouped in artificial or awkward poses or affecting over-sentimental gestures. In almost every case, however, the work is rescued by Hornel's wonderful colour harmonies. His acute colour sense rarely deserted him.

He had another one-man show in 1917, on this occasion in London at the Old Bond Street gallery of James Connell & Sons. From about this time a variation in the quality of

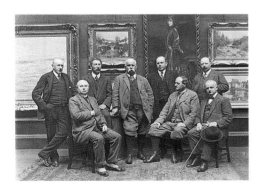

117

individual paintings can be discerned. In general his large exhibition pictures are very good, but in some of the smaller works there is a certain coarseness in handling. Two people in Kirkcudbright who knew Hornel have commented to the author about Hornel's bad eyesight (in 1931 he had to have an operation on one or both eyes in Glasgow), but this cannot be the reason.[12] Similarly, while Hornel is known to have been a heavy drinker when he was younger, contemporaries suggest that this was not the case in later life (Tizzie would have seen to that, although she never cured him of his heavy smoking!).[13] It may be that in some cases Tizzie had a hand in the painting. For some time there have been rumours in Kirkcudbright that in the later years 'Tizzie applied more paint than Hornel'.[14] Some sort of involvement on Tizzie's part appears to be substantiated in a letter received at Broughton House in 1996:

> ...The artist, Sam Peploe was a friend of E A Hornel and whenever he was in Kirkcudbright he and his wife, Margaret, visited Broughton House. On one occasion, Margaret called to see Hornel's sister and, to her surprise, found her working at an easel. 'Oh', that lady said, 'You have caught me at it! I sometimes do the backgrounds for him'.[15]

Why Tizzie did some of the backgrounds for her brother remains a mystery. Perhaps by this time his eyesight was so bad that he could remain at the easel only for relatively short periods. However he did not need to keep on turning out as many paintings as he did. His art had made him a comparatively wealthy man - he owned considerable property in the town - and he could have afforded to slow down, if not to retire completely. Perhaps he felt that he just had to paint. It is possible also that he needed money for an undertaking which was close to his heart, but he did not wish to realise investments or property.

In 1919 Hornel began an enterprise which would occupy him until his death. He started to collect books which had a connection with the counties of Dumfriesshire and Wigtonshire and the Stewartry of Kirkcudbright. 'Connection' was interpreted very widely to include authors and publishers born or living in Dumfriesshire and Galloway, books about the region or with some regional theme, as well as by or about people with some link to the region (even though in certain cases that link was somewhat tenuous).

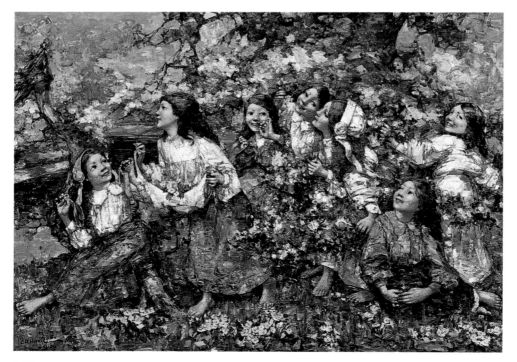

PLATE 63
Roundelay of Spring
1910
Oil on canvas, 30 x 42
Private Collection

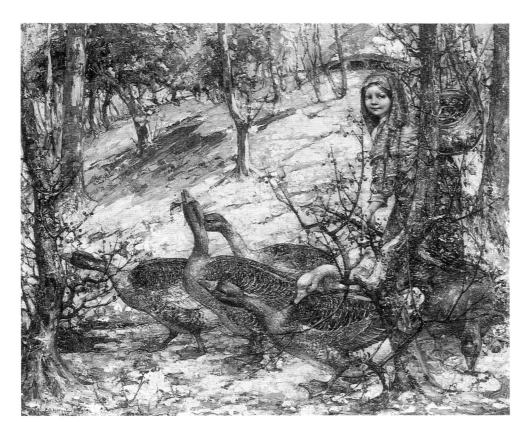

PLATE 64
The Goose Girl *1916*
Oil on canvas, 30 x 36
Private Collection

Hornel must have been considering the idea for some time, because he had a plan clearly in his mind from the outset: 'Over and above the desire to possess such a library, the wish I could hand it down to the good people of Galloway (in Broughton House as a house) is uppermost in my thoughts. So that a fine Art Gallery and library may be some day the pride of the Stewartry.'[16] It is interesting to note that as early as 1897 Hornel had proposed establishing in Kirkcudbright an art gallery for the work of local artists which would be open to the public, but nothing came of the idea.[17]

Hornel brought to the undertaking the passion and zeal of the true collector. His partner in this grand design was Thomas Fraser, a close friend since the 1890s; they had shared interests in books and gardening. Hornel provided money and commitment. Fraser supplied expertise and existing links with booksellers and other collectors. Fraser had taken up publishing in 1889 and had bought into a printing press in Glasgow in 1907.[18] As has been mentioned in chapter four, his first publication was *The Bards of Galloway*, to which Hornel contributed an illustration to Nicholson's poem *The Brownie of Blednoch*. All his life Fraser had a love for books and literature. He began to build up his own library about 1880 and by 1919 he had amassed over one thousand volumes. In the latter year he agreed to sell his library to Hornel. He was then seventy years old and must have been worrying about the future of his collection, because he wrote to Hornel:

> I can assure you at the outset that it will be a great relief to me to have the collection going into such good hands as yours: and the final destination of the books is all I could wish for. The idea of the collection coming under the hammer has always been a horror to me - whether it should come in my lifetime or on my departure from this sublinary sphere. I fancy my shade hovering the auctioneer's rostrum, and watching the work of a lifetime being scattered in a day. The thought was not a happy one.[19]

However Fraser retained an interest in his collection by agreeing to act as Hornel's agent in the acquisition of further books. Their joint aim was reiterated in a letter to Fraser sent

by Hornel from Kyoto in 1921, when Hornel and Tizzy were travelling overseas for a year:

> I think both of us have the same ideal in front of us, the creation of as perfect a local library as it is possible to make & establish for all times. It is essentially your child, & the amount of attention, care & love you are bestowing on it, is just what a man of your nature would do. Of course I am proud to be in it, and will do my part as best I can. It is a scheme after my own heart, & am proud of it.[20]

For ten years the two men pursued suitable items for the library both in Britain and overseas with a single-minded determination, as can be discerned from the letters exchanged between them while Hornel was abroad.

At Hornel's death in 1933 the library had expanded from Fraser's original one thousand volumes to over fifteen thousand, an acquisition rate in excess of eighty items each month over fourteen years. Most of the books and manuscripts were purchased, sometimes after tough negotiations or a long wait, but some were gifted on the basis that they were being preserved for posterity. Not surprisingly all this soon caused problems of space and organisation. One of their major successes was the purchase in 1922 of manuscripts, books and pamphlets from the estate of William Macmath. Although born in Brighton, Macmath's father came from the Stewartry. As well as building up a collection of items relating to Dumfriesshire and Galloway, William Macmath was an expert on ballads and folk-songs, having discovered and transcribed many of them. Macmath's collection of original manuscripts and his transcriptions form an important part of Hornel's library. Among the other treasures are some three thousand volumes by or about the poet Robert Burns, the greatest collection in private hands, and around three hundred volumes by or relating to Thomas Carlyle.[21] The library, on which Hornel lavished so much love and money, is without doubt a remarkable achievement.

In August 1920 Hornel and Tizzy sailed for Burma aboard the *S.S. Burma*, the first leg of a journey which would take them to Japan, Canada and America, before returning to Broughton House just over a year later. Hornel's letters to Thomas Fraser chart their progress round the world: Port Said; Bhamo, Mandalay and Rangoon in Burma, where they stayed for about three months; Singapore; Hong Kong; Shanghai; Kobe, Kyoto, Tokyo and Yokohama in Japan, where they remained for almost six months; Vancouver and Quebec, sailing on the *S.S. Empress of Britain* for home on 10 September 1921. The letters cover Hornel's three passions in life: his painting, his garden and his library, the latter, not surprisingly, being the principal subject. Hornel had gone to refresh his work and to visit the country Henry and he had painted almost thirty years earlier.

From Mandalay he wrote to Fraser: 'I certainly got some very nice subjects, but I have an idea on for this place & I hope to lay in my most important picture here in Mandalay; a picture I have in mind for many years & have never been able to get the material. So I will have a shot at it now.'[22] About ten days later he wrote again:

> Since coming to Mandalay, we have got right into things Burmese, & am having quite a good time. I had some misgivings about the work I had been doing, & was doubtful of how far I had got the spirit of Burma & the types. Two Burmese gentlemen, who paint fairly well, & who have kept in touch with all the work that has been done here by Britishers & others, called on me wanting to see the pictures & get some help with their own. Their work was wonderfully good. They were, to my surprise, greatly delighted with my work, said it was the first time they had seen the Burmese type really done right, & the first time Burma had been painted in cool colours as it ought to be (this last I was specially pleased at, because I had no end of controversy at home, over my Ceylon pictures).
>
> They have been so delighted, that they have arranged all kind of sights for us. I explained to them my idea of the picture I mentioned to you in my last letter, that had been in my mind

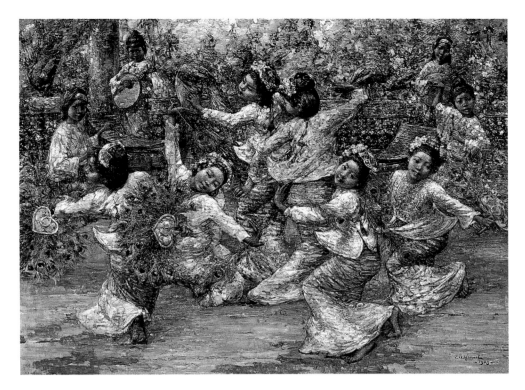

so long; a picture which would be very Burmese, dancing girls & Peacocks, with the old Palace in Background. They took us yesterday to a theatre & introduced us to the Manager who got very interested. He turned out his best Dancers, & showed us the best & most typical Burmese dances. He saw my work & said I must get all the girls photographed and he would see to it personally that the poses were absolutely right, & that I should get all the details correctly.[23]

The photographs were duly taken and the end result is the exotic *Memories of Mandalay* (1923: Hornel Trust, pl.65), which he exhibited at the Royal Glasgow Institute in 1923 and at the Walker Art Gallery in Liverpool the following year. It hangs in Broughton House to this day.

Hornel and Tizzie spent most of their time in Japan in Kyoto. Hornel got on well with his work and enjoyed seeing the country again: 'I found Japan all I expected of it. I only wish I had more ability to do it justice. It is finer than Burma. It has all Burma has, plus that something that comes to a people with great art traditions & art possessions. There is a meaning to everything you see, and it makes you think & in thinking you make discoveries…'[24] In another letter to Fraser, Hornel outlined his method of working:

…the Photoman said he would supply two good Dancing girls, if I would go & pose them…He certainly procured two very handsome & magnificently clothed females, who posed excellently & from a view of the negatives, they are a fine and useful set. So I am now in possession of a great amount of work, however it may turn out ultimately. It is quite impossible to carry the work any length here, as the conditions are so bad, so I find it more profitable to lay in compositions and schemes of colour, and delay the further development until I get home again. If one has the colour and composition, the finishing doesn't amount to a great deal. I am just making the best use I can of my time & opportunities & I can't do more.[25]

Despite the high hopes he had expressed in Burma and Japan, Hornel was not able to bring forth anything new in his finished work. It lacks the exuberance and daring of his Japanese paintings of the 1890s. Of course there are a number of highlights, such as

Memories of Mandalay, but in general the paintings are no more than a colourful record of his travels. It is Galloway transported to the Orient. Soon he returned to the all-too-sweet paintings of girls set in the Kirkcudbright landscape.

Hornel was approaching sixty years of age, a very successful artist in terms of the popularity of his work and a comparatively wealthy man. Now he and Tizzie were driven to his favoured painting grounds at Brighouse Bay, the Buckland Burn, the Doon, Sand Green or Carrick in 'a posh car' by their chauffeur Sam Henderson, who doubled as the gardener.[26] A mobile painting hut was taken to Brighouse Bay for him each spring.[27] He was a central, if rather remote, figure in Kirkcudbright's flourishing artistic community. He was very friendly with Jessie King (1875-1949) and her husband E.A.Taylor (1874-1951), who had settled permanently in the town in 1915. Jessie King had purchased Greengate in the Old High Street near the Tolbooth in 1908, but Hornel had known her for about two years before then.[28] It was rumoured that she had rejected his proposal of marriage. Her husband was one of the few artists with whom Hornel could talk about literature and his library.[29] William Robson (1868-1952), who was born in Edinburgh and trained there and in Paris, moving to Kirkcudbright about 1904, was also a good friend.[30] The Manchester-born painter Charles Oppenheimer (1876-1961) arrived in the town about 1910, renting the house next door to Hornel. Whether they became friends is uncertain, but a work by Oppenheimer still hangs in Hornel's studio. Further afield the architect John Keppie, the photographer James Craig Annan and the pianist Philip Halstead were close friends, often staying at Broughton House over Christmas or the New Year.[31] Around 1930 Hornel became friendly with the Glasgow dealer Ian MacNicol, who was to act as his agent until his death in 1933. MacNicol held a memorial exhibition that year and continued to champion Hornel's work until his own death in 1979.[32]

Hornel was well known in the town. Most of the townspeople respected him, rather than liked him.[33] As a young man he had had a very outgoing nature, but in later life he appeared to dislike publicity and 'in public places a sort of shyness seemed to settle somewhat uneasily upon his sometimes brusque but not unkindly habitual manner.'[34] Indeed he was not a very sociable person except within his immediate circle. He was careful in his choice of friends and of those he allowed into the gallery and his studio. He was rather quiet and could be rather abrupt. However he also could be very kind.[35] For example at one time it was his custom to keep the studio unlocked at night so that any

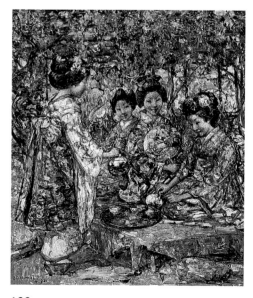

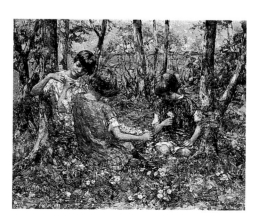

(left)
PLATE 66
Japanese Tea Party
1921
Oil on canvas, 30 x 25
Private Collection

(right)
PLATE 67
Primrose Day *1926*
Oil on canvas, 25 x 30
Private Collection

wayfarer who had no place to sleep could use it. The artist John Duncan told the story that on a visit to Hornel 'they went down to the studio one morning to find in possession a well-known Galloway itinerant who had spent the night there. Hornel at once entered into friendly conversation with him...As they conversed, the Provost turned up to make a morning call. Hornel with characteristic dignity and formality introduced the two men to one another. There was no hint of any social difference between the two.'[36]

Hornel was always prepared to do what he could in a quiet way for the benefit of the local community. After the First World War he advised several local committees on the design of appropriate war memorials, including that of Kirkcudbright. G.H.Paulin's maquette for the latter sits in the gallery at Broughton House. He had a wide range of local interests. For instance he was a keen supporter of the Stewartry Museum and served as Chairman of its Management Committee. However it was Kirkcudbright Academy which held a special place in his affections and he devoted a considerable amount of time to its interests. He served on the Stewartry's Education Authority for three years from 1925, a period when the Academy was undergoing reconstruction and re-equipment. After Hornel's death the chairman of the Authority paid tribute to his 'quiet dignity, modesty and kindliness of manner...His heart was in Kirkcudbright Academy...Only those in close touch with the movement of that time know the time and toil and thought that he expended on it...His enthusiasm awoke enthusiasm in others especially in the former pupils of the Academy.'[37] He was one of the prime movers in the establishment of the Academy Former Pupils' Club in 1926 and was elected as its first president.[38] Hornel was one of a number who encouraged Thomas Cochran, a New York banker whose forebears had been pupils at the Academy, to fund the building of the Cochran Memorial Gymnasium, which was opened in 1931. He was appointed an Honorary Sheriffs Substitute for Dumfries and Galloway in 1925 and, although the combination of art and law is an unlikely one, it was a role which Hornel carried out ably until his death.

In the later years Hornel and Tizzie lived mainly in the gallery at Broughton House. In the forenoon she often sat with her knitting in the studio, while her brother worked at the easel. If it was a good day, however, they would pack a picnic lunch and take the car to Brighouse Bay or one of the other painting grounds, where he would work until about two o'clock. Later he would go out for a walk, often accompanied by his friends Alex. Cavan the retired banker, David Clark the baker, Walter Wallace the builder and Jimmy Osborne the cabinetmaker. Hornel would be dressed in a Lovat Green knickerbocker suit, stockings, boots and felt hat with his walking stick in his hand. If it was a cold day he wore a long overcoat. He kept a magnifying glass in his waistcoat pocket, which he would always bring out to read anything, because he refused to wear spectacles.[39] Tizzie and he frequently entertained friends to tea in the gallery in the afternoon. Every Saturday evening they went over to 18 Old High Street to see their sisters Janet, Grace and Annie. The sisters were great church workers, but neither Hornel nor Tizzie went to church (but the housekeeper was encouraged to go).[40]

This rather pleasant life was shattered in November 1932, when Hornel suffered a stroke while he was visiting Glasgow. After a period in a nursing home he was allowed to return home to Broughton House, but he made little progress. He died from pneumonia on the last day of June 1933, a fortnight or so before his sixty-ninth birthday.

Tizzie was left the liferent of Broughton House and stayed on in that large house with a cook and a housemaid for another seventeen years. In characteristic fashion she lived in one room and a bedroom, which had fires in them, for about a fortnight at a time, so that over a period the whole house was aired. She was a quiet, kindly lady, spending much of her time in the garden.[41] When she died in 1950 Broughton House and all its contents passed to the Hornel Trust to provide a public art gallery and library for the people of the Stewartry of Kirkcudbright, as Hornel had planned as far back as 1919.

In his art and in his life Hornel followed his former teacher Verlat's exhortation to 'be himself'.[42] Without doubt he was one of the finest colourists Scotland has produced. In the first half of the 1890s he was at the forefront of progressive Scottish painting. His striking colour harmonies helped significantly to put Scottish art on the international map. Along with Melville, Guthrie and Henry, he pointed the way for those who came after, particularly their immediate successors Peploe, Fergusson, Hunter and Cadell. However at a turning point in his career in the late 1890s he chose to steer a safer middle course between colour and subject matter. The painter John Duncan noted that 'colour is always at its best in the hands of people that are little or nothing at drawing', adding 'Hornel's Japanese period is a good illustration of this principle. Except for the little faces which were inlaid with some care the pictures were Kaleidoscopic. He played with colour setting down splatches [sic] almost at hazard and making these splashes afterwards pass as kimono or flower or sky or water as they best happened to come. Afterwards as he and the public together took the matter more seriously the splendour forsook him. Colour will not suffer any restraint.'[43] It is tempting to speculate what the outcome would have been had Hornel continued along the path of pure colour. Perhaps Scotland rather than France would have given birth to expressionism in colour in the first decade of the twentieth century.

1 E Rimbault Dibdin, *Mr.Hornel in Ceylon, The Art Journal*, 1908, p.371
2 Letter from James Hornell to Hornel dated 1 November 1906 (Hornel Trust)
3 *The Bacchus Marsh Express*, 12 October 1907
4 E Rimbault Dibdin, op.cit., p.376
5 Letter from Hornel in Galle to Thomas Fraser dated 26 June 1907 (Hornel Trust)
6 *The Art Journal*, 1908, p.173-4
7 E Rimbault Dibdin, op.cit., p.374
8 Letter from Hornel in Kandy to Thomas Fraser dated 11 August 1907 (Hornel Trust)
9 *The Studio*, vol.43, 1908, p.321
10 Letter from Hornel in Kandy to Thomas Fraser dated 11 August 1907 (Hornel Trust)
11 Typed extract of notebook for 1910-11 (Hornel Trust)
12 In conversation with Mrs Effie McNeillie, Kirkcudbright, 15 May 1993, and with Robert Lyall, Kirkcudbright, 19 March 1996 (in the 1920s Robert Lyall and his brother, then aged about 14 or 15, were paid sixpence to carry Hornel's easel out into his garden for him on fine days so that he could paint the flowers and shrubs in the garden; they noticed that Hornel stood very close to the canvas and appeared to be having difficulty with his eyesight)
13 In conversation with Mrs Effie McNeillie, Kirkcudbright, 15 May 1993, and with the late Jock Mitchell, Kirkcudbright, 29 November 1995
14 In conversation with Mrs Effie McNeillie, Kirkcudbright, 15 May 1993
15 Undated letter (June 1996) from Kathleen Hannay to Broughton House (Hornel Trust); Mrs Hannay's family and the Peploes were near neighbours in Edinburgh and it was after S.J.Peploe's death that his widow told Mrs Hannay about this incident
16 Letter from Hornel to Thomas Fraser dated 23 March 1919, quoted in Michael Russell, *A Portrait of a Private Library*, Newcastle Polytechnic School of Librarianship thesis, 1985, p.50
17 Letter from Thomas Fraser to Hornel dated 6 June 1897 (Hornel Trust)
18 Michael Russell, op.cit., p.6
19 Letter from Thomas Fraser to Hornel dated 27 March 1919, quoted in Michael Russell, op.cit., p.51
20 Letter from Hornel in Kyoto to Thomas Fraser dated 7 May 1921 (Hornel Trust)
21 Michael Russell, op.cit., pp.22-6 & 40-1
22 Letter from Hornel at Mandalay to Thomas Fraser dated 5 December 1920 (Hornel Trust)
23 Letter from Hornel at Mandalay to Thomas Fraser dated 17 December 1920 (Hornel Trust)
24 Letter from Hornel at the Miyako Hotel in Kyoto to Thomas Fraser dated 31 March 1921 (Hornel Trust)
25 Letter from Hornel at the Miyako Hotel in Kyoto to Thomas Fraser dated 25 May 1921 (Hornel Trust)
26 In conversation with Mrs Effie McNeillie, Kirkcudbright, 15 May 1993
27 In conversation with Jim Campbell, Kirkcudbright, 30 September 1996
28 Colin White, *The Enchanted World of Jessie M King*, Edinburgh, 1989, p.97
29 Ibid., p.84
30 In conversation with Mrs Effie McNeillie, Kirkcudbright, 15 May 1993, and with Robert Lyall, Kirkcudbright, 19 March 1996
31 In conversation with Mrs Effie McNeillie, Kirkcudbright, 15 May 1993
32 I am indebted to Sheila MacNicol for showing me a number of her father's catalogues
33 In conversation with the late Jock Mitchell, Kirkcudbright, 29 November 1995
34 Obituary, *The Scotsman*, 1 July 1933
35 In conversation with Mrs Effie McNeillie, Kirkcudbright, 15 May 1993, and with the late

Jock Mitchell, Kirkcudbright, 29 November 1995

36 Recounted by J.W.Herries, *A House of Enrichment, SMT Magazine*, 1952, p.35

37 Tribute by Rev.Dr David Frew, *Galloway News*, 8 July 1933

38 Tribute by D.G.Ramsay, Rector, *Kirkcudbright Academy Magazine*, June 1934

39 John Graham, *Memories of a Distinguished Artist: E.A.Hornel, Galloway News*, 5 June 1963; in conversation with Mrs Effie McNeillie, Kirkcudbright, 15 May 1993, Robert Lyall, Kirkcudbright, 19 March 1996 and Mrs Lizzie Rae, Kirkcudbright, 19 March 1996

40 In conversation with Mrs Effie McNeillie, Kirkcudbright, 15 May 1993

41 In conversation with Miss Charters, Kirkcudbright, 3 April 1995; Miss Charters went to Broughton House when she was 15 as housemaid to Tizzie (after the death of Hornel)

42 *An Editorial Diary: Hornel's Teacher, Glasgow Herald*, 4 July 1933

43 John Duncan, Notebook No.5 1912-3, National Library of Scotland (Acc.6866); I am grateful to Helen Smailes of the National Gallery of Scotland for bringing the notebooks to my attention

SELECTED BIBLIOGRAPHY

SCOTTISH ART

Caw, Sir James L., *Scottish Painting, Past and Present 1620-1908*, Edinburgh, 1908

Hardie, William R., *Scottish Painting: 1837 to the Present*, London, 1990

Harris, Paul, and Julian Halsby, *The Dictionary of Scottish Painters 1600-1960*, Edinburgh, 1990

Irwin, David and Francina, *Scottish Painters at Home and Abroad*, London, 1975

McEwan, Peter J.M., *Dictionary of Scottish Art & Architecture*, Woodbridge, 1994

Macmillan, Duncan, *Scottish Art: 1460-1990*, Edinburgh, 1990

THE GLASGOW BOYS

Billcliffe, Roger, *The Glasgow Boys*, London, 1985

Brown, G.Baldwin, *The Glasgow School of Painters*, Glasgow, 1908

Burkhauser, Jude (ed), *"Glasgow Girls": Women in Art & Design 1880-1920*, Edinburgh, 1990

Caw, Sir James L., *Sir James Guthrie*, London, 1932

Cumming, Elizabeth (ed), *Glasgow 1900: Art & Design*, Amsterdam. 1993

The Fine Art Society, *Glasgow School of Painting*, catalogue by William Hardie, 1970

Martin, David, *The Glasgow School of Painting*, London, 1897

Scottish Arts Council, *The Glasgow Boys*, catalogue in two parts, Edinburgh, 1968 & 1971

HORNEL

The Bailie, Edward Hornel, Painter, 1 May 1895

Dibdin, E.Rimbault, *E A Hornel's Paintings of Children & Flowers, The Studio*, XLI, 1907

Dibdin, E.Rimbault, *Mr Hornel in Ceylon, The Art Journal*, 1908

Dumfries & Galloway Standard, Mr E.A.Hornel, Artist, 16 November 1921

The Fine Art Society, *Edward Atkinson Hornel 1864-1933*, catalogue by Roger Billcliffe, 1982

Graham, John, *Memories of a Distinguished Artist: E.A.Hornel, Dumfries & Galloway Gazette*, 5 June 1964

Hardie, William R., *E.A.Hornel Reconsidered, Scottish Art Review*, vol.XI, nos.3 & 4, 1968

Hartrick, A.S., *A Painter's Pilgrimage Through Fifty Years*, Cambridge, 1939

Herries, J.W., *The Art of E.A.Hornel, The Gallovidian Annual*, Dumfries, 1938

Herries, J.W., *A House of Enrichment, Scotland Magazine*, July 1952

Hewison, James King, *Mr E.A.Hornel - A Distinguished Galloway Artist, The Gallovidian Annual*, Dumfries, 1924

Kirkcudbright Academy Magazine, tributes by E.A.Taylor and D.G.Ramsay, June 1934

Kirkcudbrightshire Advertiser, An American Appreciation of the Art of E A Hornel, 24 November 1905

Lavalle, Pierre, *The Giant of Kirkcudbright, Scottish Field*, March 1964

Little, G.Allan, *Hornel - A Painter of Galloway, Scots Magazine*, September 1968

Macaskill, Fiona, *The Role of Photography in the Work of Edward Atkinson Hornel*, University of St Andrews dissertation, 1983

Munro, Neil, *The Brave Days*, Edinburgh, 1931

Obituaries, *Galloway News, Glasgow Herald, The Scotsman*, 1 July 1933

Pinnington, Edward, *Mr. E.A.Hornel, The Scots Pictorial*, 15 June 1900

Quiz, George Henry and E A Hornel, 16 February 1893

Russell, Michael, *A Portrait of A Private Library*, Newcastle Polytechnic School of Librarianship thesis, 1985

Scott, Freda, *The Role of Japonisme in the Art of E.A.Hornel*, University of Glasgow thesis

Scottish Arts Council, *Mr Henry & Mr Hornel Visit Japan*, exhibition catalogue by William Buchanan, Ailsa Tanner & L.L.Ardern, 1978

Simpson, James Shaw, *Broughton House, Kirkcudbright, the residence of Mr E.A.Hornel, Scottish Country Life*, June 1916

Studio-Talk, The Studio, IX, 1896

Studio-Talk, The Studio, XLIII, 1908

Tanner, Ailsa, E.A.Hornel - *Portrait of a Portrait, Scots Magazine*, November 1990

Tanner, Ailsa, *Bessie MacNicol*, unpublished manuscript

Weyers, John, *The Painter with a Chauffeur, Glasgow Herald*, 14 December 1974

INDEX